ISBN: 9781290434898

Published by:
HardPress Publishing
8345 NW 66TH ST #2561
MIAMI FL 33166-2626

Email: info@hardpress.net
Web: http://www.hardpress.net

PENINSULAR SERIES

OF AMERICA

HISPANIC
NOTES & MONOGRAPHS

ESSAYS, STUDIES, AND BRIEF
BIOGRAPHIES ISSUED BY THE
HISPANIC SOCIETY OF AMERICA

PENINSULAR SERIES

I

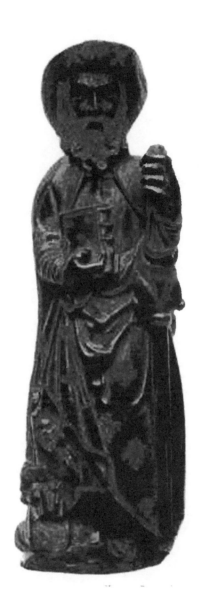

THE WAY OF SAINT JAMES

By

GEORGIANA GODDARD KING

SANTIAGO MAYOR

(From a Compostellan *Azabache* in the
Hispanic Society of America)

G. P. PUTNAM'S SONS
NEW YORK AND LONDON
1920

THE WAY OF SAINT JAMES

By
GEORGIANA GODDARD KING, M. A.
Professor of the History of Art, Bryn Mawr
College; Member the Hispanic Society
of America

In Three Volumes

Volume I

Illustrated

G. P. PUTNAM'S SONS
NEW YORK AND LONDON
1920

The Knickerbocker Press, New York

FOREWORD

During my stay in Rome of two years and a half, I employed all the spare time I had from Books and Libraries in viewing the Monuments; and I at last prescribed to myself a certain Method in making my Observations so as to go through the whole City in twenty Days. This same I repeated as often as either at the Request of my Friends or for my own Satisfaction I surveyed the city, always allotting twenty Days to review the whole. — Père Montfaucon.

FOLLOWING the precedent of the learned Benedictine, I have made one straight story out of three years' wanderings, and places visited and revisited. The outcome offers, first, a record of what exists, where other accounts are incomplete or inaccessible, and, secondly, an explanation of it. Spain

I. Record

II. Explanation

is a long way off, and pictures are not always explicit. It has taken seven years of my life. The writer's contribution, in particular, is first, a record and interpretation of iconographic detail all along the way, *e. g.*, at Leyre from observation, at Santiago from Aymery Picaud's account; second, an attempt to date, by comparison with such dated examples as exist, without any *à priori;* third and last, an occasional small hypothesis and the ground for it, *e. g.*, about the original west front at Compostella, and the cult of Santiago.

The general intention is stated at length in the first chapter; briefly, it was to discover and record the evidence of Spain's debt in architecture to other countries, France in especial, during the Middle Age. By contrast with the French style which came in along the *Camino francés*, it was necessary to define the Spanish styles which that supplanted or modified, and was swallowed up in at last: this must justify the consideration given twice or thrice to earlier churches on sites now

occupied, especially to the earlier sanctu-
aries of the Apostle. At Leon Sr. Lampérez
had already made such a study. The
intention being to supplement his work and
Street's great book, not to compete with
them, repetition of what Street had pub-
lished is avoided and, in consequence, only
a single aspect of each of the great cathe-
drals can figure here. To deal adequately
with any one, would want a book at least
as large as this.

For those who desire to secure facts
while avoiding the context, a very careful
Index is supplied. This makes it possible
for the learned to look up a church un-
molested by the dust of the highway, and
even the learned may care to look into the
pages for some of the churches which are,
so far as may be ascertained, hitherto
unpublished: of these are Torres, Bar-
badelo, Puerto Marín. The writer has
looked into a good many old books and
not a few remote and distinguished periodi-
cals. The excursus into what may seem the
field of comparative literature, indispens-
able to the argument, was long, laborious,

Assertion without substantiation

Compara-tive literature

and scrupulously at first hand. The religions of the Roman Empire were investigated in competent and first-rate authorities, which are enumerated in the bibliography. *Cursor Mundi* is cited so often, though an English work, because it is precisely what it calls itself, a Pilgrim of the World, that has gathered up an immense quantity of current and floating lore, and represents just what might be in the head of any stone-cutter or master of the works. It is a popular and plebian substitute for Vincent and Honorius. The *Bibliography* represents not the books consulted but those which yielded matter of worth, — a very small proportion. In the *Appendix* are printed a few *pièces justificatifs:* quotations in verse or others too long for a footnote; the *Grande Chanson des Pèlerins*, the *Great* and the *Little Hymn of S. James* and his Miracles out of the *Acta Sanctorum*, the Miracles of our Lady of Villa-Sirga out of the *Cantigas del Rey Sabio*, Thurkill's *Vision*, and a selection of *Itineraries* for the curious stay-at-home.

Possibly it will be said that this little

book is neither one thing nor the other, for it offers archaeology without jargon, and travel without flippancy. The writer's hope is that the learning, however small, may be judged sound, and the style not unworthy of it in being the ordinary vehicle, which is the daily speech of cultivated people: and that some worth and some pleasure may consist in the exact account of what was done and seen with the sense and in the light of a whole history and literature yet palpable and precious, though less familiar to the gentle reader than the immortal ambience of the Lombard plain and the hill-towns of Tuscany. *Nor pedantry nor impertinence*

To pay the gratitude I owe to all who have helped me would take too long a list: it would begin with the great S. James himself, with the good Companion of many days, with a great and generous lover of Spain; and end with the long suffering guardians of books in many libraries, the good-tempered boys and girls who fetched and carried dusty piles, and the outraged librarians who despatched too *The Good Companion*

many tiresome loans by post. Some names however may not be omitted, nor may I leave unsaid my thanks, for untiring and learned assistance, to the Reverend Father Middleton of Villanova College,

Kindness academic, who has answered questions intricate and importunate; to Dr. Wright and Dr. Patch of Bryn Mawr College, who have read a number of chapters in manuscript, and bettered them, and Dr. Frank and Dr. Barton who have answered demands sudden and surprising; to D. Juan Agapito y Revilla, the Vallasoletan architect and ecclesiologist, for precious time spared to me and the gift of publications, some otherwise unattainable; to my friend D. Ángel

ecclesiological, del Castillo of Corunna for other articles and specific advice and instruction simply invaluable; to D. Benito Fernández Alonso, of the Commission of Historic Monuments in Orense, for many courtesies and gifts; also to Mgr. Ragonesi, the Apostolic Nuncio in Spain; to the Archbishops of Santiago and Burgos and

and clerical the Bishop of Leon; to the Dean and Chapter of Santiago and the Abbess of Las

Huelgas; to the *Canónigo Fabriquero* of
Mondoñedo and the *Canónigo Archivero* of
Santiago, and D. Felix Araráns, *Canónigo*
Magistral of Burgos: and to twoscore
parish priests who without a single
exception offered me of their best, from
erudition down to new milk, *to the glory*,
in the grand phrase of one of them — *to the*
glory of religion and of Spain.

<div align="right">G. G. King.</div>

BRYN MAWR,
 All Souls' Day, 1917.

The illustrations are taken in part from
old books and museum pieces, in part
from coins, and I have to thank G. F. Hill,
of the British Museum, for a generous
gift of casts from some coins in that col-
lection; in part also from photographs
of my own, and others, better, of E. H.
Lowber. For drawings of difficult matter
I am greatly indebted to Miss Helen Fer-
nald, Instructor in the History of Art at
Bryn Mawr College.
 To the Curator of Publications at the

The glory of religion and of Spain

Use

Hispanic Society, Miss Isabel K. Macdermott, the reader owes as much as the writer, for her long patience and vigilant oversight during the publication. For the use in Spanish words, names, and titles, she and I are responsible, jointly, but it seems desirable that I should explain the principles to which we conformed; Spanish names of persons and places, and titles of modern books, are spelled and accented in accordance with the latest rulings of the Spanish Academy; the titles of old books are given as the author gave them. But it is a proud truth that the relations between those of English and those of Spanish speech were not established yesterday, nor even during the Peninsular War, but are a part of the ancient heritage of the two nations, and the sign thereof is that Spanish places have English names. We speak of Seville and Corunna, Pampeluna and Saragossa, Castile and Leon, by the same token that Shakespeare wrote of Katharine of Aragon, and Southey of the Infants of Carrion rhyming to Robin Hood's Marion. Those names I have used as we say Venice,

Rome, and Florence, Paris, Lyons and
Marseilles. They are each a token and a
pledge that insularity is merely geographical
and not intellectual, that isolation on the
other side of the world cannot cut off
Americans from talking in free and homely
speech of the great places to which they
turn with ancestral love and longing. In
referring to Kings and Queens of the
Spains, and other saints or heroes, I have
not been careful always to call them by the
same name, but as Jack and Jill may be
addressed as John and Joan at times, I
have taken the liberties that old acquaint-
ance allowed. To call Isabel the Catholic
Elizabeth, or the English Tudor the
Isabellan style (though others have done
it), I should hold for presumption, but
Ferdinand and Alfonso may alternate
methinks with Fernando and Alonso when
the chronicler or the hagiographer prompts,
and S. James is still recognizable as San-
tiago. This is not meticulous nor pedantic,
but it is comfortable and easy, which is a
great good in travel. G. G. K.

Jack shall
have Jill

CONTENTS

BOOK ONE: THE PILGRIMAGE

BOOK TWO: THE WAY

AND MONOGRAPHS I

ILLUSTRATIONS

BOOK ONE
THE PILGRIMAGE

Grot Sanctiagu!
Herru Sanctiagu!
E ultreja!
E sus, eja!
Deus adjuva nos!
 —Marching Song.

I

INTENTIONS

*C'est souvent sur
grands chemins que
vérité apparaît aux c
cheurs, ainsi qu'aux c
ants.*—Courajod.

THE original intention of this book
to examine the claims for the sour
of Spanish architecture in the Gothic a
Romanesque period. They are varic
Was everything invented in Persia? On
Syria, or Asia Minor, or Mesopotamia? V
everything borrowed from France? V
nothing learned from outside the Peninsu

M. Dieulafoy will have it that all
structural forms of Romanesque ca
from Persia to Spain, passed thence i
France, and came back to Spain after
Reconquest. On consideration it appea
n the first place, that this contention v
be affected, in a way, by the larger questi

now undecided, of *Orient oder Rom*, and its later development, *Byzance ou Orient*, and in so far may be left until these are nearer solution. In a way, of course, there is none, for every beginning has its antecedents. The argument of Professor Strzygowsky is alluring, but English travellers have pointed out that for the chronology of the churches of Syria and Asia Minor, while the sequence is plain the absolute dates are wanting, and if they are not of the fifth and sixth century, as once so confidently asserted, the argument of priority falls to the ground. The same is true of a good deal of Persian building: and if Justinian sent architects to Ctesiphon, he probably sent others direct to Betica and Carthagena, where he was settling what once had been an army. *Commendatore* Rivoira has shown with a proof beyond challenge the early Roman use of forms which, the Romans not fancying them, were used indeed rarely. Anything however that the Romans might know, the Spaniards could and would and usually did know, and here the law of parsimony affects the thesis of M. Dieulafoy. To

turn the pages of Rivoira's great work on the origins of Lombard architecture, is to encounter one by one, most of the typical plans enumerated by M. Dieulafoy in the opening pages of *Art in Spain* as oriental, and most of the structural devices as well.

In the second place, he offers no direct means by which architectural methods and forms could be conveyed from Persia into Spain. If they came by Europe, the Romans must have brought them: this he dismisses. If they came by Africa, where are the *étapes* of the long journey? The wonderful little churches that French architects and officers have unearthed along that shore belong to Roman and Byzantine imperial building. The Moors are generally believed to have developed their marvellous civilization on Spanish soil, as the Saracens on Sicilian and the Arabs on Mesopotamian: it flourished after an interval long enough, and it relied upon such characteristics and essential elements as the horse-shoe arch and the philosophy of Aristotle, which it found already in Spain. In this Arab question it is possible to com-

The route of church-builders

Arab trails

mand expert testimony. Says Ibn-Khal-doun the historian, "When a state is composed of Bedawi [Arabs] it needs men of another land for building." M. Gayet, who supplies this,[1] goes on to say that the Arabs depended on the men they con-quered, architect and day labourer alike, for their edifices: that alike in Persia, Egypt, and Spain, their art is moulded about a pre-existing formula, and betrays the in-clination of a race which, though it may touch at points the Arab civilization, yet preserves its individuality and haughtily affirms it. So much for the intrinsic likelihood of their serving as carriers from Persia.

Thirdly, there is small evidence of French borrowing from Spain before the year 1000. Sr. Lampérez once began to make a list of such cases: the first number[2] was the little church of Germigny-des-Prés, due to Theo-dulf the Spanish bishop of Orleans: the second number has not yet been published. The domed architecture of Périgord and Quercy is more wisely referred, when dates are scrutinized, to the repeated experi-

Loans to France

ments of French builders, helped by the presence of a Venetian colony at Limoges.[3] The architecture of Roussillon is not borrowed from Spain, it is simply Spanish, for in the Middle Age Roussillon was a part, most of the time, of the King of Aragon's domain. Isolated instances of imitation in France there may well have been, but rather in decoration than in structure, and most apparent in borrowing the cusped and trefoiled openings for arcades, windows and doors; but no general movement such as M. Dieulafoy postulates.

The great wave which he calls a backwash, the influx of French architecture into Spain that began in the eleventh century and lasted till the fourteenth, few nowadays will try to deny or even mitigate. French knights came, and French monks, and French master-masons, carvers and builders both. The main business of this book is with them. What is not so much denied, by serious scholars and the world at large, as ignored, unknown, is the importance of that which it supplanted, the beauty, in

The backwash

truth the existence, of an art noble and autochthonous. In . Asturias and Leon, in Galicia, in those southerly parts of the ancient county of Castile which are now the provinces of Soria, Palencia and Valladolid in Catalonia and Aragon, stand lonely and forgotten churches, some cruciform, some basilican in type, marked nearly all with the horse-shoe arch; some built early in the Reconquest, some due to a long persistence of the type in places remote or unpeopled:—they are the great might-have-been of Spain. They owe much to Constantinople and more to Rome: something to the Visigoths, and wherever was the earlier home of them; little or nothing to France, that is to say, to Franks. With these pre-Romanesque churches I hope in some measure to reckon in the book that shall follow this, but not here: they are not found along the Pilgrim Way.

The extent of Spanish relations with the lands that lie east of the Mediterranean, is matter of history. In the first three centuries, religions were fetched thence, the worship of Serapis, of Mithras and, accord-

ing to Spaniards, of Jesus; then heresies, then precious relics, and memories of the Holy Land; then travellers' tales, and the exploits of Crusaders and the Great Conquests of Over-Seas. The question is not whether this Oriental influence, so hotly asserted, was possible, but whether it was actual. Spiritually, in religious worship and belief, it is apparent, though even there Rome may nave been the carrier. There is a debt to Egypt, and the worship of Isis and Serapis was deeply rooted in Spain. It has left traces perhaps on Spanish worship even to this day. Just what the Coptic contributed to the formation of Carolingian and Romanesque art, we are not yet prepared to say, but certainly Coptic Christianity influenced Spanish hagiography. I shall have to show later how great perhaps was the debt to Syria, how legends were carried by bishop and merchant like seeds by birds. Sr. Lampérez will have it that he has found the trail of a Syrian architect who came on the Pilgrimage in the twelfth century, at Irache, and at Zamora. I believe him. Yet on exam-

The Great Conquests of Over-Seas

Isis and the Coptic Church

ining the plans and photographs and statements of fact—I expressly exclude the deductions drawn thence—of *The Thousand and One Churches*,[4] for instance, of Professor Butler's Mission to Northern Syria, of Crowfoot's journey and de Voguë's, the correspondences that appear with what I know in Spain are so few, that it seems safer to classify them as like effects of a common cause. Two further limitations must be put to the last sentence: one, that Templars' building and that of the Orders of the Hospital and the Holy Sepulchre, in Spain, are excepted, for there is Syrian or other Asian influence there, but the buildings form a class apart, as will appear in the course of the book. The other is that there will be no consideration of any styles, in Asia Minor or Asturias, Mesopotamia or Galicia, Syria or Andalusia, of which all the examples have completely disappeared.

Into the fault of not getting, intellectually, the sound of your town belfry out of your ears, have fallen some very distinguished Frenchmen who habitually speak on Spanish matters as having au-

The Thousand and One Churches

Campanilismo

thority. When M. Bertaux[5] too lightly attributes matter very various, all to the school of Toulouse; when M. Enlart rashly insists that Peter Peterson, the architect of Toledo (*Petrus Petri*, reads his epitaph), instead of Pedro Pérez, is Pierre the son of Pierre, and wants to make one of these Peter of Corbie,[6] then they bring reproach upon their nation. There is only one method to form a judgement of this sort, the exactest and most disinterested comparison of objects. When Street wrote that Leon Cathedral was built from French designs, at some time after the year 1230, he cited in evidence the mouldings at Rheims, Amiens, and Laon: the passage is quoted elsewhere. Nothing less would serve him. M. Bertaux has wide reading in contemporary Spanish ecclesiology and a facile and happy instinct which oftener guesses a truth than proves it. M. Enlart has a recondite experience of early Gothic: on the churches of Italy, of Cyprus, of Scandinavia, he can speak from acquaintance, but he has not pushed so far as might be, into Spain, else had he never fobbed off

MM. Bertaux and Enlart

Vol. II, p. 250

Ripoll with only three apses, instead of seven.

There is nothing for it but to shrug the shoulders when a Spanish Canon and his English admirers go astray; taking up, for instance, the dispute as to priority between the churches of Santiago and S. Sernin, if one of them asserts that there were, in that style, early instances a-plenty in Spain, but unhappily all have perished except those posterior to Santiago; or if another wrests the pilgrim's note that S. Martin of Tours had ambulatory and chapels "like Santiago," into an authentic statement that it was copied after Santiago. This is not scholarly, not critical. An elder generation of Spanish ecclesiologists was betrayed at times into an assumption that Spain, like the Great Council at Venice, was at a certain date closed to outside influence, just as in the year 1559 it was closed to foreign learning: but the men of weight and the men of genius in Spain today, are free from taint of error.

If the names of two French scholars only, *muy respetables*, are singled out, it is

precisely because they are so rightly and so heartily respected. There are others. The rest—for instance, M. Henri Stein,[7]— when they snatch everything in Europe,[8] are left with another shrug.[9] But these are not in like case. Of their judgment and experience we should not anticipate the crowning argument that because the tenth century, or the twelfth, in France came to no such flower, therefore it could not in Spain. Both these, if they knew better the land of Spain, would doubtless abate their claim for France, as the present writer has had in due course to do. When one has learned really to know, league after league, a single region, the *Tierra de Santiago* and thereabouts, for instance, or the Burgalese, or northern Catalonia, or southern Navarre; or when one has studied the development through the centuries of a great *chantier*, that of Leon or that of Compostella, one comes at last to realize that the stuff, whencesoever it comes, is soon altered and made over. Sometimes one sees the French leavening a vast lump; sometimes the metal is French but Spanish the image and superscription.

The image and superscription

That stands to reason. It is not much better, with M. Bertaux, to dismiss everything of a certain sort as school of Toulouse, than with Richard Ford to talk about Norman architecture in Segovia, because we are used to calling it Norman in England. In spite of all their likeness, the English churches are not like those of Normandy, though the conditions made a relation far closer there, of incessant passage and interchange, than ever existed between Spain and France. Building French by origin may be Spanish in detail; again, the converse appears.

A great *chantier* at its very inception must have had to call in local workmen. Raymond of Burgundy, for the repeopling of Avila, in 1090, fetched, along with ninety French knights, twenty-two masters of *piedras taller* and twelve of "*jometria*," for the walls: these had to build, besides the walls, the cathedral and the churches; yet in 1109 the work on S. Vicente was reported as well along. The masters had trained their men, and this case is probably typical. From time to time new blood

was wanted: sometimes after deliberation the chapter would write away for an architect, as that of Astorga sent, fearing it was too late, to enquire at Burgos for Master Francis of Cologne. Sometimes one came along of himself, like that William the Englishman who is said to have built the great church of Sahagún. So Villard de Honnecourt went to Hungary; so he passed by Chartres and Lausanne and sketched there. Workmen from the Royal Domain formed the style at Leon; from Burgundy, that at Avila. Workmen from Chartres, passing, left their handiwork on doorjambs at Sangüesa; from Rocamadour, left a plan like Souillac at Estella.

 The stone-worker's is a wandering craft. That R. Lombardo who signed a contract in the Seo de Urgell, to build the church with four other Lombardos, had crossed, belike, both Alps and Pyrenees with a sack of tools on his shoulder, some sort of sketch book in his wallet. Bishop Alonso of Carthagena, riding home from the Council of Bâle, broke the journey, it is conjectured, at Cologne, and there picked up an honest

A wandering craft

workman, Hans by name, with as little
ceremony as he would have used to hire a
running-footman, or buy a hawk or a boar-
hound. Was not Master William called "of
Sens," master of Canterbury Cathedral?
Did not one same Master William and one
same Master Nicholas leave their signatures
at Verona and at Modena, and their sign
at Cremona and Ferrara? Up and down
the coast of Catalonia and even into the
isles of the sea travelled Jaime Fabre: all
over the kingdom of the Castiles you may
track the work of John of Badajoz. When
the princely uncles of the King of France
were still in their splendid ascendency,
Claus Sluter, working for the Duke of
Burgundy, wrote home to Holland for his
nephew to come down and join him; André
Beauneveu, working for the Duke of
Berry, was visited twice at least by work-
men of Burgundy, bent on learning. In
October or November, 1373, Claus Sluter
and Jean de Beaumetz were sent to him
at the Château of Mehun-sur-Yévre, "pour
visiter certains ouvraiges de peintures,
d'ymaiges, et d' entailleures et autres que

Monseigneur de Berry faisit faire audit Meun."[10] The other party consisted of masters in works of carpentry and of masonry, of *Philippe le Hardi* in Flanders, all expenses paid.

A few more examples may serve: Eudes de Montereau went to Palestine with S. Louis, and worked much, and learned more. Jean Langlois of Troyes went on the pilgrimage to Jerusalem in 1267, not probably alone, and it has been pointed out that the cathedral of Famagusta, in the island of Cyprus, bears a strong likeness to the characteristic style of Troyes. For Charles of Anjou in Naples, worked at least one builder from the Isle of France, between 1269 and 1284, — Pierre d'Angicourt. A hundred years later, in 1377, Guillaume Colombier of Avignon was occupied at Anagni—that removal, however, left him still in Papal territory. Matthew of Arras appears at Avignon in 1342 and the Emperor Charles IV takes him thence to Prague to build the cathedral there. Henry Arler of Boulogne-sur-Mer is said to have drawn the plans for that of Ulm —

but if so, something happened in the course of executing them.

"*J'ai esté en mult de tiere, si cum vos porés trover en cest livre,*" writes Villard de Honnecourt,[11] and again, beside the drawing of a window in Rheims, with a sudden recollection of bitter home-sickness: "I was in Hungary when I drew that, therefore I love it more."

The architect in other days, indeed, like the portrait painter, trusted more to his mind and less in his material: Villard in Hungary drew out from memory the pattern of the lovely rose and lancets at Rheims. Still, when he encountered the antique he sketched from it on the spot, here a votive statue, in the nude or all but, there a Gallo-Roman sepulchral monument. "*De tel maniere,*" he notes, later, quaintly, "*ju li sépoulcre d'un Sarrizin que jo vi une fois.*" The chance to study a living lion, out in Hungary, was seized as a piece of great luck; almost as well as Mokkei with the tiger, he caught the pose of the huge doggish creature in the moment before his spring. The design of a clock,

Villard de Honnecourt

The Sepulchre of a Saracen

the pattern of an inlaid pavement, the tracery of a rose or a labyrinth, he sets down as he encounters them; a device to make the lectern-eagle turn and bow at the Gospel, another to keep the priest's hands warm enough to celebrate the Mass on bitter mornings in northern winters. He preserves these as he thinks them out: afterwards, turning over the leaves with a friend, or in his old age, he makes his comments and adds his reminiscences. An admirable plan was that which he and Peter of Corbie worked out for vaulting the double ambulatory.

So when such men met, on the tramp, travelling for commissions or on pilgrimage, be sure the sketch-book came out, yielding much, acquiring more, as they sat each with other, through the long hours of dark, *inter se disputando*.

All along the Pilgrim Way you may see where they have been. Desirous merely of finding out, at first, what evidence exists for these French claims and these Spanish disclaimers, I have followed step by step the route laid down by Aymery

Peter of Corbie

Picaud in the twelfth century, for the pilgrims going to S. James. Precisely there, on the main-travelled road, if anywhere, the proofs would lie. What this book records was learned from looking, and from books of history. Also at times are quoted the conclusions of Sr. Gómez Moreno, sometime of Granada, of D. Rafael Altamira who is an historian, of D. Vicente Lampérez who is a working architect, versed in the learning of his craft, for these three are men of approved sobriety, reasonable in their postulates, liberal in their admissions, well established in their inferences, but even here, as in the case of personal judgements, in the propounding is distinguished whatever is matter of opinion. I have rung the changes on *belike* and *peradventure, it seems,* and *it well may be,* till the reader doubtless is heartily sick of them all. I owe the scruple to the original intent, which was simply, I repeat, to disengage and present evidence. Everything believed at the outset was abandoned long ago; and, out of examination and comparison and perpetual returns to view old matter under

a new light, has been built up a theory, not new, but not before, perhaps, just so applied, of the importance of the *chantier*.

Half by accident, at the outset, was Aymery Picaud taken for guide. In an earlier piece of work, editing Street's great book on *Gothic Architecture in Spain*, the main lines of French penetration into Spain were marked and approved. Before the breaking out of the War I had hoped to follow those ancient roads across France, and pause with the pilgrims at Vézelay and S. Gilles, at Limoges and Saintes and Toulouse; to see Saumur, and Parthenay-le-Vieux, the home of Aymery, and Blaye, where Roland lies buried and beside him Oliver, and Oliver's sister who died of sorrow, "*Aude au vis cler.*" I had hoped from among winding riverside poplars, or on the huge domes of the volcanic land, or by S. Gilles, beside the great waters of the glimmering meres, to look up on August nights and see how ran the starry track, straight south-westward to Compostella. Personal disappointment, the imperfection of a little piece of work, is

La douce France

not so much as to be uttered where the sacred name of France is invoked today. Acquaintance from of old with much that was best in France, *la douce France*, made the first plan not impossible though modified perforce: but the close study of the *Camino francés* has been commenced and ended inside the Spanish frontier.

The intention, as the reader will see, has grown long since from a mere pedantic exercise in architecture, to a very pilgrimage, to following ardently along the ancient way where all the centuries have gone. The kings of Spain had built a highway to assist pilgrims in the twelfth century: but the road was there already. The Romans had built a military road as sign and condition of their domination: but the road was there already. Palaeolithic man had moved along it, and the stations of a living devotion today, he had frequented; there he made his magic, and felt vague awe before the abyss of an antiquity unfathomed. Along that way the winds impel, the waters guide, earth draws the feet. The very sky allures and insists. *"Commo se de-*

The Road

mostróu á Calrros as estrelas enno ceo," commences the Gallegan version of Turpin the Archbishop, "how the stars in the sky revealed themselves to Charlemagne." "It signifies that you shall go into Galicia at the head of a great host, and after you all peoples shall come in pilgrimage, even to the end of time," thus the vision spoke to the Emperor: and the vision said to Bernardette: "A chapel shall be built here; I mean that people shall come in processions to it, . . . so that all peoples shall come in processions from all places in the world," multitudes and multitudes, forever.

The known facts of geography, though edifying, cannot wholly explain this matter of the elder sanctuaries, nor tell why, though religions come and go, men set their feet eternally toward a certain hilltop, there to lift up their hearts. *Sursum corda!* the attitude is old as humanity, the emotion is strong as death. At S. Michel du Péril the Druids held their assemblies in the place of those they had supplanted. At S. Michele in Gargano the bull of Mithras still lurks in the cave, wounded

Angelorum agmine sepe visitatur

for the timeless sacrifice. An awe broods
even over the Protestant's and the Puri-
tan's line, when he comes to "the great
vision of the Guarded Mount." In the
lonely shrine of the Madonna del Parto,
Piero della Francesca paused to paint a
strange figure, older than the Maiden,
older than the Romans' homely gods of
hearth and garth, for Piero, mountain-
born, could hear the noises that travel
along the earth and over frozen seas.
That sound of underground waters, which
we call folk-lore, murmurs through all his
inscrutable art; and his figure is worshipped
there as from of old, the earth goddess
invoked by women about to bring forth.

Mystics can tell how journeys to such
shrines are made: *The way is opened
before you, and closed behind you.* Simple,
that: believe it or not, it happens. So
with Compostella: to those grey granite
hills, ringed round with higher, the blind
longings are drawn, the restless feet are
guided. It is not a place to live, *triste*,
grey, quite dead; nor even a place to love,
not beautiful, not sympathetic; but when

you are away, it draws you. In the spring, when frost is out of the ground, and ships are sailing, week by week, you cannot get it out of your head: as you smell the brown fresh-turned clods, it works in your blood.

There, as I went, so went the Middle Age. The great Pilgrimage was something hugeous, incredible. On the current of it was borne this noble French architecture, already spoken of; along the stream of it grew up a body of noble French epic; in the winding gorge of Roncevaux, still echoes the *Chanson de Roland.*

Roland's horn

II

TURPIN'S CHRONICLE

Es livres qui parolent des roys de France trovons escript que par la proiere Monseigneur Saint Jacques dona Nostre Sires cest don a Charlemaine c'on parleroit de lui tant com le siecle dureroit.

CHARLEMAGNE was old, he had worn out his life fighting all over the earth; he was weary and would rest, when one night he saw a starry road that, beginning at the Frisian sea, crossed France and Gascony, Navarre and Spain, to the world's end. It ran on across the sky to Galicia, where the body of S. James at that time lay unrecognized. Many a night he saw the marvel, and understood it not. At last a fair lord appeared to him, and when the

Emperor asked, "Lord, who art thou?"
he answered, "I am James the Apostle,
Christ's servant, Zebedee's son, John
Evangelist's brother, elect by God's grace
to preach His law, whom Herod slew: look A road to a grave
you, my body is in Galicia but no man
knoweth where, and the Saracens oppress
the land. Therefore God sends you to
retake the road that leads to my tomb and
the land wherein I rest. The starry way
that you saw in the sky signifies that you
shall go into Galicia at the head of a great
host, and after you all peoples shall come
in pilgrimage, even till the end of time. Go
then; I will be your helper: and as guerdon
of your travails I will get you from God a
crown in heaven, and your name shall
abide in the memory of man until the Day
of Judgement." *In saecula saeculorum,
Amen*—the promise rolls like thunder among
the reverberating centuries.

.So Charlemagne makes three expeditions
into Spain. In the first he pushes as far
as Compostella and beyond, riding into
the sea and sticking there his lance in sign
of his dominion even to the ends of the

earth. In the great church he establishes a Bishop and Canons under the rule of S. Isidore, bestows those bells that Almanzor was to carry away. In the course of the second foray he builds a church and founds an abbey hard by Cea bank, where Sahagún is situate. In the third invasion he holds a Council at Compostella and confers such privileges as Rome could never enforce for herself — every house in Spain must pay four pence a year, every plough-land recovered, a measure of wheat and a measure of wine; bishops must come thither for investiture and kings for coronation. Compostella he makes the metropolitan see of Spain, co-equal with Rome the seat of Peter, and Ephesus the burial-place of John. On the way home he takes Saragossa and in the mountains his rear-guard is beset by Saracens. Roland and his twenty thousand good knights are slain, and buried by the Emperor at Blaye and Belin, Bordeaux and Les Alyscamps. He calls a Council at S. Denis to dower that abbey like S. James's and at Aix he paints the history of the Spanish wars

upon his palace walls. Finally, when he is dead, and the deeds of all his life lie in the balance, and that is insecure, a Gallegan without a head throws in the stones of all the churches that he built, and thus redeems the promise of his early apparition. This ends the Chronicle of Turpin. The same crisis, it will be remembered, occurred in the case of the good King Dagobert and also in that of the German Emperor Henry who lies now sainted in Bamberg, thanks to prompt action by S. Michael.

The latest contribution to letters of M. Bédier has been to show how all this is related by action and reaction to the great pilgrimage, and how the incidents which have sprung up along its route contribute to its success. He goes so far as to say that the whole *Book of S. James*, the Codex called of Pope Calixt, of which this of Turpin is a part, was compiled, probably by a French monk, in the middle of the twelfth century, and was intended precisely as an instrument of propaganda, in other words, an advertising scheme for the pilgrimage. As the pseudo-Calixtus

The Epical Legends

asked of clerks notes on the saints of
their churches, so the pseudo-Turpin asked
of professional jongleurs notes on the per-
sons in their romances. Charlemagne
and his peers are Pilgrims of S. James,
they are the first Knights of Santiago.
The idea gives occasion to M. Bédier's
ripe and poetic genius for *une belle page*
that may be detached without much more
damage than a flowering hawthorn bough:

L'idée est belle de grouper dans les
Landes de Bordeaux les héros de toutes
les gestes, appelés des quatre coins de
l'horizon poétique, de les acheminer
tous, épris d'un même désir, vers le tom-
beau de Galice, et de les ramener par
Roncevaux, afin que l'apôtre, à cette
dernière étape de leur pèlerinage, leur
donne tous à la fois leur récompense, la
joie d'être martyrs. L'idée est belle de
ce crépuscule des héros, qui renaissent
ensemble à la lumière éternelle. L'idée
est belle de distribuer leurs dépouilles,
leurs reliques, sur les routes de Com-
postelle, pour qu'ils en soient les gardiens,
pour qu'ils protègent, eux les pèlerins
triomphants, ceux de l'Eglise souffrante:

ils sont leurs modèles sur ces routes, leurs patrons, leurs intercesseurs.

Idée recente, dit-on. Sans doute, puisque la vieille *Chanson de Roland*, celle du manuscript d'Oxford, l'ignore. Mais idée qui procède pourtant de la vieille *Chanson de Roland*. Charlemagne et ses pairs chevaliers de S. Jacques, c'est l'invention nouvelle; mais déjà, dans la vieille chanson, ils étaient les chevaliers de Dieu. Ils meurent à Roncevaux au retour du pèlerinage de Galice, c'est l'invention nouvelle; mais la donné est ancienne, héritée, qu'ils meurent à Roncevaux, au retour d'une croisade, et déjà la vieille *Chanson de Roland* est, à de certains égards, une Passion de martyrs. . . .[1]

enton Rulan martere de Jhesu-Cristo. . .

Certain *chansons de geste* show an exact nowledge of the long way and the stopping laces on it. Even in the *Entrée d'Espagne*,[2] hough the Paduan poet who composed : in the fourteenth century depended but ttle on the pseudo-Turpin, the Pilgrimage ; the necessary antecedent, and the back-round, of the action. Composed in onour of Charlemagne, it is perpetually

L'Entrée d'Espagne

preoccupied with S. James. The business
of the warriors is not so much to deliver
the Apostle from the Saracens in occupa-
tion, as to keep the road open. Of the
Way the Paduan has only hearsay knowl-
edge—he knows of Nájera, and the bridge
at Nájera, and sets his great battle there,
but we must suppose he brings in his army
not by the pass of Roncevaux but by the
sea-shore route, otherwise they could never
have got to Nájera before Pampeluna. He
knows of Estella, about which lies much of
the action, Astorga, and Carrion: on the
other hand, he puts Belin close to Pam-
peluna, and if Orthez is to be identified with
Nobles, then he makes a like mistake there
again. Not knowing the mountain passes,
he takes a safe course and makes the entry
vaguely by Port d'Espagne.[3] Burgos is
merely Bors d'Espagne, a place from which
came one of four kings, the others ruling in
Logroño, Estella, and Sant Mart. Now
Santas Martas is a tiny sanctuary on the
Camino francés that no one would ever
remember unless he happened to sleep
there.[4] Nothing could be more significant

than this information, concrete and in-
exact, about the places familiar to the
pilgrims.

On the other hand, the *Prise de Pam-
pelune*[5] is as exact in its itinerary as *Childe
Harold's Pilgrimage.* Charlemagne takes
a town, baptizes the people, and moves on
to another; takes it, baptizes it, and treks.
The man who first planned this poem, not
necessarily Nicholas of Verona, for some
of the incidents of it lie in the dim back-
ward and abysm behind the *Chanson de
Roland,* — either had made himself the
journey from Pampeluna to Compostella,
or had taken notes from the talk of a
pilgrim who had made it, or else, conceiv-
ably, he had access to a better and fuller
Guide than Aymery Picaud's,[6] and his
public knew as much as he. This is in the
situation of *The Road in Tuscany*, of *A
Note-Book in Northern Spain:* half the
interest lies in the presentation on the one
hand, recognition on the other, of matter
familiar to both and by both felt romantic-
ally. While Saragossa, Cordova, and To-
ledo are vaguely envisaged, the westering

*La Prise de
Pampelune*

road runs straight and plain, by Pampe-
luna, Estella, and Logroño.

> Sus le cemin seint Jaques somes sens
> gaberise,
> Veés là Charion,— [7]

and after Carrion we see Sahagún, Masele,
which will be Mansilla de las Mulas, Leon,
and Astorga, where was once, as still at
Compostella there is, a Porta Francigena.

> Ver la porte che veit ver Françe e ver
> Bertagne[8]

Roland spurs, and the episode ends with
a movement westward

> A la porte che veit ver Seint Jaques
> tutour. [9]

Anseis de Carthage

Another long and very readable poem,
composed in the thirteenth century,
Anseis of Carthage,[10] draws not only from
the pseudo-Turpin but also from the
legendary store of Spain. Spanish and
French critics are agreed that Anseis, the
old Councillor Ysoré and his daughter

Lentierra, owe their being to Roderick, Count Julian, and the unhappy lady called *la Cava*. The morale of it is different; the young king is shown as pretty nearly unable to help himself in the false position that the lady has contrived, the father as a renegade hell-ripe, and the countess, remanded to a convent, gets off too easily with a knightly young son to intercede for her and to succeed her. The Saracen princess Gandeira, whom Anseis intended all along to marry, comes out as the conventional good wife of chivalry. It is not really necessary to suppose much more borrowing from Count Julian than from Paris of Troy: where likeness exists, the story is common enough in history, in romantic poetry, and in life. But the geography is rich and responsible. Taking place up and down the Way, all over the Way, the action is a little, in places, like a battle in Shakespeare, and in others, like the page which good Baedeker consecrates to an all-day journey. Anseis, beset by Saracens, falls back from somewhere beyond Astorga making one desperate stand after another, as far as

Astorga in
the plain

Hornillos del Camino and Castrojeriz, and thence sends messengers along the whole route up through France to the court of Charlemagne: the emperor marches, stage by stage, reconquers Spain, and finally goes home and gives thanks: the reader also, having now been over the road three times. It Pierrot du Ries wrote the poem, not merely copied it, then Pierrot had himself once skirted wood, descended painfully into a valley, forded the stream at the bottom, breasted the hill beyond the Orbigo and had the sudden vision of Astorga in the plain adobe-walled, crested with huge towers where it stands yet like the ivory elephant on a chess-board and —

Droit ver Luiserne tout i antiu cemin,[11]

he too had gone with Franchois.

This same city of Luiserne, with its story out of the *Arabian Nights*, had long intrigued scholars, and to M. Bédier belongs the praise for having found it, at last, simply by following the path. Here too, the main concern of everyone in the poem is:

Le cemin ke tu as Dieu promis
Del bon apostle.

'his art, moreover, has its roots in th
. First was the station, then th
y, as M. Bédier points out. Some (
stations may be older than he reckon:
ight mist lies late in mountain hollow
: memory of innumerable dead brood
certain fields from before the dawn (
ory. The prehistoric bones in th
neland about Cologne were so mult
inous as to give the seat, and possibl
occasion, of two legends at least: that (
Ursula, with her eleven thousand maider
t to death with arrows by the Germa
barians from further north and eas
that of the Theban Legion who, havin
ived corporate baptism and give
r pledge to the Wonderful, the Ever
ing, the Prince of Peace, then soone
a fight the battles of the Empire electe
die where they stood, non-resistan
: dead of Roncevaux all lie with the
ers far back. At Bordeaux, a grea
lo-Roman necropolis surrounded th

shrine and tomb of S. Seurin; at Blaye it would seem S. Romain (*ob.* 384) found some such an one when he rebuilt the famous temple in a field of sepulchres: at Alyscamps the Romans had buried in the burial place of those they overcame.

Where lie the tombs of the dead, where pass the feet of the living, there the little flames of the holy story burn brightly, and the ancestral ghosts are worshipped as martyrs and intercessors.

S. Roland and S. Charlemagne were not fantastic titles to the Middle Age.[12] In the cathedral of Chartres they enjoy a window of their own, like S. Stephen and S. Eustace and S. Magdalen.

With Chartres, in truth, though the way is long, Compostella has more than one curious connexion. The famous Codex named of Pope Calixt, which contains the Chronicle of Turpin and the Itinerary of Aymery, contains also a sort of liturgical mystery play, dealing with the Mass, that was written by Fulbert of Chartres. A clerk of Santiago who knew the great Bishop, or one visiting, may have brought it, or a

pious pilgrim, long after, made of it a
sweet offering, or the chapter came by it
through some ecclesiastical intermediary:
at any rate, there you handle the MS. and
music of Bishop Fulbert's composition, as
the owner laid it up in the Codex among
other precious things. There were plenty
of possible intermediaries, for instance that
Bernard of Angers who wrote the Book The
of the Miracles of S. Faith and dedicated Miracles
it to Fulbert while he was yet alive:[13] now from Conques
the sanctuary of S. Faith in Rouergue was
specially recommended to pilgrims on the
Way. The Codex was compiled, as most
students agree, before 1150; at the close of
that same century or very shortly thereafter
a workman from the *chantier* at Chartres,
passing on the *Camino francés*, stopped at
Sangüesa, and carved six figures on the door-
jambs of S. Mary's Church, three of them Three
queens, poor relations of the great figures Queens
in La Beauce. They stand there yet in San- from Chartres
güesa. In the thirteenth century the glass-
painters of Chartres portrayed a window
of the eastern ambulatory with the his-
tory of SS. Charlemagne and Roland, after

the versions of Turpin and Vincent of Beauvais.

That window is flanked, there in the eastern aisle, by the legend of S. Vincent of Saragossa on one hand, and on the other, by that of S. James, Spaniards both, in a little Spanish *reunión:* and in a clerestory window above still rides, as donor, in the glowing rose, S. Ferdinand.

and S.
Ferdinand

III

THE BOOK OF S. JAMES

> *Nay more — where is the third? — Calixt?*
> — Villon.

THE codex called of Pope Calixtus has Calixtus II nothing of him but the name. Seeing that he was in the world Count Guy of Burgundy, born brother to Count Raymond, Queen Urraca's husband, and thereafter Archbishop of Vienne, he made a plausible *parrain* for the MS. which was written under the influence of the great Archbishop his friend, Diego Gelmírez, if not in his day. It consists of five books, described as follows by a monk of Ripoll, Arnaut del Monte,[1] who saw it in 1173:

I. De scriptis sanctorum patrum, Augustini, videlicet, Ambrosii, Hieronymi, Leonis, Maximi et Bede . . .

(aliaque) scripta aliorum quorundam sanctorum, in festivitatibus predicti apostoli et ad laudem illius per totum annum legenda, cum responsoriis, antiphonis, prefationibus, et orationibus ad idem pertinentibus quam plurimis.

II. Apostoli miracula.

III. Translatio apostoli ab Hierosolymis ad Hyspanias.

IV. Qualiter Karolus Magnus domuerit et subjugaverit jugo Christi Hyspanias.

V. Varia.

Carmina Compostellana

In the first Book or part occurs the Mass with a Farse or dramatic and musical liturgy credited usually to Fulbert, but retouched perhaps a little at Compostella. Among the Hymns and Tropes many are attributed to great names, Fulbert of Chartres, the Patriarch William of Jerusalem, S. Fortunatus; or others lesser but still historical, Bishop Hatto of Troyes, Joscelin of Vierzy Bishop of Soissons, Alberic of Rheims, Master Airard of Vézelay. Others are offered as the composition of Magister Johannis Legalis, of

Pope Leo and Master Panicha, of Albert of
Paris, in whom one would fain see a hum-
bler precursor of Albertus Magnus; and
one as a Prayer of Master G., whom Fr.
Dreves,[2] probably with reason, would
identify with Master Gautier of Castel
Renaud, elsewhere presented as composing
music—Magister Gauterius de Castello
Rainardi. A good many in the collection
may be of this kind, which is indeed the
same kind as *Hymns Ancient and Modern;*
a little one of Master Anselm's, two or
three named of Pope Calixt, and, also
charged to the last-named, a quaint set of
macaronic verses in Greek, Latin, and
Hebrew. Of Calixtus it must be admitted
that there is a very ancient tradition at
Santiago that he came thither.[3] Not
here, but after the Guide, along with some
of those already enumerated, occur the
poems of Aymery Picaud, the two hymns
and a third in unrhymed quantitative
verse, in Sapphics of a sort, which the
original editor annotates with touching
pride. But the best in the collection is
the superb drama of the Mass, intended

¿De dónde eres peregrino?

The Drama of the Mass.

for antiphonal choirs, at least two great
solo voices, and a chorus that included,
along with masses of trained singers, at
times the entire congregation of the crowded
church. Only to read it, you hear the
bellowing of the bull-voiced mimes and the
roar of *Amen* and *Eleison:* of this com-
position more will be said elsewhere in
the proper place. The Hymns and Re-
sponsions in prose, with musical notation
arranged usually for two or three voices,
in the Appendix that follows the Itinerary,
differ from the rest only in the date of
transcription; some are repetitions from the
earlier part, one is dated 1190; all are in
another hand from the Codex proper.
There is no more reason to doubt the
good faith of the collector than to believe
in the authenticity of these vague and
traditional attributions—it is enough that
Aymery believed them.

Ensamples

The second Book contains a choice of
twenty-odd miracles or Ensamples, mostly
contemporary:[4] about such a collection as
you would find at Lourdes. Of these the
second belongs to the time of Bishop

Theodomir and is credited to Bede; the third befell in 1108; the fourth is told on the faith of Master Hubert, the pious canon of the church of S. Mary Magdalen of Vézelay; the sixth and seventeenth are credited to S. Anselm, and the eighteenth befell a Count of S. Gilles "not long since." All the rest, with some of these, belong to the lifetime, and most to the episcopate, of the great Archbishop. Arnold of Ripoll adds two more that he found elsewhere in the Codex, in one of which figures Abbot Alberic of Vézelay (1138–43), a member of the household of Cluny. He copied out parts for those at home, some of which might be read in church and some at dinner, some parts, that is, being doctrine and others pious opinion.[5]

The third book, which tells the journey of S. James's body, Mgr. Duchesne has examined in the finest critical spirit, beside which seem dull and doubtful the patient labours of Fr. Fidel Fita to reconcile nonsense and make forgery plausible. The fourth is the Chronicle of Turpin,

already summarized; the fifth, the Pil-
grim's Guide of Aymery Picaud, liegeman
of Vézelay and clerk in orders—to which we
shall come shortly.[6]

The core of the MS., then, is a sort of
offertory, compiled, in the better parts, of
what the pilgrims brought, though for-
geries are arranged behind and before and
on either hand, to make all secure. It was
intended to increase devotion and promote
the pilgrimage.[7] It succeeded; pilgrims
waited their turn to make extracts and
copies. But it is something more, a *Spici-
legium*, a true and faithful gathering of
the legends told along the way. The
whole *Book of S. James* is seen to be,
in this light, a book and not a miscellany.
It gathers up the tales along the road-
side, sometimes saintly legends, sometimes
epical. It begins with the history of the
Apostle, continues with Charlemagne, and
ends with a choice of contemporary
miracles.

The legend of S. James is told, in its
essentials, about as follows—in the Codex,
in the *Golden Legend*, and in the *Recuerdos*

A Spici-legium

de un viage that Fr. Fidel Fita made in the year of grace 1880:

James the apostle, son of Zebedee, preached after the ascension of our Lord in the Jewry and Samaria, and after, he was sent into Spain for to sow there the word of Jesu Christ. But when he was there he profited but little, for he had converted unto Christ's law but nine disciples, of whom he left two there, for to preach the word of God, and took the other seven with him and returned again into Judea.

When the blessed S. James was beheaded, his disciples took the body away by night for fear of the Jews, and brought it into a ship, and committed unto the will of our Lord the sepulture of it, and went withal into the ship without sail or rudder. And by the conduct of the angel of our Lord they arrived in Galicia in the realm of Lupa. There was in Spain a queen that had to name, and also by deserving of her life, Lupa, which is as much to say in English as a she-wolf. And then the disciples of S. James took out his body and laid it upon

The Golden Legend

a great stone. And anon the stone received the body into it as it had been soft wax, and made to the body a stone as it were a sepulchre. Then the disciples went to Lupa the queen, and said to her:

Lupa, by interpretation a she-wolf

Our Lord Jesu Christ hath sent to thee the body of his disciple, so that him that thou wouldest not receive alive thou shalt receive dead, and then they recited to her the miracle by order; how they were come without any governaile of the ship and required of her place convenable for his holy sepulture. And when the queen heard this, she sent them unto a right cruel man, by treachery and by guile, as Master Beleth saith, and some say it was to the king of Spain, for to have his consent of this matter, and he took them and put them in prison. And when he was at dinner the angel of our Lord opened the prison and let them escape away all free. And when he knew it, he hastily sent knights after, for to take them, and as these knights passed to go over a bridge, the bridge brake and overthrew, and they fell in the water and were drowned. And when he heard that he repented him and doubted for

himself and for his people, and sent after them, praying them for to return, and that he would do like as they would themselves. ʾAnd then they returned and converted the people of that city unto the faith of God. And when Lupa the queen heard this, she was much sorrowful, and when they came again to her they told to her the agreement of the king. She answered: Take the oxen that I have in yonder mountain, and join ye and yoke them to my cart or chariot, and bring ye then the body of your master, and build ye for him such a place as ye will, and this she said to them in guile and mockage, for she knew well that there were no oxen but wild bulls, and supposed that they should never join them to her chariot, and if they were so joined and yoked to the chariot, they would run hither and thither, and should break the chariot, and throw down the body and slay them. But there is no wisdom against God. And then they, that knew nothing of the evil courage of the queen, went up on the mountain, and found there a dragon casting fire at them, and ran on them.

<div style="text-align: right">and wild bulls</div>

And they made the sign of the cross and he brake on two pieces. And then they made the sign of the cross upon the bulls, and anon they were meek as lambs. Then they took them and yoked them to the chariot, and took the body of S. James with the stone that they had laid it on, and laid on the chariot, and the wild bulls without governing or driving of anybody drew it forth into the middle of the palace of the queen Lupa. And when she saw this she was abashed and believed and was christened, and delivered to them all that they demanded, and dedicated her palace into a church and endowed it greatly, and after ended her life in good works.[8]

Some of this seems to come too near to Colchis' strand, and the devout of today have quietly dropped overboard the dragon. It must be said in fairness, that the dragon has as good a right there as the bulls: for the twelfth century as for the fifteenth, they would sink or swim together. After this, the disciples set out on the Roman road that runs from Padrón to Betanzos,[9] and buried S. James in a fair marble

S. James: From Berruguete's Tomb of Cardinal Tavera

sepulchre, which they may have found Arca
marmorea there disused, or which a convert and his family might offer as once Nicodemus did; Moors came, and the memory of it was lost even in Galicia.

About the beginning of the ninth century, in 830 or 813, perhaps, a hermit named Pelayo lived among the rocks of a steep hillside; by night he watched the stars, and once he saw one burning strangely low and strangely bright. There is another version, however, by which many little lights were seen hovering and flickering above the spot. The villagers near by saw it as well, the Bishop Theodomir was apprized: excavations revealed the tombs of the Apostle and his followers, and Alfonso the Chaste in person beheld and adored. Remain only the episodes when S. James appeared again and showed himself, like Castor, on a huge white horse. At the battle of Clavijo, in the Rioja near Nájera, to the cry of "Santiago, Cierra España!" he swept the field clear of the Hagarenes: this was in 845. At Simancas, in 939, with mitre and crozier he was manifested along with S.

The little lights

The White Horsemen

In all, 38 apparitions

Millán, the two together, "white horsemen that ride on white horses, the Knights of God."[10] He appeared at Baeza before 1149, and helped in the winning of Estremadura, at Ciudad Rodrigo and Merida, and elsewhere, and in America, though at times the credit was transferred to others.

Two traits, rich in human nature, belong, if anywhere, here. M. Paul Claudel, a Neo-Catholic man of letters sometime resident in Paris, of the most excessive and unctuous piety, is persuaded that S. James suffered martyrdom in Spain. In brief, though his theme is *The Year of God*, he does not know the first thing about the Apostle:

> S. Jacques à la fin de Juillet a péri en Espagne par l'épée:
> Entre les deux mois ardents il gît, la tête coupée.[11]

On the other hand, Father Fita, a very learned Jesuit, believing what he is told, yet saves and reserves his scholar's wit and his Spanish humour. Apropos of the eldest altar of S. James and an inscription on it, he writes:—"The monks believed

aright, if they thought the disciples of S.
James made an altar with these stones
over the grave of the Apostle, after the
most ancient use of the church: but they
believed not well, if they imagined that with
the holy body from Jerusalem came along
a Celto Hispanic column and tablet!"[12]

Because some Neo-Catholics love to
suffuse with emotion their ignorance;
and because even scholarly Jesuits some-
times are bound to twist and turn the
impossible in the hope of making some-
thing credible—which is the task of making
ropes of sand—there must be no pause
before presenting another sort of priest, of
the kind not uncommon in France, who
loving their God with heart and mind have
thought to serve Him by blowing up old
lies and making plain the way of truth.
Mgr. Duchesne of the French School in
Rome, at Brussels in 1894[13] and at Bor-
deaux in 1900 squarely encountered this
huge mass of legend, in the light of learn-
ing, and cleared the ground. He did to
his church son's duty and knight's service.
His reward is in the *Index*.[14]

The Pillar

A French priest

Follows a very brief abstract of his argument,[15] omitting points that seem of pure scholarship,—as, for instance, the true history of the *arcae marmoricae:*

S. James's journey to Spain is not mentioned by Prudentius: no references to it have been found in the fourth, fifth, sixth, seventh, and eighth centuries. Orosius of Braga, Idaeus, Bishop of Aquae Flaviae, S. Martin of Braga, Visigothic ecclesiastical writers, S. Isidore of Seville, etc., all are silent in their authentic writings. So also in Gaul: for instance, Gregory of Tours, with all his knowledge of the sanctuaries of Spain, makes no reference; Fortunatus, even, in an epistle to S. Martin of Braga, writes: "It is to S. Martin the Elder that Gaul owes the light of the Gospel, it is to the new Martin that Galicia owes the same benefit. In his person she enjoys the virtue of Peter, the doctrine of Paul, the help of James and John." In the collection of apostolic histories known under the name of Abdias, although there is plenty of legend, "apocryphal and fabulous accounts," there is not a word

of the journey of S. James to Galicia or of his burial there. Pope Innocent's letter, 416, denies any apostle but S. Peter in Italy, the Gauls, Spain, Africa, Sicily, and the adjacent isles. This may be for reasons of his own, and indeed he is insisting on acceptance of the Roman use. To be sure, S. Jerome has a passage about nets and fishers of men, Jerusalem, Spain, and Illyria, but the geographical choice of names is rhetorical rather than historical.

The so-called *Apostolic Catalogues* are hopelessly apocryphal, and entirely discredited; this was settled in 1894. Aldhelm, Bishop of Malmesbury, used the legend found in one of these, in composing an altar-inscription, at the end of the seventh century: S. Julian of Toledo had used the same compilation as early as 686 but he made S. James preach to the Jews, at Jerusalem, and deliberately omitted the Spanish episode. It is worth noting that Archbishop Rodrigo Ximénez of Toledo, in the thirteenth century, treated it as an old wives' tale.

Old Mozarabic liturgies before the

Apostolic Catalogues

twelfth century take no particular interest in S. James. The feast of July 25 came into Spain very late: it is lacking from many calendars of the tenth and the eleventh century.

Before the eleventh century the Spanish apostolate of S. James, then, is mentioned only in a Latin version of the Byzantine *Apostolic Catalogue,* and in books which depend on this version. Neither this *Catalogue* in its original Greek text, nor the additions which characterize the Latin recensions, have any title to represent an authentic tradition: certainly not a Spanish tradition. S. Julian of Toledo knowing their assertion, as we have seen, left it out. The *Catalogue* moreover does not bury him in Spain. The oldest uncontested document is the *Martyrology* of Adon, c. 860: "Hujus beatissimi apostoli sacra ossa ad Hispanias translata et in ultimis earum finibus, videlicet contra mare Britannicum condita, celeberrima illarum gentium veneratione excoluntur."

Long before this, Spain was restless, insubmissive, independently disposed in

relation to Rome. Galicia was the strong-hold of Priscillians; the invasion of the Suevi, 409, alone saved the bishops from wholesale eviction; as late as 561 they were still strong in the north-west corner of the province; i. e. in the very diocese of Iria Flavia. The heresy disappeared in the seventh and eighth century and the Suevian church was absorbed by the Visigothic. The fall of the Visigoths and the Moslem invasion touched the north-west lightly and not for long. Charters of Alfonso II the Chaste, 829, Ramiro I, 844, and Ordoño I, 859, are highly to the point, but they are not universally admitted as authentic. They say that the body of S. James was revealed during the reign of Alfonso, in the time of Bishop Theodomir of Iria Flavia: — that is all, just "re-vealed," down to the end of the ninth century. The *Chronicon Sebastiani* and the *Chronicon Albeldense* have not a word of it. Adon probably echoed some en-thusiastic pilgrim who had picked up the story on the spot. Almanzor took Com-postella twice, in 988 and in 994, and

sacked and burned it. By 1078 the great
church still standing, was begun, and the
pilgrimage was in full blast.

The two great books on which, after
this, all hangs, are the *Historia Compos-*
tellana and the Codex called "of Calixtus
II" (called here *The Book of St. James*).
The former deals chiefly with contemporary
events, down to 1139, and is virtually a
history of Bishop Diego Gelmírez; the
second contains (as mentioned before)
*The Translation of S. James from Jerusalem
to Spain*, a letter of S. Leo the pope, the
Miracles of S. James, collected, nominally,
by Calixtus II, the Passion of S. Eutropius
of Saintes, the history of Charlemagne by
the pseudo-Turpin, and an apocryphal letter
of Innocent II authenticating the whole.

The *Translatio* is a clear plagiarism from
the History of the Seven Spanish Bishops
martyred in the south of Spain, at Acci,
now Guadix, near Granada. That story,
which includes the seven disciples, the
Lady Luparia, with the bridge that breaks
down, and the Monte Sagro, was known in
Italy and France by the ninth century.

The letter of Pope Leo (possibly meant for Leo III, 795–816) does not attest the discovery of the relics, only their translation — that the body of S. James was brought by his disciples from Jerusalem into Galicia. Three redactions of this letter exist: the oldest from a MS. of S. Martial of Limoges, in Visigothic writing of the tenth century, added on a blank page. Another, from a MS. in the Escorial, was published by Fita and Guerra in *Recuerdos de un viaje a Santiago de Compostela.* The third is that of the *Liber Calixtinus.* The first depends on the *Translatio* and the Apostolic Catalogues; the second on the work of Adon; the third, quite different, depends on the *Translatio* and on the *Passio S. Jacobi* in the pseudo-Abdias. The shrine being by this time troubled by competition in other places that claim some portion of the relics of S. James, this version insists on "integrum corpus," separates itself from the legend of the Seven Spanish Bishops, and makes the two disciples who escorted the body, Athanasius and Theodore. On this ver-

sion depends (1139) the *Historia Composte-*
llana. It may have been known in 1077,
if we may so conclude from an act of that
year between Bishop Diego Peláez and
Fagild, abbot of the monastery of Anteal-
tares. At any rate, it belongs to the re-
building of the church.[16] The work was
begun in 1082 (so Mgr. Duchesne) and it is
quite possible that they looked at the
crypt, discovered that therein were only
three bodies, therefore revised the legend.

Fita and Guerra give no reason for saying
precisely that the crypt under the church
is of the first years of the Christian era.
One can only admit that it is Roman.
Probably a great Roman tomb was really
discovered in the first third of the ninth
century.

In summing up, Mgr. Duchesne says—

1. The belief goes back to a Latin
recension of the *Apostolic Catalogues,* in no
sense traditional documents or trustworthy.

2. About 830 an antique tomb was
found, which was considered S. James's;
the cult is attested by Adon in France
within thirty years.

. About this time, the middle of
th century, was compiled an accc
the Translation. A body brought
Seven Saints from near Granada,
poses the preaching of S. James in Sp
ing his life.

. At the end of the ninth century
ed a letter of Pope Leo (*any* I
ed a contemporary of S. James.

. Nearer the end of the ninth centi
early in the tenth, the letter was revis
Seven Bishops were left out and
disciples put in.

. In 1136 the *Historia Compostell*
d the tradition.

. All that remains is the Galician c
n the first third of the ninth century
Mgr. Duchesne leaves in a footnote
ognition of the relics which had k
oved in 1589 (when Drake went
unna sworn to burn and disperse the
l were recovered in 1879, — ratifiec
4.

IV

THE STATIONS OF THE WAY

Airiños, airiños, aires,
Airiños da miña terra,
Airiños, airiños, aires,
Airiños, levaime a ela.

AYMERY PICAUD, Poitevin and clerk in
orders of Parthenay-le-Vieux, came to
Compostella with a Flemish dame called
Girberga, and probably her husband,
Oliver of Iscan, vassal of land dependent
on S. Mary Magdalen of Vézelay; and for
the redemption of their souls they made a
gift of the Codex, the *Book of S. James,*
to the apostle. The Latin text here is a
little difficult, through some corruption: it
is possible that Aymery was travelling with
Girberga as her secretary or even as her
husband, though the Council of Rheims had
again forbidden the clergy to marry. In

t case Oliver would be Aymery's na
thenay his birthplace and Vézelay
erain, and in truth, he copies ou
acle on the faith of an abbot of Véze

one concerned, though he also tı
bes the Passion of S. Eutropius
ıtes, and a passage about him from
gory of Tours, being a good Pc

We must be content probably
w little more about him except tha1

a poet, and wrote a rousing g
·ching-song which starts off to the t
Gaudeamus Igitur, and a longer po
rhymed, summarizing the curr
ıcles.[1] These will be found in
pendix. Furthermore, it is genera
l that he was not probably the sa
ı the Aymery who was chancellor
tiago, from 1130 to 1141.[2] Of thi
not quite sure, as will presently appe
is not in any circumstances to be c
·d with Aymerico de Anteiaco, who ı
surer of the cathedral of Santiago
5, wrote the manuscript called *Tumbo*
probably the Latin Chronicle of Ar
op Berenguel.[3] This was the Ar

bishop who, a Frenchman from Rodez in the
south of France and a Dominican,[4] liked
but ill the account of Jacobus a Varagine
(whom we know better as Jacques de Vora-
gine) and ordered Bernardus Guidonis to
write something more to the purpose:[5]

> . . . ut Legendam alteram ex sincerioribus
> actis colligeret et ederet, quod et fecit,
> quod tamen non impedivit ne Legenda
> Jacobi de Voragine sua brevitate com-
> moda passim ab omnibus conquireretur
> et avide legeretur.

The fifth book of the Codex that he gave,
is the *Pilgrims' Guide*, written avowedly in
part by Aymery, and by him attributed
in part to Pope Calixt, whose endorsement
is prefixed. "There are moreover many
yet living," he says, "who can testify to
the truth of what is writ therein."
Since upon the approximate date within
the twelfth century scholars are in complete
disagreement, a word of common sense may
be permitted. The only positive date
which occurs in the Codex as a *terminus a
quo* is in that difficult passage about the

deaths of kings, quoted and discussed later in another connexion, which reckons from the beginning of the cathedral works as fifty-nine years to the death of Alfonso of Aragon (1134), sixty-two to the death of Henry of England, and fully sixty-three to the death of Louis the Fat of France, which occurred in 1138. Common sense suggests that these three events, not very important to Santiago except in the case of *Alfonso el Batallador*, must have been recent.

Supposing for a moment that Aymery who gave the book wrote it and the three hymns that bear his name, then (1) since he knew the men working on the roads in 1120, he went by that year; (2) since chapter xxi in Turpin's Chronicle relates how Charlemagne gave to Santiago all the rights of Primacy, it would be most useful at the time (1120-1124) when Archbishop Diego was trying for that rank; (3) the style of chapter ix of the *Guide*, written avowedly by Aymery the chancellor, is precisely like that of all the others, so there is evidence for supposing a single author — and

Margin notes: Deaths of Kings

Hypotheses

if Aymery came to Santiago as a poor clerk in 1120 he could still rise to be chancellor by 1130, D. Diego had done as well as that or better; (4) the attributions of the other Hymns in the Codex are plausible though not convincing: one comes from Poitiers, one from Vézelay, the Patriarch William of Jerusalem was a fellow-countryman of Dame Girberga's. There seems a fair presumption of Aymery's good faith, and a probability that the date should be set in the eleven-thirties, where for his own reasons Gaston Paris put it half a century ago.[6]

Not forgery but politics: compare Vol. III., p. 127

The forged authentication of Innocent II, on which, by the way, we depend for all we know of Aymery Picaud, is the only piece in a different handwriting: it proves on examination not so bare-faced as recent scholars would have you think. Of the signatures, only two profess to be autograph: one, and it is the first, that of Aymery the chancellor, who says the book is authentic and true, and sets his hand thereto. The next signer, Gerard, Cardinal of S. Croce, calls it precious and with his own

pen signs; the following five endorse the Pope or praise the book, no more; and lastly, Alberic, Bishop of Ostia (sometime abbot of Vézelay) approves, as "legalem et carissimum et per omnia laudabilem fore."[7] The known historical dates of the personages will fix the intended date of this document as between 1134 and 1140, which corresponds with all that can be known or inferred about the state of the building as therein described. Dr. Friedel, a competent palaeographer,[8] has conjectured that the hand in which the whole Codex is written (he makes no allusion to the changed script that Fr. Fita noted but judged to be still contemporary) belongs rather to the first than the second half of the century. If Aymery the poor scholar brought the kernel in 1120 when he came with Dame Girberga—and here the kernel includes all but Book V, the account of the journey—and while he was yet chancellor had the fair copy made, bringing the account of the church up to date, then the original compilation would have come from France, have been compiled in the interest

of the pilgrimage, would belong to the first third of the twelfth century, and Aymery's good faith would be safe from suspicion. Indeed the attacks upon it have been mostly copied from book to book without examination of evidence. The character of Aymery is my chief concern, as Turpin's Chronicle was that of Gaston Paris, and M. Bedier's was the *Chansons de Gestes* (while Dr. Friedel's I cannot make out),—for I have kept company with him too long, and found his testimony too good, not to owe him at least a presumption of good faith.

These are the chapters:

The Guide

I. Of the Ways to S. James the Apostle.
II. Of the Stages of the Way of S. James by Pope Calixt.
III. Of the Names of Cities on the Way of S. James.
IV. Of the Three Hospices of the world.
V. Of the Names of those who repaired the Way of S. James, by Aymery.

eaving the itinerary on one side fc
nent, we may consider briefly
stance of these chapters. After tel
r the principal stopping-places on
ɤ, with indications what they are l
l some repetition, as though Chapte
l the original of Chapter vi mi
eed have fallen into his hands as in
tion already prepared, the clerk pat
. praises God for the three pillars t
tain God's poor in the world, which

three hospices, one at Jerusalem, one on the
Mount of Joy,[9] and, third, that of S. Cristina
in the Port of Aspe. He recites a litany of
praise:—Holy spot, house of God, refresh-
ment of saints, repose of pilgrims, comfort
of the needy, health of the sick, succour of
the quick and the dead! Next he relates the
names of those who took care of the road
from Rabanal to Puerto Marín in 1120,
which affords the probable date for his
famous pilgrimage, and adds a prayer
that their souls may have rest and peace.
The good rivers and bad he · carefully
reviews. Chapter iii was simply an en-
larged and revised version of ii; in vi, on
the other hand, the earlier notes (if such
there once were) have dropped out, leaving
what corresponds to iii, that tells what
water is fit to drink and what is deadly,
naming towns not elsewhere mentioned,
like Torres and Castro de los Judíos, which
preserves still a tomb dated in the year
1100: lastly a river a couple of miles from
S. James, in a woody place, which is called
Lavamentula because the pilgrims there
wash their clothes and themselves. This is

in Aymery's best vein, and most characteristic. He concludes: "I have described the rivers that pilgrims going to S. James should study to avoid drinking the deadly and be able to choose those which are fit to drink." Then he frees his mind about all the folk amongst whom he passed on the journey: the Poitevins are heroes and warriors: men of Saintonge speak a patois but men of Bordeaux a worse: Gascons are vain of speech, ragged, drunken, and gluttonous. To the Basques he gives an entire treatise, and of their language, which sounds like the barking of dogs, nearly a score of necessary words. Once through Navarre and past the wood of Oca, the traveller comes out on Castile and the Campo, the north of the province of Valladolid. This happy land he loves for its foison of gold and silver, its stately houses and strong horses, provision for all seasons, bread and wine, meat and fish, milk and honey; but yet the woods are desolate.

In the eighth chapter he deals with the saints along the way. Now the great saints who were travellers have always

been good to great travellers, and the present writer owes debts not alone to S. James in particular, and in general to S. Raphael, S. Roque, and S. Christopher, but also to S. Hilary for valuable information at a critical time, and to S. Julian of the North for harbourage in bitter cold. Therefore of their honours not one shall be omitted:

I. To be revered by those who come through S. Gilles: S. Trophime at Arles, and S. Caesar, B. and M., S. Honorat B., at the Alyscamps. also S. Ginès, [the player]. Also, all the blessed dead, more than a thousand, in the Alyscamps. Item, S. Giles himself, in his glorious sanctuary, [whose shrine is described at full length, for the imagination to figure what were the treasures of Romanesque art]. Four saints there are whose relics may not in any wise be moved [and they are all found upon this journey] — to wit, S. James, the son of Zebedee, S. Martin of Tours, S. Leonard of Limoges, and S. Giles. [Here also was preserved another *Farse* of Fulbert's.]

II. By those who come through Toulouse: S. William who was a Count of

Charlemagne's: SS. Modestus and Flor-
entia, S. Saturninus.

III. For Burgundians and Germans,
coming by Le Puy, the most sacred body
is S. Faith's, V. M., at Conques.

IV. The way by S. Leonard's begins
really at S. Mary Magdalen's at Vézelay;
thereafter S. Leonard is glorified at great
length: and S. Front at Périgueux.

V. Pilgrims from Tours will revere in
Orleans the True Cross and the Shrine of
Bishop Evurcius: then S. Martin, S.
Hilary, S. John the Baptist, [who has
left his name to S. Jean d'Angély but the
Jesuits have left to his sanctuary only
one arch and a buttress to hold it up].
Saintes, next, gives occasion for the long
story of the Passion of S. Eutropius.
At Blaye lies the Blessed Roland; at
Bordeaux, S. Seurin; and in the Landes
of Bordeaux at Belin, four peers of
Charlemagne, Galdelbode of Frisia and
Otger of Dacier, Arastagne of Britain
and Garin of Lorraine.

VI. The Spanish saints we shall en-
counter in due course:—S. Domingo de
la Calzada, SS. Facundus and Primitivus,
S. Isidore, and above all, S. James.

So he ends with a prayer that their merits
and their intercession may avail for us, and
with a rolling Gloria, *per infinita saecula
saeculorum, Amen!*

The chapter which follows describes the
church as Aymery saw it: this, by great
luck for us, was before the addition of
Master Matthew's porch. These sections
are reserved for consideration with the
history of the fabric. Then the author
enumerates relics and treasures, with the
same intent as his phrases of Basque: —
just as the Picard Manier copied out the
inventory and preserved his own collection
of Spanish words made for use at need.
Plainly, this sort of literature constitutes
a *genre* by itself, established and self-per-
petuating long before Murray was born or
Baedecker dreamed of.

The closing chapter enforces the obliga-
tions of evangelical hospitality, by a string
of miracles that punished those who re-
fused it. At Nantes a surly weaver saw
his web miraculously rent; at Villeneuve,
for a woman who denied that she had
bread, her store was turned to stone. In

case of two Frenchmen begging tl
r home, at Poitiers, close to S. Porcha
the street that refused a lodging
ned, but the fire stayed at the house wh
c them in. On this testimony ends B(
Ipsum scribenti sit gloria sitque legen
'o the roads, then, we return:—

Chapter I. Of the Ways to S. Jar
1e Apostle:
'here are four ways which, leading
antiago, come into one at Puente
eyna in Spain. One goes by S. Gil
Iontpellier, Toulouse and the Port
spe: another by S. Mary of Le Puy a
. Faith of Conques and S. Peter
Ioissac: another by S. Mary Magda
: Vézelay and S. Leonard of Limo
1d the city of Périgueux: another by
Iartin of Tours and S. Hilary of Poiti
1d S. John of Angély and S. Eutrop
: Saintes and the City of Bordeaux
 Those by S. Faith, S. Leonard a
. Martin join at Ostabal and pass
1e Port de Cize, at Puente la Rey
)in the way that comes by the Port
spe. And one way thenceforth g(
1 to S. James.

In the second chapter, that gives the stages and the time required, Aymery repeats apparently what was told to him. From the Port d'Aspe (between Pau and Jaca) to Puente la Reyna is estimated as three short days' journeys: from the Port de Cize (by Roncevaux, between S. Jean Pied-du-Port and Pampeluna) to S. James takes thirteen days, some not long, some so long that they must be done on horseback. The *Guide* was written, of a truth, chiefly for those who go afoot. None of my mules or men, nor myself, of a truth, was able to push ahead of this itinerary, yet I am assured by one who knows that good walkers in training can do thirty miles a day on a long stretch, and that exceeds considerably the estimate of Murray's Ford for a well-used horse. From general experience I should say the stages are all possible, those indicated for horseback, from Estella to Nájera and thence to Burgos, being the hardest, and the last three coinciding exactly with the personal recommendations of D. Ángel del Castillo, who has walked all over Galicia.

Alquimia de la experiencia

The third chapter, Aymery's own, names and discusses the towns, indicates hospices, bridges and the like, with a memorial, for instance, of the spot where victor's lances burgeoned in green leaves, and a note on the cairns at Mountjoy. For these he accounts by the pilgrims' custom of picking up a piece of lime-stone at Triacastela and carrying it to Castañola to make mortar for the building of Santiago. He explains that he has given these indications in order that intending pilgrims may calculate their expenses beforehand. Cairns

His comment on the towns will be found generally along with the present author's and the complete tabulation of the route, according to the *Book of S. James*, among the *Appendices* in the last volume. There, XIV, 1 that the curious reader may perceive how little the way has changed in eight centuries, are draughted some typical records of the stations: first Aymery's, that of the Chevalier de Caumont, who went to Compostella in 1417, and one from an English poem of about 1425: the broadside that Columbus's son bought

in the fair of Leon for twopence in 1535,
which is entitled *Le Chemin de Paris a
Sanct Jaques en Galice, dit Compostille,
et combien il y a de lieues de ville en ville.*
Follows that from the *Reportorio de
todos los Caminos,* of Juan Villuga, Val-
encian, printed in 1547, for the assist-
ance of those who have an appetite to
travel—"for all," says he, "who come
into this life are travellers"—and though,
as a Spanish proverb affirms, "Quien
lengua ha, a Roma va,"[10] yet delay and
fatigue are inevitable where one misses
the way even a little, and time and dis-
comfort are saved by a previous knowledge
of the certain and true road. Finally, he
indicates the pilgrimages most in repute—
to the Six Angelical Houses, Monserrat,
the Pilar, *Nuestra Señora la Blanca* at
Burgos (whom I do not otherwise know),
Nuestra Señora del Sagrario at Toledo,
and Her of Guadelupe, and Her of Peña de
Francia—that he may profit by the users'
prayers and acquire merit through their
gratitude.

The *Nouvelle Guide* of French Pilgrims

of 1583, reprinted by the Baron Bonnault d'Houët, adds little even to the fantastic disguises that place-names take for an alien ear. The route of the Picard pilgrim Manier of Noyon, who made the journey in 1726, comes next in order: he, like the fantastical *Pelegrino curioso* in the seventeenth century, offers entertainment by the way and figures in the chapters which follow: an *Itinerary of Spain* dated at Alcalá, 1798, completes the series. The reader will see, having perused this volume as well, how little the journeys varied: how Estella, praised for bread and wine and all manner of good victuals in the twelfth century, still stirs regretful longings today; and how the eels of the Miño that were lauded by the Licentiate Luis de Molina at Puerto Marín, were served in a noble pasty to the traveller who now testifies.

and itinerants

The road never changes. The English route from *Purchas his Pilgrims* is found in an early fifteenth century poem which Purchas took out of a MS. of Sir Robert Cotton's: it is most vile doggerel and contains seventeen hundred and fifty-four lines. It is headed:

Purchas his Pilgrims

Here beginneth the way that is marked and made with Mountjoies from the Land of England into Sent James in Galis, and from thence to Rome, and from thence to Jerusalem, and so again into England; and the names of all the cities by their way, and names of their silver that they use by all these ways.[11]

The account is excessively confused in places, but I have thought well to reprint and discuss the itinerary because it shows already in circulation the travellers' tales of a cleft in the mountain out of which come grievous cryings and groanings.

In *Chansons des Pèlerins de S. Jacques*, which was reprinted by the Abbé Camille Daux from sources which are none of them earlier, I believe, than broadsides printed at Toulouse in 1615, Valenciennes 1616, and Troyes in 1718 (permitted, there, because already of great age) the data are probably much older than the form. Here you find, at the Mont-Étuves, in Asturias, the same terror, with cruel cold; and a *Pont qui Tremble*, before which the pilgrims said, one to another, "Comrade,

you go first." The songs, while they go to different airs, are much alike in substance and in tone; plaintive, interminable, strung out with the itinerary of the journey, wailing on like the endless litanies that children's shrill voices sing on hot summer evenings, or like the *Canticle of Lourdes* with its sixty odd verses:

> Parmi les monts et praieries
> Nous chantions la Litanie,
> Ou quelque bonne chanson;
> Et racontions à l'envie
> Ce que nous sçavions de bon.

This was in the seventeenth century: already since the fifteenth the old rough ways by Pyrenean passes were commonly disused, that by the Port of Aspe and that by the Valley of Roncevaux; and replaced by the coast road which runs by Bayonne, Irun, Vitoria, and then, through the defile of Pancorbo, turns aside in the mountains of Oca and comes out at Burgos. A great détour which they include is that to S. Salvador of Oviedo, one much recommended. A Spanish proverb says that to

visit S. James and omit S. Saviour is to call on the servant and neglect the master. It is here, in the mountains of Asturias and on the Cantabrian shore, that they place the more than half legendary Mont-Étuves and *Pont qui Tremble.* The latter Manier describes in his practical Picard literàlity: it is the name given to a sort of ferry where at one point the road crosses an estuary, and pilgrims and animals are conveyed together in what the railways call a "barge," big enough to take fifty at a time. The spray and the noise of the waves are alarming, hence—by reason of the danger you are in (he explains) it is called *Pont qui Tremble.*

Of this route from Oviedo to Compostella Sr. Villa-amil[12] says that the old highway between Villalba and Oviedo is still in good repair up to within four kilometres of Mondoñedo. Also, ten kilometres to the south was an *albergaría* which was already old in 1257. Beyond Mondoñedo it continued by Villanueva de Lorenzana (formerly Villa de Ponte): for this he cites the record of gifts and sales, one of 1578

and the other 1571, which mentions by name the *Camino francés* where runs the modern road to Foz and Ribadeo. The Franciscan monastery of S. Martín de Villarente or *de los Picos* was in the fourteenth century a place to which came many pilgrims and *romeros* of those who go to the Apostle S. James. From Mondoñedo it goes by Goilán to the parish church of S. María de Vián, at which forks the old road from Mondoñedo to Castro- Our Lady verde and Lugo. Beside S. Mary of the of the Crossways, here, was the much frequented Crossways chapel of the Trinity, and here, not long ago, was found a gold piece of Matthias Corvinus, lost by some pilgrim. From the first, thinks Sr. Villa-amil, the old Way ran to the north of Lugo, leaving what is now the province of Lugo by the Bridge of García Rodríguez and by Puentedeume. Alfonso IX and S. Ferdinand often trav- elled on it. Only a few years before his writing (in 1878) there was not a road in the region, between the Madrid-Corunna highway and the coast, except those used by pilgrims first and now by Maragatos.

There are traces, also, of another road
that came in perhaps from the south,
passed through Incio and reached Puerto
Marín. Dozy[13] quotes a gloss from the
Poem of the Cid that runs a line through
Benavente: and López Ferreiro publishes
an itinerary[14] that comes up by Verín,
Allariz, Orense, Lalín and so to Santiago
by the coach-road.

The question of the Roman roads can-
not here be ignored, though it is more
difficult than would appear to the classical
scholar. Such roads exist still in Spain,
long stretches of them in places. With
sudden picturesqueness Quadrado, writing
of Roman remains in the Vierzo, calls up
one as he has seen it:

Two and a half miles from Bergido,
he says, on the military road that went
to Lugo, in the skirts of a mountain,
there survives an arch, and remains of
buildings mark the site of an ancient
village close to the junction of the
Cabrera and the Sil, near the Bridge of
Domingo Flórez; but the Roman power
is chiefly shown in the remains of the

magnificent "street" [*calzada*] that may still be followed by the eye from afar, across the scrub, like the silvery wake of a ship on the broad sea. [15]

There is, of course, the *Antonine Itinerary*, but until lately that has remained for most of Europe in the hands of mere schoolmen, creatures of pen and paper. The various authorities cited in the old edition, disagree rather fantastically about the actual places represented by the Roman names. It means very little to a German scholar that Interamnio Flavio may be Bembibre or may be Ponferrada, that Aquis Originis may be Cháves or may be Baños de Bande, that Brigantium may be Betanzos or may be Ferrol, but if a man would look out the places on a large-scale map to draw lines between them, he might be annoyed by the divergent possibilities. It would matter a good deal to an engineer trying to survey, or to a traveller wanting somewhere to sleep and to put up his tired horse. When after Ad Duos Pontes, possibly Pontevedra, the next station, Grandimiro, is offered alternatively as

Camariñas on the Atlantic seaboard, or
Mondoñedo in the Cantabrian hills, even
the purblind pedant might be shocked into
a query, and into some faint recognition
that the two towns are in opposite quarters
of the ancient kingdom of Galicia. [16]

Hitherto, then, the scholars have not
shown up well beside the poets of the
Chansons de Gestes or even the homely
pilgrims and those who wrote down their
stages for them. In 1892, however, Sr.
D. Antonio Blásquez published a *Nuevo
Estudio sobre el Itinerario de Antonino*, [17]
which is plausible and recognizes the
geography of the peninsula. Suffice it to
note here that he identifies Lacobriga
with Carrión de los Condes, and Interam-
nio Flavio with Onamiol (a village too
small to figure on Stieler's map); puts
Roboretum in the Sierra de Roboredo,
and sets down Brevis for Mellid. The one
conviction that the mere student formed
over the dusty book is not altered by this
article, viz., a certainty that the Pilgrim
road in Spain, unlike that to Canterbury,
was not built on Roman foundations, except

in a few great segments, — from Sahagún past Leon to Astorga, for sure, and through the pass of Roncevaux to Pampeluna probably, and perhaps a bit through the mountains of Oca, toward Nájera and eastward.

The immense work of Konrad Miller, *Itineraria Romana*, which represents the labour of more than thirty years, and met long and anxious expectation at last in 1916, is not so satisfactory to consult as the cosmopolitan spirit could wish. Besides the crabbed and arid style, besides the tiresome affectations of German pedantry, which irritate and arrest the reader at every step, the plentiful lack of punctuation, the abuse of abbreviations and superabundance of conventional symbols, the contraction into unintelligibility of every word likely to recur often, so that the effect of the whole is as illegible and unprofitable as that of an undergraduate's notes, the author has had the happy thought of putting the names of Spanish towns, and indeed all modern place-names, on all the maps, in a German form and in German script.

A German's vagaries

The traveller today has three different
lines to trace, the Roman "street," the
Camino francés, and the King's highway,
the modern and admirable *Camino real*.
They cross and part, coincide and diverge,
in ways impossible to predict and not
always explicable on the map. But on
the spot all is plain: where the new road
was built longer to run easier, or was turned
aside to a new town, or wanted to tap the
railway line. In a few places the old way
is quite disused, in most it still persists
as a short cut, sometimes foot-path, usually
possible to the small-footed silken-skinned
mules. At times it is a mere track across
somebody's meadow, cut off by gates at
either end; at times it is only a conjectural
one among half a dozen trails that cross
a moor. Some one, however, is always
travelling on it: women who sit sideways
as Queen Elizabeth rode, men who trot
hard with long stirrup-leathers, like Don
Quixote. Some one is always to be met,
to give a direction or to pass a question on.
The ways fill up with tiny moving figures
on the days of cattle fair, or of the monthly

feria conceded by some dead king seven centuries or more ago. You have but to narrow your lids, and watch the pilgrims moving easily, not too slow, as they have always moved.

The pilgrims set out from home at nightfall, "circa noctis crepuscula . . . peregrinantium more": that made the first stage an easy one, and besides the practical, there may have been a symbolic reason. The *Grande Chanson* says:

<div style="text-align:right">Twilight leave-taking</div>

> Quand nous partîmes
> Pour aller a S. Jacques,
> Pour faire pénitence,
> Confessés avons nos pechés.
> Avant que de partir de France,
> De nos curés, prîmes licence,
> Avant de sortir du lieu
> Nous ont donné pour pénitence,
> Un chapelet pour prier Dieu.
> Prions Jesus-Christ par sa grâce.
> Que nous puissions voir face à face
> La Vierge et Sainct-Jacques le Grand.

Conformably, in earlier centuries, either before they set out, or at a monastery the first night, the pilgrims confessed, made

Gifts at
parting

their wills, deposited their valuables and received, apparently as a gift from the monastery, staff and scrip, blessed by the abbot. The rich abbey of *La Grande Sauve*, in Gascony, used to give a horse or a donkey. They had also to carry credentials of some sort from home: in 1671 Louis XIV required that the bishop should recommend the pilgrim and that the passport should be signed and countersigned by the king and a secretary of State. At Santiago the pilgrims confessed again, and communicated, and got other papers, for which they had to pay. For the return journey they set out in the morning, and some went then to Oviedo, some to the great southern shrines, some to Monserrat. Many, like the young Manier, pushed on to Rome, before they saw home again.

V

ROMEROS EN ROMERÍA

Encore le voient li pèlerin assez
Qui a S. Jacque ont le chemin tourné.
 — Guillaume au Court Nez.

IN a decree of a Spanish council, dated 676, cited by the Abbé Pardiac, certain limits are defined as follows:—"one boundary runs to Futa and Alarzón, by the road which goes to S. James." The value of this reference would depend partly on the authenticity of the act, partly on the question what church of S. James might be intended. It seems not likely to have been that at Iria. Compostella was still in its original estate of a field under the stars—"qua beati Jacobi corpus tunc temporis latebat incognitum." Granting that the pilgrimage to S. James commenced only in the ninth century, yet there were

Gándara,
*Cisne
Occidental,*
II, 258

pilgrims a plenty in Spain by the seventh and places famed for their resort. The Deacon Paul of Merida refers to many in the sixth century, and in 629, S. Fructuosus wrote, when founding the monastery of S. Martin de Sande: "Vobis fratribus nostris . . . concedimus reditus de Lusisino, in elemosinas et sustentationem hospitum et peregrinorum." The habit of pilgrimage in a sense is innate; in another sense, possibly it came out of the East, like so many folk-tales, to the troubled Europe of the early Middle Age. S. John Chrysostom says: "Qualem mercedem habet qui propter Deum peregrinatur, talem habet, qui suscepit peregrinantem; et fiunt ambo equales." The Council of Rheims in 625 decrees: "quicumque peregrinari volunt illam (Eucharistiam) da viaticum suscipiant." In short, pilgrimage was common to all Europe: three special pilgrimages outgrew the others—that of Jerusalem, that of Rome, and that of Compostella. English readers will recall how similarly, among those to Walsingham,[1] Glastonbury, and a thousand wells, caves

and isles, that of Canterbury outstripped the rest by far. Chaucer, who sent his Knight on the Way of S. James, like Raoul de Cambrai and many another, put his finger on the motive in a passage so fragrant of the mounting sap, so musical with the returning birds, that it breathes still as fresh as April airs:

"Whanne that Aprile..."

> Then longen folk to gon on pilgrimages
> And palmeres for to seken straunge
> strondes
> To ferve halwes couthe in sondry londes.

The precise date fixed by a Pastoral of the Archbishop of Santiago, in 1898, for the Invention of the Relics, is 813. "Charlemagne," says the Gallegan version of Turpin's Chronicle,[2] "went on a pilgrimage to the Monument of S. James, and thence to Padrón. And he flung his lance into the sea" at Finisterre — Paul the Deacon has the same story of a Lombard Duke at Reggio,[3] "and said that thence man could not further go. And the Gallegans, that were all turned to belief in God by the preaching of S. James

and his two disciples, and that had turned afterwards to the sect of the Moors, were baptized by the hands of Archbishop Turpin: and those who would not be baptized he put to the sword, or into the power of the christened. And this time the king conquered Spain from sea to sea," a profitable pilgrimage, not to be matched in times less fabulous.

The plough-land tax

In recognition of the victory of Clavijo, Ramiro gave, in 872, to Compostella, for every measure of land recovered from the Moors, a measure of wheat and a measure of wine. In 1102, every yoke of oxen from Río Pisuergo to the sea, paid a tax to S. James. I do not know how much this tax is still enforced. It was abolished in the great years of reform, in 1812 and again in 1835; but I have seen, at the feast of the Apostle, the King of Spain or his representative, offering treasure still before the altar, in a church thronged with pilgrims, among whom he moved as one Spaniard among others.

It is hard to know precisely when, out of all the tangled pilgrimages, that to S. Mil-

lán for instance and that to the *Santos Domnos* at Sahagún, the journey to S. James attained a separate and higher importance. The early donations of Ramiros and Ordoños to S. Facundo, to ensure the care of pilgrims, mean probably pilgrims that did not pass beyond. But Abbot Julian of Sahagún established, later, a hospice in his monastery purely for pilgrims of Santiago. Italians, and in particular Lombards, were protected during pilgrimages by a Capitulary of King Pepin, dated 782; "De advenis et peregrinis qui in Dei servitio Roma vel per alia sanctorum festinant corpora, ut salvi vadant et revertantur sub nostra defencione." This, again, is general. Alfonso III gave to the church of Orense, in 886, a donation for the receipt of pilgrims.

The earliest reference unambiguous and authentic, that I know, to Santiago, is a casual one of Dozy's.[4] Abderraman II sent Al-Ghazal on an embassy to the King of the Normans not long after 844 and on his way home the Arab poet and diplomat turned aside to visit S. James, in company with the Norman ambassador, and fur-

nished with a letter from the king to the
lord of the land. He stayed there two
months, very well treated, until the
pilgrim season was over. Dozy has not
apparently understood this, for he ren-
ders "jusqu' à la fin de leur pèlerinage,"
but it can only mean the other. He then
went back into Castile with returning pil-
grims, thence to Toledo, and finally reached
home after an absence of twenty months.

It is recorded that as early as 893 Pope
Formosus made the pilgrimage to Santiago
and also visited S. Julian of Brioude. By
the end of the century it is not uncommon.
Alfonso III the Great (866–910) came
with all his family. In the early tenth
century S. Genadius came: he that founded
S. Pedro de Montes, and was plucked
from his wilderness to administer the see
of Astorga, and when he had done his day's
work, fled back to the mountain again.
Almaccari says that in the tenth century, to
Compostella and Iria, came in pilgrimage
Christians from Egypt and Nubia. [5] About
that time, in 951, Godescalcus, Bishop of
Le Puy, left his diocese to go and implore

afar the suffrage of S. James, and stopped going and coming at the Monastery of Albelda, where he had copied out in French S. Isidore's treatise on the *Perfect Virginity of Mary*.[6] In 961 Raymond II, Count of Rouergue, was killed on the road to Compostella, as is written in the *Book of the Miracles of S. Faith*. S. Abbon, Abbot (988–1000) of Fleury, S. Benoît-sur-Loire, raised an altar to S. James. In his convent, immediately after his death (in 1005) was written the *Great Legend of S. James*, possibly by the monk Aymoin, his friend and pupil. It is more than likely that he had made the journey, since there is no record of relics acquired which would explain otherwise the especial devotion to that Apostle. The cities which claimed to possess relics are: Toulouse, Arras, Liége, Venice, Pistoja and Burgos.

By the eleventh century a great movement was well begun. In the first half of it, S. William of Vercelli, at the age of fourteen, walked barefoot in his shirt to Santiago, S. Simeon the hermit, also; and S. Theobald quitted his home and with a

single fellow made the pilgrimage unshod.
Under Ferdinand I (1033–1065), says
Morales,[7] the pilgrimage was quite estab-
lished, and miracles were happening all
along the road. Don Sancho el Mayor,
says the Silense, built roads for the pil-
grims going to Santiago, in 1032, and opened
a road in 1035 from the top of the Pyrenees
to Nájera:[8] and Alfonso VI, says Pelagio,
in the *Chronicle of the Kings of Leon*, "stud-
uit facere omnes pontes qui sunt a Lucronio
usque ad Sanctum Jacobum."[9]

Building of bridges and mending of
ways were good enough work, in the Middle
Age, for the best of men. More than one
saint broke stone on the roads. To this
day the *peones camineros*, in Spain, are
heritors of that great and noble labour;
they are housed like soldiers; they wear a
uniform and carry a number, like police;
they work well, and look you in the eye,
and will do you a kindness; they are in
Government employment, unabashed. A
Lombard Capitulary of 803 recalls to the
clergy their duty in building and keeping
up bridges, which is their peculiar work

"per justam et antiquam consuetudinem."
Eudes III, Count of Touraine, in 1030
built a bridge over the Loire that led to
the Tomb of S. Martin. In 1164 S. Benet
the Less, S. Bénézet,[10] founded the
order of *Hospitaliers Pontifes*, and his own
little cell and shrine still stands on the
ruined bridge over the Rhone, where they
no longer dance "sur le pont d'Avignon."
There were also *Hospitaliers de S. Jacques
du Haut Pas*, who must have lent their
name to a church and street in Paris and
who received a legacy in 1360,[11] and others,
Hospitaliers of Lucca, in Italy, whose busi-
ness was with bridges. Peter the Pilgrim,
on the fifth of October, 1126, received a
privilege from Alfonso VII to keep him
while rebuilding the bridge over the Miño
with the help of God and good souls.[12] We
have from Aymery the list of those who at
one time consecrated themselves to work-
ing on the road of Santiago between
Rabanal and Puerto Marín: — Andrew,
Robert, Alvito, Fortis, Arnald, Stephen, and
Peter — the last is Peter called the Pilgrim.[13]
S. Domingo de la Calzada got his name from

the work he did, and after his death S. Juan de Ortega carried it on, and ended in a chapel on a mountain pass, watching the ways.

Order of Santiago

The order of Santiago was founded in 1172 and confirmed by a Bull of Alexander III in 1175, but it grew out of earlier use. The prior and canons of Loyo had,

Rule of S. Loy

near Leon, on the *Camino francés*, a hospital called S. Marcos for the pilgrims of S. James. Always a canon of Loyo was in residence, to administer the hospital and give alms to pilgrims that passed by there. In time the institution declined and on

who shod the supernatural horse

petition was reformed, and again declined and they tried a prior and canons from Ucclés. The original donation, with bridge and a good endowment, was made to the Bishop and Chapter of Leon by Doña Cristina Lainez and provided for a hospice and church for pilgrims. The convent was further enriched by the body of the founder and the first master of the order of Santiago, D. Pedro Fernández, in 1184. The epitaph reads:

Mens pia, larga manus, os prudens, hace tria clarum,

'ecerunt Caelo, et mundo te Petre]
 nandi.
/iilitiae Jacobi stitor Rectorque fuis
iie te pro meritis ditavit gr.
 Christi.[14]

e the other Spanish military ord
 one fast outgrew its original intentι
tly, Ferdinand of Aragon took to h
 the Grand Mastership of this al
ι the other orders, and today it seι
·ely to lengthen the list of honour:
 gentlemen in Madrid and to dress
np and handsome canons of Comι
ι in white, red-crossed, on feast-da·
[early half a century earlier, Alfc
(1073), in taking possession of Leon ι
tile, said that, in order to do a g
ιg for his subjects and for other peo
 only of Spain but of Germany, Fra
 Italy, who by motive of religion w
:neying to Santiago, he would suppι
 tolls at Valcarcel:

In the port of Monte Valca
here was a castle where all passers
·aid toll, called S. María de Aucta

and this supplied an occasion to molest and rob travellers, which had been the custom from the reign of his predecessors, whence resulted grave grievances for all who passed by that port, such, [said D. Alonso] that they cried to heaven, and in especial the pilgrims who went to Santiago, who were never heard in the Kingdom of Leon without maledictions and indignation against this intolerable custom. He abolished the toll forever, that all, of whatsoever condition, could pass freely and without annoyance or inquietude, in such wise that this road to Santiago should be entirely free to pilgrims and even to those who carried merchandise, or went on any other business whatsoever.[15]

He makes the offering by the hands of D. Pelayo, Bishop of Leon, to the honour and glory of God and the Virgin Mary and the Apostle S. James, "In cujus ditione terra vel regimen consistit totius Hispaniae." Is it worth noticing that Bishop Pelayo was born and bred in Galicia? There were changes with changing times, belike, and some give and take, for in 1094 Bishop

A Gallegan bishop

Pedro leaves to Leon money for altar lights, and four pounds of incense for the altar of S. John Baptist, charged upon the revenues that the see had in Aguilar, in the bridge of Ardon, in Villela and in the church which was on the *Camino francés*.[16]

The Council of Palencia, in 1129, protected by identical penalties clerks, monks, travellers, merchants, women, and pilgrims — all persons going peacefully and unprotected about their business. The *Fuero* of Daroca, 1142, grants a year's delay of any partition in which a pilgrim might be involved: — "si in peregrinatione fuerit per annum expectatur"; and another law secures their goods: — "bona peregrinorum non poseunt capi pro reprisaliis." The old use by which what a pilgrim had upon him fell to the town he might die in, was altered by the *Siete Partidas*, which charged the bishop with searching out his heirs. The *Siete Partidas* are full of provisions for pilgrims — against money-changers and innkeepers, mayors of towns and lords of lands, robbers, and wars. The Church at the Council of Valladolid, in 1322, orders

Fueros and *Siete Partidas*

rector and parish priests to receive charitably the poor religious and the pilgrims, and where there are special houses provided for that use, to make sure that they are prepared conveniently to fulfill the hospitality for which they were designed. One other enviable privilege should not be overlooked: the Constitutions of the University of Salamanca, in 1422, declare that a lawful cause for which a professor may be excused from *reading* (i. e. giving his courses), is that of "peregrinationis ad limina Sancti Jacobi."

Ferdinand I, Alfonso VI and the Cid all went on that road. Of the first, the Chronicler of Silos says, "he loved the poor pilgrims, and took great care to harbour them." An old painting of the Cid in Burgos showed him with the cockle-shell at his girdle. Murguía affirms[17] that the Archives of Santiago possess, unpublished and even to scholars unknown, a circumstantial account of the journey made by Pope Calixtus II to Spain in order to visit the body of the saint. This visit has been denied by scholars hitherto.

In the second third of the twelfth century the *Maestrescuela* of Compostella, Ramiro, writing to his friend S. Aton, Bishop of Pistoja, begs him to reply promptly, sending either by the Easter pilgrims, or else by those of the Ascension. These scraps of old letters will convey, perhaps, more than any studied episode, the sense of the magnitude of the pilgrimage. The Roman priest who was a Cardinal of Santiago, Deusdedit, writes the same recommendation in the matter of a chasuble: it will be sent best by the Easter pilgrims.

Ramiro the Maestrescuela

When Ali-ben-Yussuf, the Almoravide, sent an embassy to Doña Urraca about 1121, the ambassadors were amazed at the throngs of pilgrims who choked the road. They asked the subaltern detailed to escort and assist them, the Centurion Peter, as the Latin Chronicle calls him: "Who is this the Christians so revered, for whom so great a multitude comes and goes, from this side and the other of the Pyrenees, so that the road is scarcely cleared for us?" And Peter answered with a fine gesture: "He who deserves such reverence is S. James,

Peter the Centurion

whose body there is buried, revered as patron and protector by Gaul and England, the Latin and the German land and all Christian parts."

Toward the end of the eleventh century a noble of Quercy, who was a Benedictine monk in the abbey of Moissac, was fetched by Archbishop Bernard to Toledo, made *chantre* and then Archbishop of Braga, still, at that date, metropolitan of Santiago, finally martyred in 1109. He constitutes another tie between Santiago and Languedoc, if such were needed. William V of Aquitaine made every year the pilgrimage to Rome and to Compostella. It is said in the Chronicle of Normandy that the horse which William the Bastard rode at Hastings had been brought to him from Spain by a knight, a pilgrim of Santiago.

Matilda the Empress, the daughter of Henry I of England, visited the shrine in 1125 and took back to England with her S. James's hand. Richard I the Lionhearted, in 1178 pushed an expedition[18] into the Port of Cize to punish the rustics who violated travellers and pilgrims. The

city of La Réole, where pilgrims crossed the Garonne, was an especial residence of his: it had an hospital and a street of S. James. To S. James was dedicated the principal church of Bergerac. Bordeaux has a *rue S. Jâmes*, existent since 1152: it is the sole vestige in Bordeaux of English dominion in Aquitaine. Rue S. Jâmes

The father of Eleanore of Guienne, William X of Aquitaine, being converted by S. Bernard at Parthenay in 1133, founded outside Bordeaux, in the Clos-Moron (now rue du Mirail) the Hospital of S. James for pilgrims. The chapel stands yet. He went on the pilgrimage in Lent of 1137, expired while the Passion was sung, and was buried before the altar. According to other accounts this funeral was a pious sham; he went to Rome and Jerusalem and ended as a hermit on Mount Lebanon twenty years after. Murguía publishes a rather lovely Gallegan romance, taken down from the lips of the living, which seems to refer to the blessed death of this William before the altar. The old man, who has not strength to finish the journey, whose feet William of Aquitaine

are bleeding, whose beard is so long and so white, whose eyes are so soft, so veiled, so like a lion's, green as sea water,—he meets a soldier on the road. The soldier is of course the great S. James, who cheers him and assists him, and brings him at last where he would be.[19] In the Cartulary of S. Père de Chartres is recorded a gift in the middle of the twelfth century, "dono patris sui qui in itinere sancti Jacobi defunctus extulit." Hugues IV, Duke of Burgundy, had just ended the pilgrimage when he died in 1272. In 1217 some Frisians, a people always very devoted to S. James, who were bound on the Crusade in three hundred ships, touched at Lisbon and on the petition of bishops, Templars and Knights of S. John, they besieged the citadel of Alkacer, and encountered four Saracen kings and a hundred thousand fighting-men. By adverse winds they were forced to put in to Corunna, and almost all struck out for Santiago on foot; as the ships were held there nine days before the wind changed, they had time enough for what the Dutch historian calls "their superstition."

Collect of S. James

Louis IX had as great devotion—Joinville, I think it is, reports—to Monseigneur S. Jacques as to Madame S. Geneviève, and when dying said over his prayer *Esto Domine:* "Keep, Lord, Thy people, and sanctify them, that fortified by the help of Thy Apostle S. James, they may please Thee in their works and serve Thee with a quiet heart. Amen." Louis VII of France, who had married Constance, the daughter of Alfonso VIII, had made the pilgrimage in 1157, after he had been on a crusade and to the shrine of *Notre Dame du Puy.* Luke of Tuy makes the story another of the Miracles of S. James, splendid like a reliquary with coloured gems and bossy with wrought gold. In brief, it stands thus:

Louis, King of France, thinking his wife Elizabeth [she is usually called Constance] a concubine's child, and her father Alonso [Alfonso VII the Emperor] a man of no moment in any but his own estimation, denies her his bed. So on pretext of a pilgrimage to S. James he comes to Spain, and D. Alonso meets him with the King of Navarre, and the Count

of Barcelona, and so great a train that
King Louis and his Franks marvelled,
and they all go to Santiago and thence
through Spanish cities to Toledo. There
the kings of the Barbarians and princes
of the Christians kiss his hand, till Louis
cries: "By God I swear there is no
glóry like this in all the world"; and the
tents and the plays were past numbering,
and they all offered gifts, gold, silver,
precious stones, silk, vestments, and
horses, to King Louis, him and his, so
that the very number wore them out.
Then Alonso says that Elizabeth is the
daughter of his empress Berenguela, the
daughter of Raymond of Barcelona there
present, and he comes up, glorious in
apparel, and remarks that it were well to
honour and reverence her, for otherwise
the Catalans are marching on Paris.
Louis thanks God and is content: nor
will he take any other gift but a great
emerald—which King Zafadola had given
to King Alonso—and so he went home
joyfully and gave the emerald to S.
Denis, and loved his wife Elizabeth very
tenderly and honoured her in every
possible way.[20]

Ferdinand III, Ferdinand IV and John of Brienne, King of Jerusalem and later Emperor of Constantinople, went to the shrine of S. Martin in preparation for that of S. James: at the same time, in Tours were the Archbishop of Nineveh and various bishops of Little Armenia coming back from Compostella. These are they who brought into Europe the notion of the Wandering Jew.[21] The Blessed Raymond Lull visited Rocamadour and Compostella. S. Francis is said to have come with some companions, including Brother Bernard, in 1214. I can find no sound evidence that he, or S. Dominic either — though the latter was a Spaniard — ever set foot in Santiago. Guido Cavalcanti set out, but on account of the Lady Mandetta in Toulouse he never finished the journey. Sordello, however, is said to have gone thither, and the trobador Romieu de Villeneuve, that Dante met in Paradise, where he saw the lights shining in the shining pearl, who lived at the court of Count Raymond Berengar of Toulouse for a while and being falsely accused, wandered away again:

There came to his [Raymond Beren-
gar's] court a certain Romeo, who was
returning from S. James's, and hearing
the goodness of Count Raymond abode
in his court, and was so wise and valor-
ous, and came so much into favour with
the Count, that he made him master and
steward of all that he had. . . . Four
daughters had the Count and no male
child. By prudence and care the good
Romeo first married the eldest for him
to the good King Louis of France by
giving money with her, saying to the
Count, 'Leave it to me, and do not
grudge the cost, for if thou marriest the
first well thou wilt marry all the others
the better for the sake of her kinship
and at less cost.' And so it came to pass;
for straightway the King of England,
to be of kin to the King of France, took
the second with little money; afterwards
his carnal brother, being the king elect
of the Romans, after the same manner
took the third; the fourth being still to
marry the good Romeo said: 'For this
one I desire that thou shouldst have a
brave man for thy son, who may be
thine heir,' —and so he did. Finding

Charles, Count of Anjou, brother of King Louis of France, he said, 'Give her to him for he is like to be the best man in the world,' prophesying of him: and this was done. And it came to pass afterwards through envy, which destroys all good, that the barons of Provence accused the good Romeo that he had managed the Count's treasure ill, and they called upon him to give an account. The worthy Romeo said, 'Count, I have served thee long while, and raised thy estate from small to great, and for this, through the false counsel of thy people, thou art little grateful: I came to thy court a poor pilgrim, and I have lived virtuously here; give me back my mule, my staff, and my scrip, as I came here, and I renounce thy service.' The Count would not that he should depart; but, for nought that he could do would he remain; and, as he came so he departed, and no one knew whence he came or whither he went. But many held that he was a sainted soul.[22]

In 1253 the Friar Minor William Rubroques met in the depths of Tartary a Nes-

torian Monk who spoke of setting out for
S. James of Galicia. Under Ferdinand the
Great a Greek Bishop named Stephen was
so happy when he came at last to the
Apostle's shrine, that he gave up home and
see and stayed there till he died. The
ends of Europe were drawn together.
There in 1254 was the wronged Christina
of Norway, the daughter of Haakon IV,
who though she married the prince D. Philip,
yet breathed away like a snow wreath
and died untimely. Thither also went S.
Bridget of Sweden, S. Elizabeth of Portugal,
Raymond VII of Toulouse in 1246, and
Henry II of Trastamara, the bastard who
killed his brother.

Studying the influx from abroad, Sr.
Villa-amil unearthed a curious item bear-
ing on the cost of war and who pays it. In
an agreement drawn up in 1345 between
the Dean and Chapter of Lugo, on the one
hand, and a canon called Juan Díaz on
the other, about the rent of an altar in the
cathedral church, for the sum of 700
maravedis, payable at Lady-Day; it is
expressly stipulated that if the King of

France and the King of England go to war this year between Candlemas and May Day, there shall be deducted from the rent an hundred maravedis.

Many churches are dedicated to the saint of wayfarers in Flanders and Picardy, especially in the neighbourhood of Havre, Dieppe and Compiègne. By a curious coincidence, while the two former towns are sea-faring places, the last grew into a great nucleus of railways. Frisia dedicated the gates of cities.

Traveller's towns

Slavonians had a special devotion to the pilgrimage: after three trips, a man might live exempt from taxation. They gave their name, in Spanish and English alike, to the long, waterproof pilgrim's coat, the *slaveyn*. Ojea recorded, in 1600, that they came the end of April, so as to be at the sanctuary on May Day, and immediately reported to the superior clergy and obtained certificates from them. The third year they put garlands on their heads and went in solemn procession that day, in sign that they had fulfilled their devotion and the requirements of

. . . Their hats were of the brake . . .

the law, in order to enjoy its exemptions thereafter.[23]

In the fourteenth century the practice was at its height. Froissart tells how Sir Walter Manny was evilly killed as he came home from S. James.[24] It is known that in 1361 Messire Jehan de Chartres and Pierre de Montferrand, going on the pilgrimage, took three jongleurs with them: and an English minstrel named Walter was in Compostella about this time.[25] It had become an element in politics. For instance, on the fourth of September, 1316, a contract between Robert and the cities of Flanders, and Philip, Regent of France, stipulated that "If Count Robert can, he shall go over sea with him who shall be King of France, when he shall go. He will go, and his sons, in one year or two (unless his father or he be ill), once or more to S. James in Galicia, to *Notre Dame de Roche-Mador,* to *Notre Dame de Vauvert,* to S. Gilles in Provence, to *Notre Dame du Puy.*" A treaty signed on Christmas Eve at Arcques (near S. Omer) 1326, between the King of France, Count Louis of Flanders, and the

Flemish cities, stipulates that three hun-
dred persons of Bruges and Cambrai must
go on pilgrimage, one hundred to S. James,
one hundred to S. Giles, and one hundred
to Rocamadour. Before this, in 1284, the
two sons of Herbert called the Scrivener,
for having ill-used Girart the Butcher, of
Compiègne, were condemned to make the
pilgrimage to Compostella. They were the
first of their townsmen to go.

A decree of the Parliament of Champagne
dated January 9, 1367, and preserved at
Rheims, supplies another instance. Mar-
garet, wife of the Viscount Ponsard Larra-
bis, petitions that a certain Stephen who
had called her names and beaten her
(*ratione injuriarum et verberationum*) shall
be condemned to make public satisfaction
and to go in pilgrimage first to S. Thomas
of Canterbury and after to S. James of
Galicia, living in each place a year at his
own expense, and bringing back letters
which show that he has done it.

As early as 1115 the Council of Oviedo
had prescribed for certain offences against
the Church that the criminal should become

either a Benedictine monk, or an anchorite, or a church serf, or a perpetual pilgrim — for all the days of his life. The penitentials of Bede and of Theodore both contemplate this penalty, of temporary or perpetual pilgrimage, according to the offence, and Rabanus Maurus disallows it. In the Capitularies of Charlemagne likewise it is forbidden, because it ruins the man: it creates the tramp. The Inquisitors of the South of France often imposed annual pilgrimages at fixed dates, called Visitations, which worked like reporting periodically to a Probation Officer. On the other hand, in the twelfth century the Archbishop Hildebert wrote to Foulques, Count of Anjou and Maine, who wished to set out on the pilgrimage:

Among the talents that the master of the house divides among his servants, no doctor has ever counted that of gadding abroad; and S. Hilarion, being near to Jerusalem, went thither one time lest he should seem to despise the holy places, but only once. . . . You will say to me perhaps, I have made a vow, and not to

:eep it were a sin. But consider t
ou yourself bound yourself by this v
ut God laid on you the charge of g
rning your peoples: see if the good fr
his journey will yield, can make up
he loss of duties left undone. If
atter good is beyond comparison
reater, as cannot be denied, then s
1 your palace, live for your state, do :
ice, protect the poor and churches.[2]

1 England, a pilgrimage to S. Ja
not infrequently a necessary condit
the inheritance of property.
m, however, that the Early Eng
t Society reprints, has little to do w
James beyond the first couplet.
is devoted to sea-sickness and the
iforts of ocean travel.[27] But the Eng
ie, notwithstanding. Out of ten
ed years, running from 1397 to 1456,
s Corinde makes up a total of
is, and 7907 pilgrims arriving in Gali
inspiration of this great volume of tra
in part, at least, commercial, just
nomic reasons underlay the change w
the following century we read, inste

of Drake's raid on Corunna, or "The True
Relation of a Brave English Stratagem prac-
ticed lately upon a sea town in Galicia,
one of the Kingdoms of Spain; and most
valiantly and successfully performed by one
English ship alone of thirty tons, with no
more than thirty-five men in her."[28]

The Licenciate Luis de Molina, in his
Description of the Kingdom of Galicia,
which he printed in Mondoñedo in 1550,
relishes highly the long roll of countries
represented, reciting them with a reminis-
cence of the Pentecostal miracle:

Roll-call

Visítale Albania, Normandos, Gascones,
Mallorca, Menorca, Cerdeña, y Cecilia,
Efesios, Corintios, Dalmacia, y Panfilia,
Vascos, Chiprianos, tambien Esclauones,
De Ponto, y Tesalia, y acá los Saxones,
Polonia, Noruega, Yrlanda, y Escocia,
De Egypto, de Siria, tambien Capadocia,
De Jerusalen, con otras naciones.

Visítale Francia, Ytalia, Alemania,
Ungria, Boemia, gran parte de Grecia,
Los Negros Etiopes, Ybernia, Suecia,
Caldea, Fenecia, ni Arabia se extraña,

/ mas Ynglaterra, con Flándes, Breta
)el gran Preste Juan, de Armenia, y
 Frisia
'eniendo tal cuenta con esta Galicia
،os quales afrentan á nos los de Espa

'he pilgrimage could be made by pro
)y delegates.　Barcelona, in 1465, w
 plague was there, sent Fray Mi؛
)eller and Fray Leonardo de Gra
٤475 from Palma de Mallorca came
plains of the church of S. María
r.　Kings sent ambassadors.　The E
 King, Henry II, asks once rather
iently for a safe conduct for the jourr
if he cannot have that for his prc
son, then one for ambassadors of
er the death of Louis XI, Marti
ıe to Santiago to make the offeri
vided by the King's will, and brou
h him founders to make goodly b؛
 representative, later, of Philip IV
.in and Margaret his Queen, ca
hop Diego de Guzmán, who was to
hbishop of Seville.　His offerings w
efly in kind, Florentine textiles of
alleled magnificence, and wrought sil

It was possible, also, to go for the dead.
In the year 1403, Juan Fernández de
Guermeces signed a very devout will in
which, after ordering a certain number of
masses to be said, and leaving divers alms
to the convents, hospitals and asylums
situate in various streets and houses of
Burgos, he directed that two men should
go on pilgrimages on his account, one to
the Sepulchre of S. James and the other
to the shrine of Our Lady of Guadelupe.
It is not far from this possibility of a jour-
ney for the dead, to the belief that the
dead themselves may go. In the Asturian
Romance of *El Alma en Pena*, among those
collected by D. José Menéndez Pidal, the
poor soul itself fulfills the pilgrimage.

On the way of Santiago went a pilgrim
soul: the night was starless, the earth was
shaken. A *caballero* comes to the win-
dow: — "If thou be of evil, I conjure thee
to depart, if thou be of this world, tell me
what is wanted." The sinful soul has
come to running water, and cannot cross, —
"Trust to the rosaries said in life." — "Alas,
I said none." — "Trust to the fasts." —

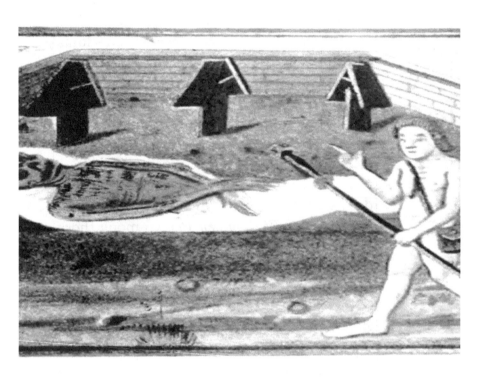

The Soul as Pilgrim

(From a Miniature of the Fifteenth Century)

"I never fasted."—"To the alms."—"I gave none." Then the *caballero* lights consecrated tapers at the window and ·on the ray of light they cast, the soul crossed the running water and went on: and returned the same night singing: "Blessed the *caballero*, who has saved his soul and mine."²⁹ As this condensed version gives no notion of the touching loveliness of the poem, I have reprinted it in the *Appendix* along with an English ballad that shows some curious divergence in the midst of likeness.

In another of Sr. Menéndez Pidal's Romances, the pilgrim who passes on her way taller than a pine-tree, so charms the eye and draws the desire of the King that he lays out the finest bread and wine, the richest clothing, the warmest cloak, and sends a page to fetch her; she is under an olive tree, combing out her blond hair silken-fine: she will not be bribed by his offers, for she is queen in heaven, she is the blessed Magdalen.³⁰ In yet another, she is Mary Queen. Very little abashed, he renounces seduction and betakes him to supplication: she hears him graciously.

Running Water

XI

X

The pilgrim who is not a pilgrim but some one else in disguise, is a commonplace of the *Chansons de Gestes*. In *Guy de Bourgoyne* the venerable Charlemagne thus disguises himself: in *Anseis of Carthage*, by this device the King's messengers get through to France, just as this is the array in which those of Gelmírez try to reach the Pope, in the *Historia Compostellana*, which is truth written by eye-witnesses. In the *Cantar de Garci Fernandez*, the Countess Argentina was first carried off, like Bernardo del Carpio's mother, while *en romería a Santiago*, and afterwards she was greatly taken with a count of her own land who *yva en romería* in his turn: and the end of all these persons is in the tragedy of blood. In the *Poem of Fernán González* it is a knight bowne to S. James from somewhere in Lombardy who brings word to the King's daughter that the good knight lies in prison, and again it is she, disguised as a *romera*, who contrives his escape, in a famous romance that Lockhart has translated. The latest editor of *Flores y Blancaflor*,[31] the fifteenth-

century Spanish novel, wants to have the whole exquisite romance, with all its French and ·Italian forms as well, fall into line simply as another of the Miracles of S. James. His argument is not quite weighty enough, but the setting, at least, of the orient gem he shows to be the cult of the Apostle: with the pilgrimage to Santiago the action begins, by an unaccountable miracle the dénouement is contrived, and with another pilgrimage to Rome the whole ends.

The incident lay always ready at hand, plausible, symbolic, romantic, for history, epic, or allegory. The miracles that happened along the road are of all sorts, but mostly quite practical, and they seem to have happened over and over again. From Ozanam's *Pèlerinage au Pays du Cid* I have gathered one, fragrant as the rosemary of the Pyrenees, that perfumes all the day.[32]

It is told of S. Bona of Pisa, who with a company of pilgrims came to a torrent where the bridge was ruinous. As the party stood about wondering what to do, Christ appeared to her and said: "Raise

Flores y Blancaflor

. . . Far out at sea, says Howell

S. Bona of Pisa

your arms, and pass." The company cried out as she started, but a multitude of saints came down from heaven, popes and bishops in cope and mitre, and stood in the stream on both sides of the bridge. She passed in safety. Then Christ said: "Call your companions; not one of them shall perish if you keep your hands raised all the time they are crossing," and at last she coaxed them all across. One man saw the popes and bishops as he passed.

Usually, however, S. James took care of the miracles. There is the story of the stolen cup and the pious German pilgrim, falsely accused by a maid-servant he had rebuffed:[33] he was hanged, and his parents went on, but when they came back he was yet alive, for S. James had held him up so that the rope did not strangle. This is told of Toulouse.

Que cantó la gallina asada

At S. Domingo de la Calzada they still keep, caged, above the transept arch, a pair of white chickens of the breed that got up, under the carving knife, and crew, to confute a judge who in a like case had pronounced sentence and seen it executed.

Navagero saw them, and I. You remember the story: have seen it painted on a chapel wall at Forlì: the parents shaken by the conflict of long grief and new-born hope, the judge who says, "That man was dead as these roast chickens," and the cock who claps his wings and stretches his throat to testify that the saint can protect his own.

Another story is not without edification, that of a pilgrim from Barcelona who prayed never to be a captive. He was taken by the Saracens and sold thirteen times, but the chain always broke on his limbs. In the end, however, the apostle suggested to him that the chains of sin were worse and his prayer would have been better directed upon the spiritual side.

There is a touching history of a boy, a good lad of Lorraine, who when one of the party fell ill by the way in Gascony stayed with him while the rest went on, nursed, and at last buried him. This was in the year 1080. Then he resumed the wallet and staff to go on alone, but a rider overtook and picked him up on a great white horse that devoured the miles, that gal-

loped up mountains and down them again, splashed streams an instant and was far on in the dust, till the trees whizzed by and the sun was left behind. At nightfall the boy found himself set down on the Mount of Joy, in view of the cathedral towers, just a pace ahead of all his friends with whom he had set out from home.

The Venerable Guibert de S. Marie of Nogent-sous-Coucy, in the diocese of Laon, tells of a young man who made the journey girt with the girdle of his mistress. The devil, seeing him so far on the road to salvation, made a furious assault, flung him into despair, and persuaded him to suicide, which meant, of course, damnation. S. James interceded for him in heaven, restored his soul to earth long enough for penitence and absolution, and took it back with him into Paradise.

Need was there, after all, on the long road, of miracles, for it was a hard road, and of great saints to take care of little souls, for not all who went came home again. I have the story, in a private letter, of a French gentlemen, my cor-

respondent's ancestor, who setting out on the pilgrimage in the fifteenth century, arranged his affairs and provided that if he should die on the way, his bones might be brought back to rest in France; or if the money upon him should not suffice, then, at least, be brought so far as possible. There you feel, for an instant, the home-sick, the exile, as in the words which Dante uttered prophesying, for he knew not yet what way he should die:—"These pilgrims seem to me to be from a far country and I believe that they have not even heard speak of my lady and know naught of her; rather their thoughts are of other things than of these here; for perchance they are thinking of their distant friends whom we know not . . . The wide sense, in so far as whoever is outside his fatherland is a pilgrim: in the narrow sense, none is called a pilgrim save him who is journeying towards the sanctuary of S. James, or is returning. They are called *palmers*, in so far as they journey over the sea, there, whence many times they bring back palm branches; they are called *pilgrims* in so

Dante in the *Vita Nuova*

far as they journey to the sanctuary of Galicia, because the tomb of S. James was farther from his own country than that of any other apostle."[34]

Graves by the way Very many who set forth, came not home at the long last: by the side of the road are their graves, in parish churches, in forgotten sanctuaries. The bishop who had been all the way to Jerusalem and had got him a precious relic of S. Andrew to bring home, lies yet in Estella. The Knights who were surprised as they slept by Cea bank, yet sleep there still. Every hospice or its site, along the way, has more graves than names of pilgrims to tell over. Urged by more than mortal desire, through the centuries, they pressed on, "for they seek a better country, that is, an heavenly."

> Vous qui allez a Sainct Iacques,
> Je vous prie humblement
> Que n'ayez point de haste:
> Allez tout bellement.
> Las! que les pauvres malades
> Sont en grand desconfort!
> Car maints hommes et femmes
> Par les chemins sont morts.

BOOK TWO

THE WAY

*A-t-il ceint ses reins pour le voyage
de Compostelle ou pour celui de la
Mecque? S'est-il embarqué dans un
pieux pèlerinage archéologique? A-t-
il pris le besace et le bâton du Juif
errant? A-t-il été de monument en
monument, de relique en relique, de
porte en porte, se recommandant à
tous les saints ou à tous les prophètes
du Paradis, mendier fièrement sur les
grands chemins, à la sueur de son
front, le pain de la vérité.*

 —Courajod.

I

SETTING OUT

*"Nous étions bien bonne
compagnie de gens studieux
amateurs de pèrégrinité."*

THE cypress, it seems, grows in Languedoc along with the poplar, the poplar of northern France with the Italian cypress, side by side. The country was gilded with ripening wheat, and the sun was in the sign of the Lion. From thick green banks blew into the train the scent of elder; there bloomed eglantine and the pink wild rose together. When Jehane came back after coffee at a station, she found the carriage pleasantly populous with irresponsibles, — old women, babies, and a priest: two sickly children with their sickly mother in cheap ready-made clothes, two handsome, wholesome grandmothers *en bonnet*, and the

priest's the most beautiful woman's face
of all. Jehane is long and brown and
deceptively gentle, children gravitate to
her very luggage; with difficulty we kept
our seats at the window and our attention
on the thick slow waters and strong vegeta-
tion without. We had met, by appoint-
ment, in Toulouse on Midsummer Day,
Jehane coming from Italy and the other
from farther, following the starry track,
both firmly purposing to go into Spain by
the mountain road. Where the railway
ended we should take a diligence, or, if
there were none, a carriage; where wheels
did not go we should take mules; where
rocks were too steep, we should essay them
on foot. We had corded up our boxes
and left them with the landlord; we had
strapped up our bags and put them in the
carriage; and had taken our tickets for
Pau and thence *au delà*. We knew it lay
somewhere beyond Pau, to which city,
English-haunted, we had letters that we
hoped never to present; that it lay some-
where beyond Olorón where the portal of
S. Mary's church looks already more Span-

Crest of the Pyrenees

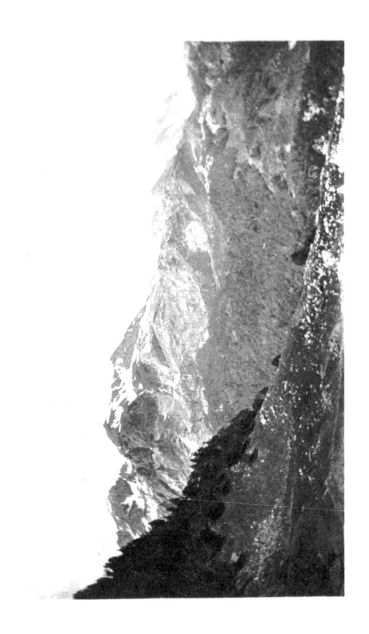

ish than then we knew. Bedous was the present terminus.

The last part of the way was stirring. We had left the soggy plain, with its water-channels and its dark green stuff, all irrigated. The pale far crests of the Pyrenees, and their blue gulfs in between, we had lost from sight in the approach: — say, at Lourdes, or shortly thereafter. There everyone else had got down, for there was the end of their pilgrimage. About the train, as it halts, the hills rise kindly, a little river winds clean and pure below, the rock still stands, with a living spring beneath — all the ancient site where celts and arrow-heads are still dug up, where earliest man and thereafter his sons came worshipping, before any history had begun. Between the great flanks of the mountains lie valleys blue like the calm blue that sleeps in a horse's eye; in an hour the train had burrowed among the red and tawny rocks of them, and through the cold air of torrents it climbed and twisted, through the scent of dark fir trees; and when the laborious panting engine was quiet a

moment, the green stream below roared into stillness. Twilight closed in upon the glimmering rapids, among the dark tree trunks, and in the pale strip of sky some pale stars shook, before the line suddenly stopped, as though it too were only halting for the night or for a week, while the great building of the railway went on incessantly. Having asked a few questions at Olorón, and knowing beforehand that wherever engineers could sleep, there could we, with thankfulness we undid the bags in an interval and took out the ultimate indispensables for a night; then, at Bedous, abandoning the rest in a corner of the station, walked out into the dark of a village street behind a friendly railway employee. We need have no fear, he assured us, for the man who drove the daily motor omnibus would put up that night at the inn. There was no porter, for nobody was expected by the evening train, but he carried the little sack as well as the post bags, and guided us, stopping for various matters on the way, down the whole straggling white-faced village to the

inn. When we got there at last, no room remained; the landlady was honestly sorry, not so we, for the men eating and drinking looked in the candlelight noisily disposed. There was, it came out, another inn, to which the maidservant kindly took us, "though it is not like ours," she said proudly. They were all so honest and proud, in Bedous,—the new landlady, again, in her offer to send out and buy meat at that hour of the night. We supped contentedly, after a homely fashion, and went to bed above the mules in a room big enough for town meeting. One end opened above the little street of houses that recalled the Engadine, stuccoed and iron-barred, the other on a wooden gallery above a garden that smelt of lilies and roses under the dew-fall, and at the end of every opening and above the crest of every building rose into the filmy moon-light the vast back of mountains.

Next morning, when the yellow motor omnibus backed out of a hangar and circled up to the station, for passengers arriving or awaiting, we sought out the driver

A Pyrenean village

and bribed him with a small fee over and
above the extra fare, to allow us on the seat
beside him, whereby the other man in
corduroys who took up fares and handed
down bundles, and the like, travelled most
of the forty miles to Jaca on the step,
holding fast by the dashboard. Including
all stops, and the customs examination at
Canfranc, we ran those forty miles in four
hours, along the little river valley. Every-
where it was lovely, but not so romantic
as that of the night before: a perfect road,
hard and white, ran easily, for the most
part almost by the water side; and now
above it, now below, sometimes even on the
other side of the stream, ran the railway
that should carry back and forth, between
France and Spain, where once the pilgrims
passed. Being born and bred to railways,
one could admire the building, so skilful
that it looked easy, done in accord with the
modern admission that the Indians' way
was the right one—the way of the makers
of trails, who expend less strength going
around an object than climbing over it,
and bend the path if a tree falls or a rock

topples. On that summer day the men expected that two years more would see it done: the two years are passed and much, belike, has been undone, and the rest remains untouched, but the road yet runs. So there it ran, now white and winding above the river bottom, now grey and barred with shadows where a village flanked it on either side. Dogs fled, children were snatched back, the glare of mountain light was tempered for a brief space, and then grey hillsides drew away again and grey stucco lay far behind. In the first hour the houses, square and colour-washed, their windows square and barred, still recalled the Engadine, as indeed do, a little, the mountains, in their large lassitude, so un-Alpine. Then one was aware of small iron balconies more frequent, and the slope of the roofs unfamiliar and alien. The river is left suddenly below, to burrow like the railway through the international barrier, but the highway climbs in many loops a vast mountainous bulk, set there as if ordained for a barrier, though it has never stopped

and
Engadine
houses

Visigothic king or French bishop, Charle-
magne or Bonaparte.

The fort of Urdos is a mere rocky boss
in the midst of rock, crowning a wooded
spur, and the granite way zigzagging up
to it is walled and loopholed; the very
granite mass of the mountain is loopholed
and fortified. Then green trees, the light-
leaved sort, were left.

Somewhere here a shapeless rocky mass,
of weather-worn stones that once were
hewn, marks the site of the Hospice of S.
Cristina. From the time of the Goths[1]
existed on the crest of the Pyrenees above
Jaca, a shelter where various monks took
care of pilgrims that passed that Port.
Aymery Picaud praised it before all:—*hos-
pitale S. Christinae, unum de tribus hos-
pitalibus cosmi.*[2] Gaston IV of Béarn,
a hero of the first Crusade, founded and
Gaston V in 1216 refounded the hospice
above Somport,[3] and the name of that town
is *summo portu*, the pitch of the pass. He
dowered it with various revenues in Aragon
and gave it to canons of S. Augustine.
King Alfonso of Aragon, great lords of

Spain, Gascony, Hungary, and Bohemia, contributed to its foundation, and built in their domains hospices depending on it. It lasted till 1558 and then, like so many other ancient and pious works, it was removed to the capital.[4] Possibly the monks preferred living in town: certainly the crown preferred their keeping within reach.

When Leonore of England, the daughter of Eleanore of Poitou and the sister of Cœur-de-Lion, came into Spain to marry Alfonso VIII, five Spanish bishops met her at Bordeaux, and with them "the most exquisite flower of the nobility of both Castiles,"[5] white monks and black, Cistercian and Benedictine, and especially the great dignitaries of the Religious Orders. With them came back by the Port of Aspe, by Somport and Canfranc, a noble escort of her own people: the archbishop of Bordeaux, the bishops of Agen, Poitiers, Angoulême, Saintes, Périgord, and Béziers, and a host of lords and knights, English, Gascon, Breton, and Norman. They rode together as far as Tarazona, escorted by Alfonso of Aragon, to be met there by her spouse, his

A Queen's progress

namesake of Castile, with all the prelates
and nobles left in Spain, it would seem;
and thence the visitors turned back again
in July weather, heavy horse and sleek
mule, steel-armed knight and frieze-cowled
monk, velvet cloak and silken cope, climb-
ing the brilliant dusty steeps, filling the
pass with the heat and murmur of a mov-
ing multitude.

The still upland heights were open,
rocky, heathy, pasturable, when we reached
the plain stone column that marks the
limits of a kingdom: just before the last
boundary post a beautiful range opened up
to reveal beds of snow and crests of carven
rock. There the car stopped an instant,
the man in corduroy running to the road-
side to receive from a goatherd waiting a
knotted kerchief full of curds. This he
hung on the front of the car, for whey to
splash and spatter and yield him in Jaca a
goodly lump of cheese.

The frontier is at the top but the customs
at the bottom: we coasted down to find
a pair of the neatest, smallest, civilest
Spanish soldiers imaginable, in their sum-

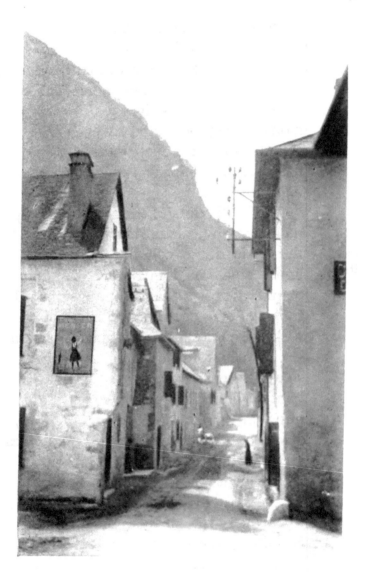

A Pyrenean Village

mer uniform of white with a grey hair-line, just pulling on clean white cotton gloves in which to examine our luggage. The wonder was how they got so much courtesy into so brief a matter. In the little towns now men wore *alpargatas* and flat caps; they had lost the candid French look. One hundred years of *liberté* and *égalité* have given some meaning to the word *fraternité*, and when you cross a frontier into France you know it in the eyes that meet your own so friendly and frank. The French look says, you are good as I; the Spanish, I am as good as you—usually, better. Of quite plain people this is meant.

Another river was running beside the road, between the rocks. The landscape was widening, with an indefinably Spanish look in the colours and contours, the brown dust and palisaded cliffs. The impression yields to one of a dusty plain, white with dust, immense within the blue enclosing heights; of an arid heat that intoxicates and blinds; then two lines of river-bordering trees that converge; and lastly, the dusty brown walls of Jaca and towers within them.

I, as good as you

II

HEART OF ARAGON

> De esta nobleza que es
> gozar de libertad mas
> goza el noble Aragon que
> todos los reinos, porque
> hasta sus villanos faze ser
> mas nobles que los nobles
> mas nobles de las otras
> provincias del mundo. Cá
> nazen tan libres, viven tan
> francos, son tan esentos
> los villanos de Aragon!—
> Fray Guaberto Fabricio.

THE city still keeps a kind of state, the houses are built of stone, their façades adorned not merely with monstrous rococo coats-of-arms but with Romanesque mouldings and Gothic traceries, not frittered away in glass galleries; the streets straight and well paven, the cathedral dominant. *La muy noble, muy leal, y vencedora,* Jaca

Muy noble, muy leal, y vencedora

was already great in Roman days, strong in Visigothic; was the last to yield to the Arab conqueror Ayub (as late as 715) and the first to rise and support the struggle of Count Aznar (758–795). Court of the counts of Aragon, and seat and stronghold of the kings their successors, from the first Ramiro down, it holds the type pure, in the figures of the brown small men, the spare swift grace of the women, the strong Romanesque forms of the cathedral. Though the fairs of Jaca in the latter Middle Age drew merchants from Aragon, France, and Navarre, these brought no changes with them; and like the coinage that fixed the standard of the realm, those *sueldos jaqueses* that kings on their coronation swore to maintain undebased, so the temper of the people kept the one image and superscription.

. How unlike is Aragon to Castile, we were to feel later more strongly, most aware now of the entirely Spanish quality of it all. The boy in *alpargatas*, with his swift soundless movements, entering on a message, with his snowy linen shirt, and velvet jacket

Last to yield, first to rise

worn over one shoulder, with his bold eyes and fine teeth, was just the *gracioso* of the old comedy. He was all one golden tone, the sunburnt dress, hair, and fine skin, relieved by the shadow on his upper lip and the deeper shadow of his eyelashes. Unhappily, when hired to pose for a photograph, he looked silly enough, but once released, his comment, I make no doubt, was in the antique vein, spiced and seasoned, and sent up in good Castilian.

Don Quixote you remember was a Castilian, so indeed were the Cid and Alfonso the Wise; Jaime I *el Conquistador* and D. Martin the Humane were of Aragon; but the distinction is easier to apprehend than to make plain. Aragon is more European, Castile more Peninsular; the one presents the ideal Romantic of chivalry and humanism, Mediterranean, almost Frank, almost Latin; the other cherishes the quintessential, the Iberian, condensed, insistent, the self-centered, self-judged, and self-approved.

In the kingdom of Aragon alone was

there anything of the feudal system, and, from the very beginning of the Reconquest, something in the way of a Parliament, with right of election and recall. The *fucros* of Jaca in the twelfth century supplied a model for those of Castile, Navarre, and elsewhere. The famous haughty formula will bear quoting again: "*Nos*"—the nobles say to their king new-crowned,— "*Nos que valemos tanto como vos y podemos mas que vos, os elijimos rey con tal que gardareis nuestros fueros y libertades, y entre vos y nos uno que manda mas que vos: si no, no!*"[1]

The pride of the nobles gave their vassals liberty, and the need of the king gave the cities rights. King and *Cortes* are mutually dependent—"For neither the king without the kingdom, nor the kingdom without the king, may severally make a law of the land nor alter that agreed to once, but all united must conjoin in making new laws and providing for the weal and regiment of all: and the more that is done without admixture of any force, cautel or deceit, by so much the more is it more estimable, stabler,

and diviner."[2] Thus the *Chronicle of Aragon*, which breaks out elsewhere, to proclaim in a droll passion of constitutionalism, "that it is greater grandeur and majesty to be king of kings than king of caytiffs,—that those who rule kings are (and all the more those who rule well) like the Aragonese, who may make no law without a common accord and have place and power to say what best to them beseems in respect of the regiment of the realm, that greater king there may not be than the king who rules such kings and lords as the men of Aragon be."

Individuality of this metal does not take easily a strange stamp, and there are no foreign traces on the cathedral here. Jaca was the mountain capital when the plain yet lay in power of the Hagarenes.[3] In the eleventh century the bishop of Aragon, whose seat was in Jaca, exercised jurisdiction not only over the Christians of the Mountain, but over the *Mozárabes* of Huesca. In Saragossa they had their own Bishop and possibly also in Tarrazona.[4]

Jaca: the Cathedral.

> *There still, although the*
> *world autumnal be and*
> *pale,*
> *Still in their golden ves-*
> *ture the old saints*
> *prevail;*
> *Alone with Christ, deso-*
> *late else, left by man-*
> *kind.*

The quality named architectonic, seems
alien to the Spanish genius. This appears
in many ways, some of them very curious:
in excessive formalism in the Spanish
drama, for instance, as if the author could
not move himself without the steel and
buckram of theatrical convention, and in
the interminable assonances which every
poetry but the Spanish outgrew some cen-
turies earlier; or, again, in the attitudinizing
formulae of Berruguete's choir-stalls; but
nowhere so much as in the architecture.
The average Spanish church has no par-
ticular shape, when you look at it. Barring
the great cathedrals built by foreign inspira-
tion and under foreign direction, they are
too often mere lumps. The king's daughter

*Architec-
tonics*

is all glorious within, but outside she looks like a fat market-wife. Yet as the butter-woman was once a trim milk-maid, Jaca cathedral was a fine sight once. From the cloister garth, amid the rose of Sharon, the *lilium inter spinas*, rusty fir tree, and potted bamboo, you may make out above the built-up cloister face the gable of the transept roof, the low tower to mark the crossing, the bold round-headed windows of the aisle, quite blocked now. Then, crossing the beautiful and dim interior, you may pass by way of a market square to a glimpse of one remaining side apse with its own noble round-arched window richly moulded, its billet-moulded cornice carried on splendid and fantastic corbels, where the spaces between these, and the under face of the cornice, are carved with foliage, rosettes, and other luxuriant and highly developed forms, all this, however, hidden behind a ten-foot wall overflowing with eglantine and fragrant leafage.

Within, it is wonderfully little spoiled. The stone that turned brown as iron under

the suns of Aragon is a graver grey in the quiet indoor light, almost a silvery in the sculptures of tomb and retable. Enter from the blazing square; the light is cool and grave, the vista lofty and noble. There are cathedrals which have been erected from parish churches; there are others built express which might as well have been that; this is none of them. Not large, it is yet princely.

The kingdom of Sobrarbe was founded in the seventh century, and this see in the ninth, but not a stone is earlier than that church of the eleventh (commenced A.D. 1040) where nine Bishops attended a council and after consecrating the new edifice (*i. e.*, probably apses and transepts) signed a document which survives. This was in 1063. The transepts and apses alone can belong to this date: to the end of that century the enclosing walls, the west door, and the beginning of the western tower: to the close of the twelfth the aisles of the nave: to the fifteenth their rib-vaulting, sexpartite, and the elaborate sexpartite vaults of the nave that, leaving the fabric

below practically untouched, descend upon consoles to a sort of cornice under the clerestory windows, at about the springing of the original great barrel vault.[1] Then the eighteenth century overhauled generally. It is easy for the imagination to construct the original Romanesque church, of which the barrel-vaulted transepts give the scale, and the great cruciform piers, that alternate with cylindrical columns, suggest the mass: many capitals have lasted on from this, some historied and some of strong stiff leafage, and a billet moulding at the springing of the vault and semi-dome.

There were four bays to the great nave, and the piers carried just such transverse arches as may still be seen on the four openings of the crossing and against the end walls of the transepts. On them rested the strong barrel vault, windowless, the light coming from the lofty aisles vaulted in a plain quadripartite form, unribbed, for which the alternate columns of the nave sufficed. The eastern end had three parallel apses, the central one very deep;

it opened directly from the transept, and
the central portion of this is covered by an
octagonal dome under a low lantern, vaulted
on ribs that spring from the centre of each a Spanish
builder's
of the cardinal sides and from arches thrown
across the corners—*i.e.*, squinches. In this
same way the vault is turned in the apsidal
chapels at Las Huelgas, in the Constable's
at Burgos, and under the lantern at Irache,
and it is a Spanish builder's way.[2] At a
time when the builders of Auvergne were
opening the first tribunes of their dark
naves, and those of Languedoc were turning
the first ambulatory around their lofty
apses, the king's men here had carried a
form, simpler indeed, to a greater perfec-
tion. D. José María Quadradro quotes
from a parchment in the cathedral archives,
the prescription of Ramiro's foundation:

> . . . Quod ejus tectum fiat et perficiatur
> de crota lapidea sive boalta per omnes
> tres naves sive longitudines incipientes
> ab introitu magne porte usque ad altaria
> majora que sunt in capite ipsius ecclesie,
> et una turris supra dictam portam ubi
> jam incepimus eam hedificare pro cam-

Lights and
incense

panali cum octo campanis, quatuor magnis et duabus mediocris, et duabus parvis, cum quibus Dominus noster pius Pater excelsus laudari et universus populus evocari possit, cuius tegumen volumus etiam fieri de lapide firmo.[3]

Then he continues with provisions for eight lamps to burn continually and incense to smoke upward at all hours of day and night. This is rather an exercise in rhetoric than a builder's instruction, and the king is more concerned with the bells and lights and incense of his daily worship than with the fabric already going up, but from it we make out the Spanish vaulted type unmodified. In the time of his son Sancho Ramírez the rule of Cluny was introduced into the convent of S. Juan de la Peña and some other royal houses of the north,[4] but there is no evidence that builders were fetched during this reform, nor is it likely that the princely bishop of Jaca would have borrowed any from the proud abbot of S. Juan. Relations were strained: at the Council of Jaca the said abbot had affixed his signature

before any of the bishops present, and in 1076 the bishop of Jaca, D. García, Infant of Aragon, opposed the undertakings and exemptions of the abbot.[5]

The western narthex, below the tower, was already commenced at the dedication: it was three bays in depth and possibly once more than one in breadth, but not probably. The square projection westward is characteristic of Asturian and Visigothic churches, and the narthex at S. Martial of Limoges[6] and at S. Benoît-sur-Loire, which might have afforded models of a close-pillared Galilee, were not yet builded, for they both must be referred to the height of the twelfth century. The low chamber here, with storied capitals and tympanum sculptured with the labarum, is elder. The sacred symbol is treated like eight rays or spokes, with roses in between, and flanked by a pair of symbolic and rather oriental lions, the one respecting a fallen man, which signifies that God's judgements are disarmed by contrition, the other trampling on human heads, in sign of Christ taking empire over death.

The beautiful and airy portico on the south flank, while Romanesque, is of the latest and most perfect period. That side porch is not peculiar to Spanish churches, but it is very common among them. Only a few leagues away, at Tiermas, the parish church has another, just such, except that it is quite formless. Transept portals in purely Spanish building are rare, even when conditions seem to exact them, as at Las Huelgas: instead, you get the opening in the flank. If the two fine portals at Estella may pass as imposed by the fall of the ground, this cannot be urged of S. Vincent at Avila or S. Martin or S. Millan at Segovia. Neither of these last churches has a proper transept, which also is characteristic. There seems to be an elder Romanesque tradition, which appears in France at S. Benoît-sur-Loire, for instance, and Notre-Dame-la-Grande of Poitiers, and S. Seurin of Bordeaux, which explains the early and precious portal of Bordeaux cathedral, and determines the side door in the rather archaic cathedral of Avila. It is this which is invoked to

explain the symbolism of the wounds of Christ in the five doorways of the church, and the Spanish practice may possibly be determined by the greater glory of His wounded Side.

S. Juan de la Peña.

Fundamenta ejus in montibus sanctis; gloriosa dicta sunt de te.

At three o'clock the *gracioso* called up from the street under Jehane's balcony, and before four we were driving in a purple starlight, that deepened and blanched, along the river Aragon, fringed like all Spanish waters with green linden and plane-trees. A ray shot up and the mountains turned to the purple of heather; the primrose brightness grew and they turned blue; lastly came up a white-hot mass and they were vaporous. By the water-side grew wild iris, and on the other side of the road wild rose and hawthorn. We passed that shrine of Our Lady of Victo-

Dawn

ries which commemorates the wives and daughters who could not stay idle in Jaca while their men made a stand against the Moors. In the white mantles and veils of their sheltered life they made a sudden sally and turned the day and helped the slaughter.[1] At a grange called Esculabolsas

Escula-
bolsas

where men were piling logs by the roadside, we waited while two mules were fetched and a guide, and with them a lame dog who looked like a wolf, yellow and elderly; with these we struck up toward the mountain through stony lanes almost like the English, along a brookside. Logs were dragging down the brook, each at a horse's heels, and the high bank of the lane was often musical with water-channels and flashing where the runnel spilled over into a terraced field. For a long time a sort of doubtful tower rose ahead.

At the very head of this valley stands S. Cruz de la Serós,[2] of the Sisterhood, a convent abandoned when the nuns, feeling it lonesome in the country, moved into town in 1552. The convent has fallen away into ruins, but the church is fairly intact.

Just a minute upstream from the poor little village, it lifts well above the willows and alders of the high bank a series of high and heavy masses. The great tower, crowned by a low octagon and pierced by pairs of windows in the upper stages, stands above the south transept, of which the walls are incorporate with it and from which projects one of the two shallow, square-faced structures that enclose the lateral apses. Between them the vast central apse, semicircular, divided by attached columns, adorned with moulded windows, round-headed and shafted in the jambs, is crowned by a cornice on corbels and a low roof. The face of the east wall is continued up a long way, and roofed by a sort of low pyramid, the church having above the crossing a true lantern, thus disguised on the outside and hidden on the inside by a vaulted bay. Approaching from the north, the effect is odd: above and beyond the flat end wall of the transept you see a high square structure sustaining a low broad octagon and behind this again, not much higher, another square, octagontopped. The tiny nave runs off, absurdly

low. The apse appears in strong profile; and all these square contours, while not structurally so connected, as S. María at Tarrasa is really, perhaps, related — yet do a little recall the characteristic architecture of Auvergne. That is almost the only hint of the sort, however, here in the heart of Aragon.

The nave will have been low always, and at present a number of steps lead down into it. The portal looks like Benedictine work of the twelfth century: it is enclosed by a strong billet and adorned by a superb roll moulding, and then by balls disposed at regular intervals in a hollow — an ugly motive too frequent in twelfth century work; which was to be revived with fatal enthusiasm by Torquemada and the Catholic kings. Quadrado,[3] publishing a sketch that shows ruins now disappeared, copies also three lines of Latin verse about the doorway and a fourth in the cornice:

Janua sum praepes: per me transite, fideles.
Fons ego sum vitae; plus me quam vina sitite,

virgines hoc templum quisque penetrare beatum.

Corrige te primum, valeas quo poscere Xristum.

The low lunette of the tympanum, carved with the chrism and a pair of lions, is copied from that of Jaca, but a daisy or sunflower is unexpectedly dropped into the space below one of these. Of two shafts on which the great torus descends, the right-hand is transitional; under true volutes you find a sheath curling over a ball (rather than a bud); the left-hand has, also under volutes, a pair of lions and other beasts more Lombard-looking than those above, with the same brutal heaviness as some of the monstrous things at the Seo de Urgell. Benedictine, twelfth century, regional — that is the conclusion of the whole matter, exception made of the sunflower.

Inside, the western gallery rests on one fantastic shaft, which the holy-water stoup encircles. There are three bays of barrel vault, out of the easternmost of which open the transepts without occupy-

<div style="float:right">Benedictines</div>

ing the whole of it; the apse is preceded by a shallow bay and occupies no more than a third of a circle. That you could never divine the lantern, strongly suggests that it was an exotic idea. The transept arms are cross-ribbed, with a very domical vault; a billet moulding runs along the top of the wall and lunettes fill the space below the vaulting — another suggestive trait. The side apses are of course very shallow, lighted by a single window, now half blocked up, at the central line where the square outer face of the mass is tangential to their curve.

M. de Lasteyrie says this is frequent in Byzantine architecture. I should have thought it came either from Asia Minor or from Rome. Apses in this form are found in the undated churches on the Anatolian plateau; and, later, in Provence, in the crypt of Montmajour and at Maguelonne. Now the bishops of Maguelonne figure frequently in the ecclesiology of this region, and Bishop Godfrey went along this road when S. Juan de la Peña was consecrated.

Anatolian
and
Provençal

A narrow and steep staircase leads up
from the nave, in the thickness of the
wall. The lantern consists of a superb
vaulted chamber with four ribs, mould-
ed, supported on four shafts in the
centre of the sides, and deep niches in
the corners. The stones of the vault
are laid horizontally, like a dome, both
here and in the upper chamber of the
tower, but not in the transepts below, as
they were, for instance, in the domical
vaulting of the Old Cathedral of Salamanca.
The bases of the shafts are cusped; three of
the capitals are historied and the fourth
uses the motive of the pine cone (found at
Vézelay and at the Pantheon of S. Isidore at
Leon), very rich: in late Roman mysticism,
the pine cone stood for immortality. The
tower chamber, just referred to, which
is reached through this room, is roofed
with a sort of dome on squinches: *ajimez*
windows, in the four faces, have three
capitals apiece but the shafts have perished
and the openings are walled up where
they should be. These capitals anticipate
Gothic, like one at the door, with volutes

somewhat as at Cuenca

"topped with a cypress cone"

AND MONOGRAPHS I

at the corners and a strong curl below, sometimes a human head.

The convent was founded perhaps in 987 or 992 by King Sancho of Navarre and his wife, Urraca Fernández, who left eighteen villages to the *sorores* or sisters of S. Cross. The great benefactors were however the family of Ramiro I, who in 1061 recommended it in his will to his daughter. Urraca was professed there and so between 1076 and 1096, were her widowed sisters, Sancha, Countess of Toulouse and Teresa, Countess of Provence. The church was built in their day, the transept vaults belonging to a reconstruction not later than the twelfth century. The wonder is, on the whole, that Toulouse and Provence had not even more to say in the matter; but, as observed already, there are as many reminiscences of northern Auvergne; and the rest are apparently of the nearest cathedral. Briz Martínez,[4] writing the history of S. Juan de la Peña, speaks of this convent as a daughter house, filled with kings' daughters and those of the great nobles and principal persons of the realm,

and adds that the widowed queens passed their lives there. By a decree of the Council of Toledo, widowed Gothic queens might not marry again, and they either took the veil, or took a house near a convent though not bound to the community life.

In the poor little village the parish church keeps a Romanesque apse, arcaded, and one house an *ajimez* window of late Gothic in an ogee curve, also rude sculptures on the lintel of eagles, bells, sunflowers, and in the centre a cross. About contemporary with this house is a treasure that the nuns left when they moved into town, and that still graces with its tarnished golds and faded reds the deserted church. The Gothic retable, dated 1490, shows on the left side the Annunciation, Epiphany, and Ascension; on the right the Nativity, Resurrection, and Pentecost; in the centre, flanking a niche, four angels; above, Calvary and the Dormition of the B. V. M. In the Predella a *soi-disant* Coronation is really a scene of the Spouse embracing the Beloved, both on one bench, both crowned, with angels making music: this

is followed by the Presentation of the B. V. in the Temple, and on the other side of the tabernacle, by the Visitation and Candlemas. The figures of the Old Covenant wear octagonal haloes. The drawing everywhere is bad and the scenes quaint rather than powerful, but the time-worn colour is pleasant and this little offshoot of the early school of Aragon would grace a gentleman's collection and doubtless will.

Beyond S. Cruz the path, quitting the walnuts of the brook-side, turns up across the great red flank of the Sierra, where crumbling soil is sparsely overgrown with aromatic plants, cistus and juniper and the wild lavender. The lame dog raced ahead, the mules followed the man, and the landscape slowly widened to northward over the white levels of the Aragon until shoulder above shoulder the Pyrenean heights heaved up and snow-wreaths pied their grey. Along a shelf the road was following a gorge and was constructed of loose stones, any size from a man's fist to a man's torso. Rocks bigger than that, the road-menders had cloven into two or three.

Some were of pink marble, others of grey
and purple, and the ocherous soil was beset
with flowers of Alpine loveliness, hawthorn
and wild rose and many unknown: like the
rue-anemone, but pink; like the cowslip,
but purple; and a white flattish blossom
that persisted very high. Going up thus
among the hills was like going up the map:
the northern plants appeared, and we came
out at last, on the crown, through thick
pine woods into what might have been a
clearing ·in the Adirondacks, where the
pines stood more openly in a meadow
of tall grass starred with white daisies.
There is situated the new convent, red as
the mountain side, of little interest, the
seventeenth-century church decently kept
with a Sunday mass; the range of conven-
tional buildings reduced to a single dwelling
habitable for the caretakers, shepherds,
and who not. We were urged to rest and
eat or drink. One asked, by mischance,
for the single thing that taxed the woman's
kindness, a drink of water. Wine they
had and pressed upon us, but the water
had been fetched from far, and was not

with wild flowers

and grasses

purple iris

fresh, and the mistress must be consulted before the maid would pour a drop. In the dark cool kitchen we watched them preparing the family dinner, with a piece of meat as big as your palm. The mistress arriving with keys and water, we set out for another mile, rather to the ill-content of' all the assistants, to find the ancient church. Through the meadow and down a green valley on the other side filled with wild iris we straggled, and feet were suddenly stayed as, across the tree-tops and the thick brushwood, we saw a fringe of

and pine

pines against the sky, a mighty rock, and a little clump of buildings niched under it like a child's playhouse.

One Vico went hunting the deer in the great forest, it is said, and followed hard upon a stag till it went over the cliff, and the horse, reined up, hung there on the verge by miraculous intervention till the prince could throw himself off and crawl down over the rough jutting face. At the bottom he found the game dead, before a cavern, and a dead hermit within waiting for burial, his name written beside

him. Vico devoutly thanked the good Baptist who, himself acquainted with wildernesses, had stood by him that day, and after burying the hermit assumed his place. A brother joined him, and to them came from time to time the Christian chieftains; before them was made a league and a covenant of the fellows and the followers of Pedro Atares: in their sanctuary was founded, it may be, the kingdom of Sobrarbe, which was to bring forth the kingdom of Aragon. What Covadonga is in the west, that in the east is S. Juan de la Peña, and the venerable church is a place of pilgrimage still, sanctified not only by bones of martyrs, but by dust of kings.

It is still, in spite of all, homely and lonely, a hermitage and no more. A mighty abbey rose, and fell apart again, and the shrine under the rock abides. In the entrance court the tombs of powerful feudatories were adorned seven hundred years ago with such patterns, of panther and griffin, as cheap workmen at Jeypore enamel in brass for the tourist to-day. The low little church, without aisles, barrel-

Bones of martyrs

and dust of kings

vaulted, is of no particular style or age, it is mere building, no more. About the twelfth-century cloister, which disdains a vault, for the hugeous rock overhangs it, are set the chapels that devout ages have shapen; one of lovely late Gothic, the arch cusped within and crocketed above; another in the stately beauty of the late Renaissance, with column and cornice, pediment and orb; and the cloister itself barbarously carven with Scripture history after a fashion strictly its own.

S. Juan de la Peña is building of the same sort as S. Cruz, modified in part, first, by survivals of the earlier hermitage, secondly by directly oriental motives, thirdly by its remote inaccessibility, its neighborhood to Jaca, and the presence probably of a body of workmen continuously engaged about the great abbey, who would gradually create a style of their own,—that is to say by a *chantier*. This I have thought to recognize elsewhere, sometimes. It remained an hermitage, occupied by anchorites, till the time of Sancho Garcés I, who organized them as monks cenobite, with an

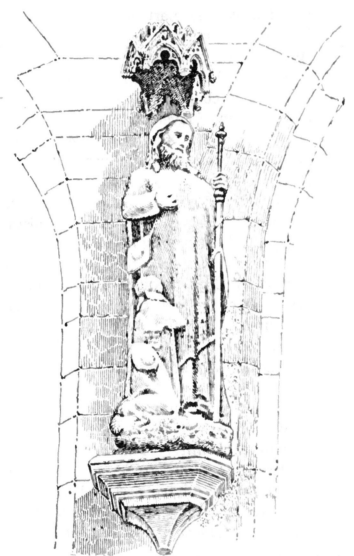

S. James and Pilgrim, from S. Cernin, Pamplona

abbot under the rule of S. Benedict.[5] At the
end of the tenth century the Abbot Paterno,
or, according to some, García, called from
France by Sancho *el Mayor*, introduced
the discipline of Cluny; the monastery,
however, was never subject to Cluny, and
was in some measure under the authority
of the Bishop. When Abbot García died
the king called a Mozarabic hermit, S.
Íñigo,[6] from his cave in the mountains of
Jaca. The dignity of the abbot began
humbly, but came to be magistral, or
equal to episcopal, and could once compete
with the greatest in Spain. He was a great
lord not only in the church but in the king-
dom. Sixty-five monasteries depended on
his, and these not only priories but lesser
abbeys as well. There were likewise num-
bered a hundred and twenty-six secular
churches, among them S. Pedro la Rua of
Estella, of which the prior was a professed
monk of S. Juan.

The tombs in the atrium, while mostly
of the thirteenth century, have among them
dates like 1089, 1091, 1123. In the cloister,
one dated 983 can hardly be original: here

too the inscriptions commemorate abbots mainly of the thirteenth and fourteenth centuries. Sancho Ramírez, we know, rebuilt the monastery and church in the end of the eleventh century; in 1094 Peter I left the siege of Huesca to attend the consecration and, among others, went to it, as said, Bishop Godfrey of Maguelonne.

The body of the little church, as you come upon it descending the glen, looks like no more than a transept, with high, formless wall on either side, enclosing, northward, the atrium and whatever remains of monastic building, and southward the cloister and its chapels; the whole niched under the vast rock and smothered in boskage.

The tiny shrine is roofed with a simple barrel vault and ends at the east in a wide sanctuary cut off by three semicircular arches. This is primitive arrangement, Asturian and Mozarabic. There is little to see; rebuildings and repairs have added nothing new but have left nothing marked.

The crypt below, however, is divided down the centre by a row of piers on which rest true horseshoe arches, and the door which

opens from the church upon the cloister is of horseshoe form, and of masonry different from the wall around. These are remnants of the original cenobium founded in the ninth century by Sancho Garcés. On the other hand, the cloister was not finished until the twelfth.

It lies there, four square, without a vault and without a garden. Of the arcade, two sides are still quite perfect, one has perished completely and been built up with simple brick piers and arches, and into the fourth, that next the church, have been built a couple of capitals quite different in style and half a century later. One of these shows a tangle of creepers and creatures, and the other, griffins carrying off sheep. These are in the same style as the capitals of S. Domingo de Silos, but certainly not by the same hand as that, nor yet as those at Estella, sometimes referred to the work at Silos. The themes are worth recording; they run as follows:

1. On the farthest corner begins a Scripture history with the Creation of Adam,

Rock-roofed and ancient in the sun

and Adam and Eve. These corners, with four shafts clustered against the outer faces of a pier, are very fine; of the rest, the shafts are sometimes double, sometimes single, under a large capital. The history goes on:

2. The serpent tempting, Adam and Eve abashed, God rebuking them. Adam ploughs with two horses, like the men on the mountain below, while Eve spins. The sacrifice of Cain and Abel.

3. The Annunciation, Visitation, Nativity, Announcement to the Shepherds.

4. Angelic warning to Joseph in slumber. Flight into Egypt. Joseph carries scrip and cloak over his shoulder, people look out above an arched gateway not in the form of a horseshoe but one very familiar throughout Spain, in which the abacus projects and the circular arch is set back as far as the line of the jambs below.

5. Epiphany; the Three Kings; Herod's soldiers; doctors pointing out places on the scroll they are consulting.

6. Ruined: there was a castle with a king sitting in it: probably the Massacre of the Innocents.

7. Two kings:—for the rest, ruinous.
8. The Three Kings riding away.
9. Presentation.
10. Temptation.
11 and corner: Two scenes of boats; Christ walking on the water.

The next, the north side, bears on the corner:

1. The Miracle of Cana.
2. Christ and his disciples with staves, in talk, Mary entreating them. Wayfaring theme
3. The raising of Lazarus and the feast in the house of Simon.
4. Entry into Jerusalem, with the foal of the ass, Zacchaeus in the tree, and the gate of Salem.
5. The Last Supper, Washing of feet.
6. Betrayal: the Jews in high caps.
Then a corner, quite different: four saintly figures within scroll work, and on the other face, Christ in a mandorla between four angels with scrolls, whose wings meet and form the edge. Of course restorers have been here, but they were restricted. One may conjecture that the Old Testament series once filled one of the sides now destroyed, and the

Death and Resurrection of Christ, with possibly a suggestion of the Last Judgment, the other.

The work is curious, excessively barbarous, and quite individual. I am tempted to associate it with the more archaic portions of the other great work at Estella, the portico of S. Miguel, but only after a long interval. Here at S. Juan the modelling is done at times with little more than incised lines; the hands as well as the heads are too large for the figure, hair and beard are indicated by curving parallel lines. The high cheekbone is emphasized by a special line, and the eyes, in Scriptural phrase, "bung out," the socket deeply hollowed and the eyelid and pupil carefully worked on the bulging feature. In spite of all this, the scenes have not only dignity but feeling.

These, it is tempting to associate with the early Lombard sculptures, at Cremona and elsewhere.[7] There is likeness to the Ferrara figures on the door jambs, where Master Nicholas worked. It would be possible, of course, that the messengers

constantly going and coming between this
powerful monastery and Rome, should have
fetched a master workman as they returned
through Lombardy. The relation was close.
In the great struggle to suppress the Moz-
arabic use, that is to say the Hispanic, S.
Juan played a great part. "The Roman
use was introduced into Spain," says
Sandoval,[8] "from S. Juan de la Peña, in
March on S. Benedict's Day, era 1071
[that is, 1033 A.D.], the Roman legate
fixing himself there." It is, indeed, more
likely, on the whole, that the model should
have come from Italy than that the lonely
mountain abbey, where all the architecture,
while sound and strong, is of the simplest
and of the region, should have supplied
masters to Lombardy and the Emilia. A
chantier once established — and we have the
opinion of Sr. Lampérez that the convent
and its dependencies were building steadily
from the middle of the eleventh to the
middle of the twelfth century — the style
would develop with little modification
other than refinement and growing power
to express beauty on the one hand, and a

of the
chantier

constant approach to nature on the other.
We may, provisionally, discuss this style
as if it commenced where we find it first,
at S. Juan.

The two capitals compared with those of
S. Domingo de Silos must be treated apart.
They are probably from another and a
later cloister, the sole remains of it. The
work is ruder and less lovely than that at
Silos: for instance the locks of hair curled
at the tip on the griffins' back are more
summary, less oriental and exquisite than
the lions' manes at Silos. There is a
capital at S. Eutropius of Saintes, of birds
pecking at monsters, which, though with-
out *entrelacs*, is identical in the forms of the
birds, and uses precisely the same detail to
express respectively the long quills of the
wing and the short feathers of the body
and tail. The capitals of Aulnay are of
the same sort: now the church of Aulnay
(1135) lay on the pilgrim Road and S. Eu-
tropius of Saintes (consecrated 1096) was
one of the great shrines for veneration.

These capitals could have been, at best,
oriental only at second or third remove,

but the tombs of the *ricos-ombres* in the outer court have devices directly borrowed from the East. The tombs are mere semi-circular pigeonholes in the bounding wall, hollowed to hold a few bones or a handful of dust; the arch of the upper range decorated with a chequer or billet, that of the lower with the hollow and ball that appeared at S. Cruz. Within this lunette a central disc is adorned with arms, or an elaborate cross, the chrism, a griffin enclosed by a twist, a lion or panther in a border decorated with eight spindles: these came directly from the East, and the daisy dropped at S. Cruz came with them.

Here, then, in and near Jaca, we have a strong Romanesque style of building that appears as nearly as possible autocthonous, and a type of decoration that goes with it, developed in part, probably, from the Roman and, in part at least, drawn from the general stock-in-trade of Romanesque builders. In Jaca cathedral there is little else. At S. Cruz there is a hint of French masonry and an Eastern decorative motive. At S. Juan, superimposed upon the Spanish

Traits oriental

and regional

French

building and possibly later than the Eastern trinkets, persist the remnants, scanty but sufficient, of work done in the manner of Aulnay and Saintes. I should add that the carving of the abaci throughout the cloister has the direct and vigorous forms of the French work cited, and not the more flowing and luxurious grace of those at S. Domingo. Finally, something Italian-seeming must be admitted.

Italian

The good woman jingled her keys, the guide expected us to remember that he had not breakfasted; we left the ancient walls, where decay has been just decently arrested, to their proper quietude and, recrossing the brook and climbing again the steep path through thickets, sat down in the convent orchard to eat the luncheon we had fetched and go to sleep, face down in the grass, thereafter.

Returning

When we awoke it was not much past noon, a storm-cloud was pouring over the farther mountain range, and the guide consented to start for home instead of waiting, as stipulated, till four o'clock. The kindness nearly cost him an apoplexy.

The heat was superb. There is no other word for that air of the Spanish noontide which is like brandy in your blood: dry, white, thrice distilled, you draw it in like a perfume, you absorb it like an intoxicant.

The mules, after their kind, walked among rolling stones on the extreme outer edge of the mountain side; the tree-tops danced below. The Pyrenees were vaporous. The intervening air boiled as above hot metal. The lame dog who looked like a wolf raced ahead, dug himself a cave under the shady side of some brow or knoll ot clay and lay in the cooler redder earth till we had gone well past, then dashed ahead again. After we repassed S. Cruz we found the horses again stepping and stumbling down the brook, each with a log banging at his heels: noonday rest was over. By the grange men were piling logs again: we drove back to Jaca in the dust that choked like soot and arrived in time for tea and a long sleep before the long dinner and the walk thereafter to a bit of park along the water-side.

the tides of the day

changed

Alfonso el Batallador.

While kings of eternal evil
Yet darken the hills about,
Thy part is, with broken sabre,
To rise on the last redoubt;

To fear not sensible failure,
Nor covert the game at all,
But fighting, fighting, fighting,
Die, driven against the wall!

García Íñiguez was ruling his kingdom of Sobrarbe when he took Pampeluna from the infidel. The county of Aragon lay between the two streams called by that name; one comes down from Canfranc and the Pyrenees, and runs on one side of Jaca; the other comes down from the Port of Hecha. The first count, D. Aznar, of great lineage, was serving under D. García at the siege of Pampeluna and was sent by him with some companies of men of that country to the city of Jaca. The Moors were not expecting attack and it fell as soon as Pampeluna, in the year 759. Others say that he came in from France with his vassals and took it, and then García, pleased with his valour and nobil-

Vive con noble osadía . . .

ity, gave him the title of Count of Aragon.
Jaca is a city on the slope of the Pyrenees,
in antiquity inferior to none in Spain.
It was *muy venturosa*, more than any other
in Spain. As it was the port and entry of
France, the next year four kings and an
immense army came up from Navarre and
Sangüesa to retake it. Thanks to the
women, they did not. The *fuero* of Jaca
was probably given by Gelindo Aznar, the
second count of Aragon: so given, because
the Goths had prohibited the imperial (i.e.,
the Roman) code. Sancho Ramírez in
1073 did not change this in any wise: he
kept the Gothic code, he did not impose
the imperial: he owned no lord in the
world but the Roman pontiff. That last
clause will bear discounting — it was
written by an ecclesiastic in the seven-
teenth century.[1] Actually, belike, the
Roman pontiff got what was left after the
Lion's share had been measured.

Alfonso Sánchez, his son, the second
Alfonso, who was to be known as *el Batalla-
dor*, the lord of battles, was born at Hecha,
in the mountains. There the lords of

The Happy Warrior

Aragon held always royal hunting lodges, and kings had their sons brought up there because the cold clear air, on the very peak of the Pyrenees, made them strong, robust, and soldierly. At the age of seven years, or possibly of ten, he was put in charge of a monk at S. Juan de la Peña; the abbot named for his tutor D. Galindo de Arbas, prior of S. Salvador de Puyo, who took Alfonso with him and taught him grammar and the other humanities. This the king recalls in a privilege dated 1108. He was to be, always, a great gentleman and a great soldier. He was crowned at Huesca, and on the same day, a Grand Rabbi of the Jews there, was converted and baptised, the king standing godfather; in 1106 he stood godfather to a greater convert, that Petrus Alfonsus who composed the *Disciplina Clericalis*.

As his name reveals, he was born to be the Happy Warrior. Mariana calls him a great captain in soul, of valour and fortitude unparalleled, the glory and honour of Spain. He shared all his winnings with God; he was generous, pious after his kind,

. . . parte muy principal

and strong as his Pyrenean rocks. To the
brother whom he succeeded, and to the
brother who succeeded him, he was staunch
and generous, giving all the service that
they asked: fortunately, this lay in the line
of right conduct, and their careers, if not
unshadowed by personal grief and regret,
by too early death, and a vocation re-
nounced, yet never ran counter to the
glory of religion and of Spain. To hold
up Spain with a strong clasp, and to put
the fear of God into the Moors, was D.
Alfonso's concern: God gave power to his
arm, and strength to his party. In the
unhappy matter of his marriage with Doña
Urraca, he seems to have acted like a
gentleman and a king, never letting per-
sonal relations override political. The
heiress of Galicia, Leon, and Castile, part-
ly in her own right, partly in transmit-
ting that right to an infant son, Doña
Urraca had the same virile strength as
Queen Blanche and Queen Berengaria in
the next century; but she had not their
austerities. Since she allowed herself the
same liberties as a man, it is small wonder

*de las
glorias de
España..*

so, Flórez

that her husband treated her with the same directness as a man. In the west her matrimonial difficulties were made the excuse for faction and rebellion: in the east, his matrimonial connexions gave a good ground for conquest and annexation. In the *Historia Compostellana* D. Alfonso is painted with horns and hoofs; in the *Chronicle of S. Juan de la Peña*, Doña Urraca is a scarlet woman.

Roderick of Toledo, who must have known some who had known him, has only good to say, calling him in the *Chronicle in Romance* "a very Catholic prince, a constant benefactor of the religious, who lived always in a fervid zeal to increase the faith of Jesus Christ and continue war against the infidel." No other king of Spain had conquered so many lands from the Moors, nor entered so many times in battle with them, and always triumphed. He took Valencia; he took Saragossa, esteemed impregnable since Charlemagne's vain exploit and tragical retreat. His brilliant raid into the south did, probably, all that he expected and more. We know, through the re-

luctant admissions of Ibn-aç-Çairafi of Granada, how the Christians called him down with the offer of twelve thousand warriors to help him, and among their names not one a boy's or an old man's.[2] Coming in September of 1125, he spent a year and six months harrying the fairest lands of the Hagarenes, along the east coast and throughout the south. His expedition supplied a kind of counterpart, a *revanche*, for that of Almanzor, in the north, a century and a half before.

Queen Urraca had just died, in childing of a bastard, say some chroniclers, but she was to have her revenge of the husband she had so hated. It may be that the poison she brewed for him had done some work, had touched some cell in the brain or twisted some fibre. A curious unexplained incident recorded near Malaga is just tinged with the fantasticality that passes over into fatality. "He had a little boat built," says the Arab, "and caught fish which he ate." It seems to come straight out of the Third Calendar's tale in the *Arabian Nights*. Was it done for a vow,

or, as his enemy prompts, to be talked of afterwards? His wit and judgement had not failed: when they were passing the defiles of the river Salobreña he glanced up at the cliffs and said to one of his knights (a sheik of the country heard and reported): "What a tomb, if anyone above threw down sand on us!"

After conquering Saragossa, Tarragona, Calatayud, and Daroca, and generally speaking all beyond Ebro, he turned toward the confines of Catalonia. He took Alcobia and laid siege to Lérida, coming down the Ebro in galleys: for the Ebro used to be navigable, in Vespasian's day boats went as far as to Logroño; in the fifteenth century, they could still get up to Pampeluna. Lérida did not fall, and he threw himself into Mequineza; then in August of 1133, leaving that high-towered castle in good hands, he came out and attacked Fraga. Winter came, with great cold and excessive rain: he had to send the army home, every man to winter in his own house. Again he tried the siege in February and in April. Then Valencia

Roman galleys on coins already

was lost. Battle was joined on July 17th, and the king was killed. The Black Book of Santiago says, under the feast of SS. Justa and Rufina: "Era 1172 fuit interfectio Christianorum in Fraga." Compostella would be glad, for Galicia had, on the whole, backed Urraca, or at any rate regarded the recurrent difficulties with her like quarrels in the family. The great archbishop, out there, was dying like an old lion among jackals: the news must have struck on his heart. "But indeed," old Briz Martínez says,[3] "when he died it was as when a tree falls, any man can hack at it, however once prized." He had lived too long, and his star had over-watched the ascendant by an hour. That is the life of many men; perhaps, if truth were known, of all except the early dead. The wheel of fortune that turns so slowly and never stops turning, that brings a man to the topmost pitch, will swing him down again unless Death cuts him loose. The Happy Warrior is he full-armed and dead in the morning of battle. Men never found Alfonso's body, or his royal arms or a sure

When D. Alfonso died

sign of him: and there is another story of his end which belongs to S. Juan de la Peña.

Hither at the last, in September weather, had come *el Batallador* from the defeat at Fraga, to die. He had conquered Saragossa and Tudela and Bayonne, he had helped the Cid at Valencia; for thirty years he had been winning, and had taken many cities, and now the tide had turned. He got off his horse and went to his bed. On the morning of the seventh he bade close all the doors of the monastery, and so he died. What was the thought in all that bolting and barring before the end? Not against powers of this world, one fancies, but against elemental, and the powers of the rock and the air, and the prince of the powers of the air. Or was it the desperate determination not to die, to imprison still the escaping soul, and catch and cage it yet? By his will the kingdom was to be shared among ghostly warriors who were trained men-of-arms, knightly monks, who could count on having God behind them, the Order of the Temple, of S. John of Jerusalem, of the Holy Sepulchre.

Coronica General cap. 966, f. 261 v. Some say he lived on as pilgrim

So passed the grand fighter, but the memory of him stirs and wakes at times in Spain. Of such great figures of the Middle Age as this Alfonso, and Doña Urraca his spouse, Ferdinand the Saint, and Diego Gelmírez the prelate who so nearly was another pope, I can evoke only a cloudy and fleeting image, a flitting shape, a shadow on running water. But of their presence is ever aware the pilgrim in Spain. There is an ancient legend, told in many lands, of a traveller falling asleep in a plain or a valley or on a hillside where once was fought a battle: how in the night under the sailing moon he hears faint tramplings, the neighing of horses and trumpets blown, steel clanging, and heavy bodies falling, or he sees at such times the pale wraiths clash and strive and lose at the last all soundlessly. And when the sun is up again, the dew hangs strung on gossamers, in her quivering spires the lark trills, the tall seeded grasses wave in the freshening wind, yet unfallen.

Shadows of smoke

on running water

III

THE BATHS OF TIERMAS

*D'ailleurs, voyage t'on
en Espagne ? Au fond on
y fait plutôt des pèlerin-
ages.* — Gómez Carrillo.

At Jaca we watched the young nobility
of Spain training boy scouts: we paced
the grey flagged streets between the grey
stone houses: we sat in the cathedral, early
and late, but, though cool and grey, it is not
so good as some for sitting in. The *Coro*
takes up too much room. All the cen-
turies have bedecked and bedraped it, not
so ill neither, and it is a comely, friendly,
experienced place, not moving or edifying.
At the last we climbed a ladder and sat
down on the top of another yellow motor-
omnibus bound for Tiermas.

The road, tree-planted, follows the river

westward, all the way. The cities sit up on hills; you see them from far, and pass them, and see them far. Berdun, which is one of these, boasts a great church dedicated to S. Eulalia, but Aymery Picaud knows nothing of it, nor do I. The wide white plain is bounded by blue mountains that hardly change; the vast blue sky is strewn with white piles of cloud that sail and sail; the car climbs hills at full speed and swings around curves like a boy's sling, and you know that if it skidded you would be slung into the next kingdom like a boy's stone. When a shower passed over we pulled a rug over our two heads: the car sped through it and into blue again. In one place an old man in a wide hat was raking up and turning in the sun a square yard of daisy heads, curing them for I know not what *tisane*. Elsewhere two old men went down a road dangling empty wine flasks, their white shirt sleeves, their alpargatas and white socks and long black stockings, their broad black sashes and velvet vests, the dress of Aragon. The Sierra on the south approached, the river

Set on a hill

thermae

bed on the north widened; its sandy banks
between the shallow pools were not more
arid than the land on either side, just
diversified with purple pebbly rock and
grey aromatic shrubs, rosemary, juniper
and cistus. The great back of a hill lifted
a few grey houses against the windy blue,
and around the curve of it we drew up at
the Baths of Tiermas.

These *thermae* the Romans knew, and
bequeathed a name and an old red
porphyry tank, no more. The charm of
Tiermas is older than they, is old as the
elements. The landscape is like that of
the Sistine *Creation of Adam*, but the
ringing sky and the clear wind are older
even than the rocks and marl, are ageless
and immortal.

It is hard to tell another what we found
in Tiermas to like it so. Not, surely, the
sulphuretted hydrogen of the waters, which
flavoured the drinking and the cooking.
The very pillows and table-napkins tasted
thereof. The inn at Jaca had been excel-
lent after its kind, and that a kind which
while entirely Peninsular was for goodness

almost European: we liked it well enough. I dare say if we had stayed, in Tiermas, at the new large hotel across the tiny square, we should have been merely bored and impatient with the wide shady hall and wicker furniture, with the private chapel for the convenience of priests stopping at the house, and the upper gallery, yet more private, therein, for the reserve of great ladies; with the airy dining room and its conventional little tables and conventional long meals. But after reading the tariff painted up on a board in plain view we crossed over to the Old Inn. They took us up, past the steaming stone tanks of the basement where you sat to soak in the very troughs of a thousand years ago, down long whitewashed corridors that recalled the Springs of the last century in Virginia, into a pair of huge bare rooms, scrubbed and empty and airy. You saw outside the windows a clean sky piled with white clouds, and the vast heave of a hill where a thread of road crept and wound and men and donkeys crawled up at nightfall to the ancient town and trotted

The Old Inn

down in the early day; and all night a few lights pricked through there like low-swung stars; and you heard a tree below in a courtyard, rustling softly.

We ate plain meals, but well-tasting, at a long table with casual men travelling, like ourselves, modestly; and with the housekeeper and the bookkeeper, who, not thinking themselves too good to sit down there, maintained decorum and interest in the talk. Provision was made, in the explicit tariff posted in every room, for travellers yet more modest, who brought their own provisions and had the use of a kitchen granted. The card also enumerated the meals to which *pensión* entitled one: a good early breakfast, or, if one was not used to that, then a substantial *merienda* (in American, "snack") at ten o'clock; *almuerzo*, as big as a dinner, at one; at five chocolate with *azucarillos* and a glass of water; dinner about nine; and I believe a snack at bed-time, which occurred somewhere after midnight, but we never waited up for it. It could not have been the friendly insistence on chocolate the instant

Why we liked it

of our arrival, the cold water and the *azucarillos*, so delicious when we were dusty and faint. Perhaps it was the space within doors and without, that we so loved, or the wind that blew out of the clean spaces of the sky. There never was anything like this wind, not even that which blows on a hot day after strong rain.

The wind of the world

There we rested: I remember that I read the whole of *The Golden Ass* in old Edwardes's version, where the quaintness decently disguises the indecency, in the long afternoons, in the big silent room. We sat on the sun-warmed rocks by the roadside in cool twilights that evoked all the aromatic scents, making friends with a pair of silly brown sheep that regularly forgot us over-night; looking over at Monreal, away down stream, situate on such another hill, brown against the blue mountain.

One morning we climbed to the ancient city above us, to find no more than the ground plan of a castle that a king's and a cardinal's jealousy had ruined; and the shapeless form of a church that Jesuits'

piety later had erected and deformed with a baroque altar-piece. Considering the date and the general formlessness of the brick agglomeration, it was curious to see, notwithstanding, all the members of Jaca cathedral here: the open southern porch, the western tower, the shallow transepts and low square above the crossing; only here the apse is square-ended like the other terminations. Above the church porch, reached by a fine flight of steps, is a little apartment, inhabited. I have seen the same at S. Ciprián in Segovia, and at Fornells on the Catalonian frontier. Of the deliberate desolation of the town in the sixteenth century I spoke too hastily: one of the town gates does survive, built into a house, and through it the winds blow. In the view the Sierra de Leyre rises grandly, wooded chiefly with scrub-oak up the side and topped for uncounted miles by palisades like those along the Hudson.

Another day we pushed up into this sierra in search of the venerable abbey of S. Salvador de Leyre, motoring for about an hour along the highway to Yesa, there

taking a couple of donkeys and old women
and at the church dismissing them with
half a notion of walking home across
country. But we did not risk it, for that
the way dipped down at least twice out of
sight of landmarks, we could clearly per-
ceive, and that the land was cut up with
sheep tracks and the little foot-ways by
which each man goes in the morning to
work his own patch of mountain ground,
the long plough lashed upon the donkey's
back, and comes home at night with a
stack of green fodder piled above it.
Therefore we walked back as we had
come, to Yesa, over stony land like mons-
trous pudding-stone, and disputed the way
with a brook or two, and soaking springs.
Awaiting the motor, we made friends with
the men, who hardly at all mistrusted us;
the women who gossiped, an hour at a
time, with a water-pail like a churn borne
easily on the head; the children who were
dressed like old women and like them
covered the hair, tying a kerchief under the
chin. We saw trains of mules go through,
and again loaded waggons, three or four

. . . And
to his
labour
until the
evening

together, and everything stopping at the toll house to pay according to its value. We sketched, I recall, an old wrought iron knocker, on a street door. The church had no interest to offer, in whitewashed nave or blunt tower. Not one house in the village possessed a pane of glass: wooden shutters closed the windows at need.

Protective colouring

These brown Spanish towns have the same trait as some birds and insects and even furry things, of protective colouring. Without contour or colour to distinguish them, they disappear into the landscape at even a little distance. Men were building that year a road for automobiles to go up to S. Salvador, so for those who read this there will be no more of grey donkeys and stony tracks.

Leyre.

Heureux qui voyage On y prend passage
En ces lieux bénis: Pour le Paradis.
 — Hymn of Lourdes.

Many pilgrims must have visited the abbey, for it is very venerable and lies

only a few miles above the ancient track, yet none brought such gifts as they left in towns along the Way. In Navarre it lies, just over the frontier, but I find it called in old histories court and heart of the realm. At times it was the seat of the diocese now named of Pampeluna, and for long it held a right that the bishop should be selected from thence. It lasted for at least a thousand years; S. Eulogius visited it in 851, and it was not burned till 1835. The wealth was unspoiled until after the seventeenth century. The range of the eighteenth-century monastery, roofless and empty-windowed, dominates the plain front of the church for a long way up the road. A donation signed in 908 still exists, but the foundation is older, for Íñigo Arista we know restored it, and the present crypt, I am pretty sure, belongs to his restoration and therefore to the ninth century. Benedictines had been fetched to it, from Cluny, before 1022. In 1090 Sancho Ramírez conceded to it the exemptions of Cluny: he had then probably commenced the upper church, for under

the reign and in the presence of Pedro Sánchez his son, Peter I, the consecration took place in 1098. [1]

Present likewise was Bishop Diego of Santiago, his own church being well under way and the decoration in the hands of workmen of the same school. The work at Compostella is very different in quality from any here, that is to say, in beauty absolute; it is less archaic than some on this portal and purer and earlier than the rest. A chance such as this for the student to make comparison is precious as rare.

The church then consecrated must have consisted of three apses, circular, and quite plain without; and then two bays of barrel vaulting, the aisles excessively high and narrow. On the western face of the last pier are attached shafts, their capitals in the same style, as if in preparation for continuing a nave that was never to be built. Possibly this eleventh-century building had actually a nave, later to be pulled down: possibly the western door was commenced early and duly reared but the junction with the choir never effected.

The Bishop of Compostella

In 1230 the Cistercians were introduced:
"because of abuses," says a historian.
Benedictines dislodged them from 1270 to
1273 only, then they returned for good,
and some time thereafter built the present
nave of a single great span. In style the
building, says Sr. Lampérez,[2] is Poitevin
of the most archaic, and it belongs to the
eleventh century; the Cistercians length-
ened, raised and vaulted it. This great
span excels as a wonder that which at
Gerona Guillermo Boffy planned in 1416,
and precedes it by a generation if not two.
The vaults are of the fourteenth century
indisputably, and should be compared with
those of the church of Ujué in Navarre.

The portal as it stands was put together,
largely out of earlier material, in the four-
teenth century. The grotesques, which cer-
tainly are not earlier than that, are curi-
ously crude, not so much barbarous as pue-
rile. Like *S. Juan de la Peña*, S. Salvador
lay out of the world, out of the main
stream, and there is danger of dating every-
thing too early and mistaking archaism for
age.

It is impossible, for instance, to admit that the figures in the tympanum belong to Carolingian times, that is to say, to Íñigo Arista's building. They are of the school of Toulouse, and they are provincial imitations of work accepted and mature. We have no dated work in Toulouse earlier than S. Sernin, consecrated 1098. The figures of Christ and the angels built into the choir enclosure there, show how that art began: these at Leyre show how it could end.

Similarly in the crypt the capitals are quite literally barbaric, carved chiefly with parallel grooves and spirals that may be intended to imitate the Ionic volute but curve the wrong way. Madrazo gives some drawings of these.[3] In France, I think the capitals cited by Courajod[4] without a date in some remote Breton churches, may be of the same kind; and those of the ninth century at Cruas, in the Ardèche, though better, suggest them.

The division into nave and aisles, in the lower church, is further complicated by a row of shafts and arches carried midway

down the nave and even through the apse of it; and another transverse row, which makes four bays in all from east to west. Owing to the fall of the ground, the apses of the crypt open well into the light, as at S. Martín de Unx, in Navarre, at Saintes and Auxerre in France and in so many other early Romanesque churches. The low arches, stilted, carry a barrel vault, and inside the arch of the main apse are cylindrical shafts of which the capital is merely a larger cylinder incised with a few lines.

In the early part of the upper church the capitals, while primitive, do not lack grace. The arch of the aisles is very stilted and at the entrance to the apses stood a shaft under the arch; this was cut away at some period to accommodate retables now perished but luckily the capitals were left. The barrel vault of the aisles is much higher than the nave arcade, a curious trait which may be associated with the same relative lowness of the arches between nave and aisles in such pre-Romanesque churches as *S. Juan de Baños* and *S. Salvador de Val-de-*

Crypt

and east end

Dios. At any rate, some account must be made out for it, considering the uncommon height, normally, of the nave arcade in those churches of Poitou which S. Salvador most recalls. The interior, if the nave as planned originally was ever done, would have looked like those of Chauvigny and S. Savin, or S. Hilaire of Poitiers which certainly was, after a fashion, completed, with the same exceeding height and exceeding narrowness, and with a timber roof, by the end of the eleventh century.[5] The great difference between the French churches and this lies in their acceptance of the ambulatory chapels: but the S. Hilaire consecrated in 1049 had a great apse and two small ones eastward of the transept, and the present arrangement belongs to a reconstruction in the twelfth century when the edifice was vaulted by an architect who seems accountable for the present absurd arrangement in the nave, as well as for an ambulatory with four chapels. The piers there are cruciform, a three-quarter column on each face, so also at Chauvigny, which lies on a frequented

road. Half way between there and Poi-
tiers, S. Julian had a shrine. There was a
straight way for builders to come, sum-
moned or on the tramp.

The nave, only two steps lower than the
older part, consists of three bays of fine
ribbed vaulting and one, narrow and a trifle Nave
taller, at the western end. Like the Poite-
vin churches of a single nave, it has strong
round lateral arches against the wall, and
on the south, in the first bay, another great
round arch, higher, that springs from about
the springing of the present vault. In that
same bay, on the north wall, is a good late-
pointed window of two lights, cusped, under
a cusped triangle, and this bay ends, on
each side, with a shaft against a pilaster,
as if there had been an intention while the
walls were going up to continue the eastern
part. In the next two bays a round-
headed window comes just under the la-
teral arch on the south side, having one
shaft in the jambs and beautiful fantastic
capitals, one of birds with their necks
interlaced. A similar transitional window
in the west wall has, however, early Gothic

capitals. In the south wall a very beautiful little door that opens into a chapel led once to the cloister: the head of the round arch is strongly moulded, the tympanum carved on the outer face with the labarum in low relief; the capitals of the three shafts in each jamb are adorned with plant forms stylized without loss of feeling for the pine-tassel and cone, the young shoots of the vine, and others.

A long day Of the portal I am entitled to speak in some detail, as to iconography and style both, for I spent the best part of a day in watching it. At the convenience of the motor omnibus we had set out in the sunrise and were to return at dusk. We had inspected the church exhaustively, and the crypt and the capitals and the mouldings and the vaults. We had raised and laid again all the probabilities of date and provenance, and photographed everything accessible. Jehane has a nice sense for the look of a century, which she educated long ago at the Museum of the Trocadéro; her rough guess is always suggestive. The old women who had peered and lis-

tened after us went home again, and there was nothing to do but watch the portal and as the sun moved try another photograph. We lunched on potato omelette and cold breaded chops; Jehane slept on the grass and woke and consumed such of the chops as remained and wandered off to exchange amenities with the caretaker, her dog, and her donkey: I had nothing to do but look at the portal.

The convent of Leyre was planted on a spur of the great sierra which runs off at about half the height, on the very spine or ridge of it, so that eastward the windows of the crypt look into the sun over falling gullies and copsewood, and at the west a narrow terrace, well shaded with holm-oak and walnut, is sustained by a low wall of stone. Over this you may lean and, looking over plantations where once were forests, even into the kingdom of Aragon, rest at last upon the bare flanks of the Pyrenean outliers. Opposite the portal this wall swells into a hemicycle and receives a stone bench: lying there in the sun waiting while the shadows moved, in

Windows that look into the sun

the quiet of a land inhabited, while the insects sang a tiny tune from which you missed the constant thrill ot the cicada, where danced the blue-mailed flies, the gossamer-winged gnats, while a dog barked far away, I thought of the abbot Viril.

In his day the whole mountain side was thick forest, and the tiny church which he knew, and the cluster of cells, was walled in, houses and herb-garden, against the wolves. From this station he looked out on the heaving top of a vast wood, that filled the valley except where the white road ran, and the river's course was marked by a brighter green. It is said that one evening at the hour of recreation, Viril went out the convent gate and down to a clear spring, under a rock, in the outskirts of the wood, pacing quietly, breathing the evening cool and the grassy sweets, but troubled in mind. If Heaven were indeed all music, eternally prolonged, he had an instant fear that one might, in the end, be bored. This was right Spanish, the ennui and the orthodoxy both. The shocking thought would not away, and the good

old man was mightily perturbed. Above the spring a little brown bird on a bough sang and sang, now so softly, now so rapturously, that he stayed his walk. It sang, may be, three minutes and then spread wings and flew away, and the abbot turned back, for night was thickening under the trees. His sight was troubled in the dusk, for when he reached the convent gate he hardly knew it, nor yet the porter's face, and the brothers, coming in from recreation, looked unfamiliar. They stood about staring a little silently, and one said a word about calling the abbot, and Viril said, quite gently, that he conceived himself to be the abbot, and they fell silent again. One who had slipped away came back anon, bringing the abbot and the old, old monk with whom he had at the moment been engaged. This one it was who remembered in the puzzled talk that followed, to have heard long since how three hundred years ago an abbot Viril, going out at twilight, had never again come in: for the three minutes of the bird's song had been three hundred years.

"O grey-brown bird!"

So Viril was assured of the joy of heaven and in three days, having received the sacraments, his soul passed thither and his body was buried beside the dust of his old monks. [6]

Three bright flies, in metallic armour of blue and green, hung in the sunlight. Yes, that is Spain, the thought went on, you listen to the magical bird's song, and the sound of it is never out of your ears again.

There is a poem by Sung Chih-Wên, I recalled, to the same effect: then *In the court of silent dreams* I lost myself again.

Little by little in the changing lights details became clearer, figures grew recognizable, intentions defined themselves. It is highly convenient to go to a place in your own automobile and when you have seen enough to go away again, but to stay there much longer than you like is more instructive.

The whole portal, seen from far, is merely a projection on the flat face of the church. Pious hands have screened the worn sculptures with a bit of penthouse roof, otherwise it is as the last rebuilding

left it, six hundred years ago. The rather low arch of the tympanum encloses six figures and the traces of a seventh that were made for some such place but are merely built in here. They are of the school of Toulouse, and represent Christ blessing, with a book, between SS. Mary and John, SS. Peter and James also blessing and with books, finally, in the left-hand corner, a little seated figure writing on a tablet with style in one hand and eraser in the other, as in the miniatures of manuscripts a scribe is figured. Unluckily his head is gone, and the whole of his mate at the left. Madrazo[7] would have these figures to represent, besides the Saviour and His mother, SS. Nunila and Alodia, VV. MM., on her right and His left, and SS. Viril and Marcián at the ends. The last two identifications may be right, the other figures, however, are not meant for women, but, one of them, for the Beloved Disciple beardless and bareheaded. Madrazo also says[8] that Ceán Bermúdez read on a stone on the north side, "Magister Fulcherius me fecit," but does not care to admit that it

SS. Peter, James, and John

could have been right since Fulcherius or
Foulques would be a Frenchman. There-
fore he would amend Fulcherius and let
the unknown architect take his chance
with a Roman name!

The archivolt includes three main sculp-
tured orders with decorative moulding
between, and a broad billet outside; of
these, the innermost is decorated mainly
with plant forms, the next two with gro-
tesques based mainly on animal forms, lastly,
a broader row no less grotesque, of which
some details are masks and some are mon-
sters but most are human. a man hugging
his knees; and some musicians, one with
fiddle, one with harp; likewise a man
supping out of a pot with a long spoon, as
the proverb says in certain circumstances

"—who
sups with
the devil
—"

you must. I conceive all of this, like a
certain leaf or shell pattern (recalling the
wild mallow of garden paths) which runs
through the reconstruction, bordering the
tympanum, for instance, and decorating
the abacus of one of the jamb shafts, to
be of the fourteenth century. On each of
the flat buttress-pilasters that flank the

jambs, stands a saint, a lion above him
and another under his feet. The lions are
Lombard-looking, one eating a sheep; the
figures Toulousan. So are the capitals,
carved, two with birds, their necks inter-
laced, or with animals, one being early
Gothic. Finally stretched across the top
of the projecting mass of the portal, and
filling the spandrels, are figures and parts
of figures remotely Toulousan, left from
an earlier façade. On the capital of the
central shaft, which is formed by four
seated men, the drapery is very finely
worked and reminds me on the one hand
of the seated Saviour at Avila, and on the
other of the zodiacal figures at Toulouse.
I conceive this capital to be a bit of re-
pairing, done by a master passing who
was familiar with Languedoc and Castile.
Heads of the evangelical lion and ox jut
out as if to support a lintel.

In the mass of sculptures built about this
arch, not all are plain, but some are un-
mistakable: chief among these, in the left-
hand spandrel, the great S. James with his
staff and book. A head alongside seems

The Trans-figuration

that of one dead or sleeping. Above, in the row of statues just under the cornice, you have, first, S. Michael (or possibly S. George) with the long triangular shield of the twelfth century, trampling upon the conquered dragon's scaly folds, then, blessing, the Christ of the Mount of Transfiguration, between the chosen apostles. Two of these have beards curled and parted, like those of Toulouse; the third, the Beloved, is again young and beardless, and points to his book. In a triangular space on either hand, near the summit of the arch, angels are trumpeting to Judgement through great olifaunts, and above them, next the young S. John, are, amongst others on a smaller scale than heretofore, a couple of women whom I take to be of the risen righteous, and a man in pilgrim cloak and sun-hat, in suppliant posture. On the northern half, which is the Saviour's left, you find hell-mouth, figured as a gigantic mask with eyes, ears, and ribbons dangling down from the lips: a devil points it out to a man. Jonah lies under his whale, which is curved like a dolphin.

Into the remaining space on this side the Annunciation and Visitation have been tucked away. In the former the angel, in accordance with Byzantine iconographic use, has one wing folded back over his shoulder like a cloak, and the other stretched out behind his outstretched hand which holds a cross — a beautiful bit of symbolism that I do not recall elsewhere. Over the Visitation broods the Holy Ghost.[9] The women wear hanging sleeves with a close wrinkled sleeve below, and veils drawn up about the face to form a wimple.

The Annunciation

Now for the interpretation of all this. The early church was Poitevin in style, as shown by the great height and narrowness of the aisles and the use and proportions of the longitudinal arches. Churches of this type have room for much sculpture on the façade, even for several distinct themes; *Notre-Dame-la-Grande* accommodates more figures, and more apparently confused but really coherent symbolism than this of Leyre could ever amount to. In a church dedicated to S. Saviour the patronal

The Key

feast is kept on August 6, the Feast of the Transfiguration, and the scene upon Mount Tabor belongs therefore among the sculptures. The reader may recall that at the cathedral of Santiago at Compostella, Aymery Picaud saw this same Transfiguration occupying the west doorway, whence it was displaced by Master Matthew's Apocalypse, and a motive somewhat similar in the face of the south transept above the doors, Christ and S. James; the cypress of the mountain and Abraham who awakens for he has seen the Day of the Lord. The head I noted here at Leyre, I take to be Abraham's.

The theme of the Last Judgement was firmly established in the south by the middle of the twelfth century. At Beaulieu, at Autun, at Espalion, the angels are trumpeting and the dead are rising. Jonah appears here, fantastically indeed, but no more irregularly than on the pulpits in the south of Italy, to enforce the great mystery of the Resurrection. Lastly, somewhere among the innumerable arcades of this

The cypress

The whale

style room was found, as at *Notre-Dame-la-Grande*, for the joyful mysteries of the Incarnation, the Angelic Salutation and the Magnificat. These all belong to that church of which just enough was finished tor consecration in the last year ot the eleventh century, to permit the daily Mass and the monastic office. It may be that the saint upon the south jamb, and his fellow, quite worn away, on the north, are a trifle later in date than the mass of the work, and that the figures in the tympanum are not only more archaic but actually elder. The same difference of date among statues of a single fabric is noticeable at Compostella.

What I have shown is that the carven work here at Leyre may fairly be dated at the outset of the twelfth century,[10] may fairly be explained by comparison with that at Santiago and, being off the route of pilgrims, loses the advantage of that constant interchange of reminiscence and innovation, suggestion and combination, which was the making of a church like S. Mary's at Sangüesa.

A.D. 1099

Off the track

Sangüesa.

The City speaks:
Casada soy, rey Don Juan,
Casada soy, que no viuda;
El moro que á mí me tiene
Muy grande bien me quería.

Sangüesa lies really not very far from Tiermas, though the river Aragon likes to turn and wind with many doublings in between, and the road which follows the river makes a great business of it. The motor omnibus does not follow at all, but strikes across northward and combines at another station with the good little electric line that runs around and about from Pampeluna into the remote valley of Roncal and, on another fork, half-way to Roncevaux. The ancient way, however, made but one stage from Jaca to Sangüesa that lies fair and lovely by the green water's side. Passing through the town, you climb a long hill and come out in a sort of upper world, with heights and valleys of its own and a great sweep of clean bright air through which you look across to a brown city lying on a brown hill-

Eunate

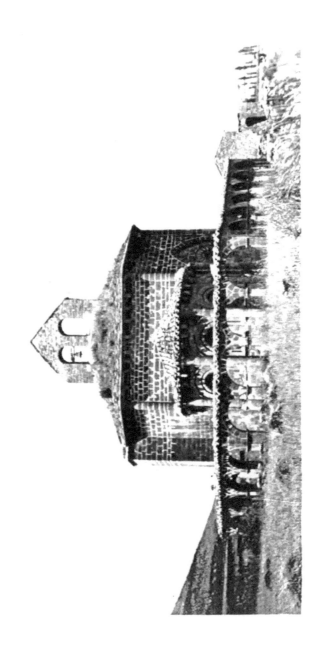

side, like a rock on the sands: that is Sos, in Aragon. It is perhaps a good moment to name a peculiarity noted more than once hereabouts, how you may climb and climb, with long loops and windings of well-metalled road, and come up at last into, so to speak, Beanstalk-country, with its own hills and dales, from which you do not again descend. Above Sangüesa it would seem you could walk on forever in the bright fierce heat, and when you turn back and descend the long declining road that grows after a while into a street, you are in an equally valid world below, by the river. Not far from here lies Javier, where S. Francis Xavier was born, a seat of pious memories and Jesuit architecture.

Sangüesa, called *la que nunca faltó*, was founded virtually by Alfonso *el Batallador*, who in 1132 gave exemptions and privileges to the free men of Sangüesa la Vieja, which was most likely Rocaforte, if they would settle on the plain below his castle. There was a ford and a bridge, there, and it was frontier, and on a main road, so the castle had to keep the way and the men had to

The Bean-stalk country

Ford and bridge

keep the castle. The year before, he had made a gift to the religious of S. John of Jerusalem of his palace which stood near the bridge and the church within it: *de la Iglesia de S. Maria que estaba dentro del patio del rey al principio del burgo nuevo.*[1] That cannot quite have been the present church. Unluckily the next useful date falls too , late, being that of concessions made by Philip of Evreux, the spouse of Queen Jehane, counted as Philip III of Navarrè, in 1330, when *por causa del diluvio de agua era perdida gran parte de la villa.*[2]

S. Mary the Royal is a noble transitional church of the late twelfth century with an octagonal dome of the early fourteenth carried on squinches: it has three apses arcaded round inside, high up, three aisles of two bays, but no transept, and a western gallery. The main arches are all pointed and a strong quadripartite vault, beautifully ribbed, descends upon clustered piers with two columns on each face and another in each corner to receive the ribs. The capitals are mainly of Romanesque form, developments of the acanthus or applica-

tions of the eagle; one pair shows griffins, elsewhere lions are eating a creature; all beautifully conceived and executed. The eastern capitals of the main arcade are early Gothic, the later, on a larger scale, are by a master. The design of a Nativity is like that of the Rood-screen at Chartres and the pulpit at Siena; the man riding on horseback belongs to a corresponding Epiphany, and the head of the following horse comes around the corner. The bases are high, with griffes in the corner. The west wall is chiefly occupied by an organ, the central apse by a monstrous retable.

Probably by reason of some disposition of other buildings around the original patio, the portal occupies. the first bay The side of the south face. We have seen, already, portal that Spanish architects took kindly to side portals. It was itself at some time rebuilt. In the upper part two rows of statues in round-headed arcades recall the southwest of France. In the lower half a great pointed doorway is set, with statues against the columns of the jambs; the tympanum being

occupied by a Doom, and with the twelve
apostles under arches and a Madonna and
child; the archivolts filled with figures.
The triangular spaces left on either side
of these are crowded with sculptures, some
left over from the earlier version of the
portal, some carved in the Spanish style
of the late twelfth century, for the places
they now occupy, to fill up gaps. The
upper part suggests the style of Poitou,
the tympanum recalls Languedoc, the
jamb statues are of the school of Chartres.
M. Bertaux[3] thinks the whole portal was
made at once in the thirteenth century,
with its disproportion and confusion, as
children make play-houses with shells and
pebbles. He is probably mistaken: six
leagues beyond Pampeluna on the other
side, at Puente la Reyna, you will find a
portal built all at once, and it comes out
quite different. Sr. Lampérez suggests[4]
that perhaps the church of Alfonso sur-
vives in the head (i. e., the east end), the
plan, with the portal up to the springing
of the pointed arches, and the outer walls:
the windows moreover and the vaults of

the apse and jambs of the door are in keeping with other Spanish work of the early twelfth century. In a restoration executed about a century later the piers and vaults of the nave will have been made, and the portal altered. The tympanum has been cut, he notices, to admit of a pointed arch, and in the face of the jambs the columns do not spring from the ground but commence rather high up, which shows that the earlier doorway lacked columns. Lastly, in the first quarter of the thirteenth century was built the lantern, of perfect early Gothic. The upper part of the tower is of the fourteenth. or fifteenth century. Straightway thereafter, the distinguished architect adds that S. Mary's may have been completely rebuilt about 1200, using only scraps of the earlier church, and finishing the tower lantern in the first third of the thirteenth century. From this the reader may judge how difficult is Spanish archaeology. In remoter parts of Navarre, at Aybar, only an hour away, or at S. Martin de Unx, the contemporary style is quite different: heavy,

Alternative dates

Romanesque and hugeous. The present business, however, is not with dates so much as with sources, not with precedence so much as inter-relation. We have seen that at Leyre when the Cistercians rebuilt the nave they made the portal out of fragments of the old façade: we shall see that at Puente la Reyna when Knights of S. John built the church of the Crucified and the King built that of S. James, the form of the portal is logical, the sculptures keep appointed places, the order is plain as in Tuscany or Normandy. If then S. María was built and rebuilt, so to speak, before our eyes, we may recognize in the workmen who collaborated, and combined so strangely such alien elements, precisely those pilgrims who were passing incessantly along the road.

In the Middle Age—it has been said already—craftsmen wandered about, and the builder's trade was less stationary than most; the parallel of the Comacine masters established a precedent half a millennium before; the note-book of Villard de Honnecourt is evidence that a man in the

thirteenth century was sketching in Champagne and Switzerland, in Artois and in Hungary. Here at Sangüesa appear (they have already been evoked) plain tokens that such workmen have come along and stopped a bit, left their handiwork and their teaching behind. Even when they came from very far, on their pilgrimage they had passed by the great shrines of the west of France, on the long Atlantic slope where English armies were already countermarching and destroying; or else they had come down through the high volcanic land midway between that and the immense river Rhone, where rocks were coloured like the skins of beasts and pied and banded churches broke up out of the ground, down into the soft luxurious plain of Languedoc, and always the ways of building and the forms of ornament were fresh and living in their minds.

As late as the fourteenth century churches were built, in the part of France represented by the departments of Vienne and Charente-Inférieure, with arcades across the upper part and statues under every

". . . in Flandres in Artoys. . ."

arch, and they were begun at least as early as the eleventh. The church of Pérignac, near Pons,[5] on the road from Saintes to Bordeaux, illustrates such an arrangement with two rows of arcading, a large window in the centre of the upper row, a Madonna enthroned with the child in the centre of the lower. This sort served as a model for S. María at Sangüesa. Under a deep cornice, sustained by animal heads, heavy and very plain, run the two rows of double-shafted arches: six figures occupy the upper arcade and in an oblong space in the centre the Christ sits enthroned, blessing, between the four living things. The ox and lion at His feet are not treated symmetrically but face the same way, to the spectator's right, which is precisely the blunder a local workman would make in handling a theme unfamiliar; but the lion has the right Chinese smile, like that of Moissac. Two angels flank this and in the outermost arches are S. Peter and another saint: eight more saints, among whom S. James alone may be distinguished, leaning on his staff, occupy the lower range; they are

probably all apostles and with the two above and the human image which represents S. Matthew in the Tetramorph, make up the eleven. On the tympanum of the door, below, the lowest third (or something more) is occupied by what should fill a lintel if one there were, another arcade, round-headed, sustained by single shafts patterned over with the chevron, meander, spiral, etc., like that at La Charité-sur-Loire. The Virgin crowned and seated on a Roman chair holds the Child upon her left knee. Here is not the *Sedes Sapientiae*, the venerable Madonna of Majesty with its ancient unalterable frontality, but head and shoulders are turned a little eastward, the right arm is laid across the body, to hold the Child's, and the head is a little inclined. The portal of Cahors, now on the north side of the church but once at the west, puts into the lower part of the tympanum, above the lintel, a similar arcade. Above sits a gigantic Christ, with cross-marked nimbus, between four trumpeting angels: He has the mitre-crown of Moissac and the bare

La Charité-sur-Loire

shoulder and breast of Beaulieu but no wound. He blesses with two fingers and the thumb. On His right two rows of the blessed crowd towards Him; on His left the reprobate, above, are chained into a long gang; below, the angel weighs the souls, which is a French motive. Looking back over the whole length of the Way, I recall it in only two instances, here and at Estella, on parish churches, and on the two cathedrals of Burgos and Leon. Hell is a sprawling monster with horns, teeth, and tongue, but the fourteenth-century motive of the Jaws of Death has not yet appeared. On the other side of the angel, three charming women lean one against the other, and you divine that they are saved.

Coming to the jamb-figures, we have further to look for origins but the case is clear. Three queens from Chartres came all the long way. Wasted though they are almost to the state of the dead, something of the old dignity and loveliness yet clings about them. That nearest the door has still the level brows, the troubling smile, of her lovely worn sisters in the

north. Opposite are men, more ruinous,
and grimly jocular without their noses, like
the French Death's head, *le vieux Camus.*
The sculptor of these six statues was trained
in the school of Chartres, which reached
from Senlis down to Bourges and from
Étampes in the west, to S. Loup de Naud
in the east. Moreover, one capital above
the innermost figure on either hand is
crowned with tabernacle work like that of
Chartres, though the bell of the capital is
filled with leafage: some workman combin-
ing remembered motives at his wanton
will. Of the other capitals, the two western-
most show the Expulsion from Paradise
and the Presentation in the Temple when
the ancient covenant was fulfilled;[6] and on
the east side one is given over to the Mas-
sacre of the Innocents and the other to a
Romanesque development, very fair and
free, of the acanthus and volutes. Someone
began working a diaper on the intervening
shafts but never finished.

Five rows of little figures, in the archi-
volt, are set on the line of the arc in the
French fashion and not on the radius as at

Leyre and in the west of Spain; and in three cases the mouldings in which they are set are carved very deeply with diaper and zigzag, meander and spiral. There is some evidence here of an alteration, of plan at least: in the innermost row an isolated head, which would be expected at the peak of the arch (as it lies in that above), falls to the right beyond one figure; in the outermost row, the highest figure on the left faces like those on the right. The themes are confused likewise: you will see a fine king and several of the Apocalyptic elders, with lamp and viol, and prophets with scrolls, and confessors or hermits, and in this company a naked lady suckling at her breasts a serpent and a toad. An angel holds a little soul on its knees, a man sharpens some weapon on an anvil, a jongleur turns his heels over to touch his head. Some of the Signs of the Months are plain: winter with cup and platter, a man killing a hog, another grafting, another holding his falcon; a mermaid grasps the two Fishes, and the Twins are knights with long shields, as at Chartres.

"... a suckling snake"

Aquarius guards his waterpots, and remembering the ladies at Toulouse fondling the signs of the Lion and the Ram, one recognizes here one man holding the sign of the Bull and another that of the Goat. They are romantic figures that might pass for the "jeune homme caressant sa chimère."

Jeune homme caressant sa chimère

The entire portal projects a little and is further enframed by buttresses all the way up. When it came to gathering up the fragments that remained, some of these were continued around the corner of the eastern buttress and against the chapel wall that projects on the west. The mate to a great winged ox, for instance, and a broken eagle, in one of the spandrels, is a lion, again very Chinese about the head, built into that chapel wall. In the same left hand spandrel occur also: the Temptation and Fall, Cain killing Abel; S. James on a great horse trampling naked men; a doe suckling her young; a rose, and a great interlaced knot of a sort that occurs at Leyre. That knot came probably from the Black Sea; it is found not only on Me-

rovingian fibulae and on a capital in the tower of Brantôme, but on an angel's breast in a capital at Constantinople, on the door jambs of Ferrara cathedral as well as the cloister-capitals of S. Bertrand de Comminges.[7] Along the top ramps a row of scaly monsters, done for the place, opposite which you find a beautiful row of dragon and sphinx forms contemporary with Puente la Reyna. The right-hand spandrel in the main is more confused, but in compensation you have, built into a corner of the buttress adjoining, an exquisite little Wise Virgin holding her lamp in veiled hands; and, somewhat above, a seated figure of Christ teaching, with three disciples about him. Here too appears a pair of lions of the Lombard breed.

All this work covers, then, at least a century, implies at least one rebuilding, and represents three separate regions of France contributing. The distance is not, even on foot, a day's journey from Jaca; the difference is indescribable. Jaca, a capital deep-rooted in antiquity, was the seat of kings, the heart of Aragon; Sangüesa

was a stage upon the Pilgrim Way, the creation of political exigency.

The church of Santiago looks battered and shapeless, both within and without. It was built in the transitional style, at the beginning of the thirteenth century perhaps, with nave of four bays, aisles, apses vaulted in a chevet, and a great tower over the beginning of the central apse. The main arches are all pointed, and also the clerestory windows in the western part; the quadripartite vault rests on strong vaulting shafts that come down to huge round columns. The capitals are all crude except the pair, of three each, at the eastern end of the nave; the shafts of the window jambs also have Gothic capitals. The portal, pointed, carries on each side three shafts, their capitals a development of the acanthus leaf, rich and fine but ruined by paint. From S. Nicholas, ruined and gone, which once owed obedience to Roncevaux,[8] the capitals have been fetched away, and are preserved in the Museum at Pampeluna: they are strong Spanish Romanesque.

Santiago

S. Nicholas

S. Salvador

S. Salvador is of the fourteenth century, with a single great nave of six bays, quadripartite vaulting. The whole apse is carried up into a tower. Madrazo says[9] an earlier portal still exists inside the present one of the fourteenth century. In the upper stage of this the Saviour shows His wounds between two angels that hold the cross and lance, and SS. Mary and John who kneel to intercede in the corners. Below, on the left, the dead are getting up out of stone sepulchres, are marshalled in a long line, at last are tumbled pell-mell into hellmouth, which now is a monstrous and practicable pair of jaws, suggested doubtless by the business of mystery-plays.

Carmen

The Carmen is a lovely little brown thing, with a door round-arched above thin mouldings, and some storied capitals, along with leaves and a *genre* theme—with the Annunciation, Nativity, Flight into Egypt, and Epiphany. At right angles to it stands a good stone building with an ogee doorway running up into eight huge arch stones, and a pair of ogee *ajimez* windows. But indeed everywhere in the town yet

stand good secular buildings; here and there on a ruin is stuck a great coat of arms, and superb roofs on carved consoles are common. Of a palace in the *calle Mayor* one wing is late Gothic and all the rest Renaissance: on another elsewhere are twisted columns and under the roof still more wonderful consoles with pendants. The town has shrunken; fig-trees, flowers, and donkeys flourish inside the compass of the ancient walls. The castle, says Ceán Bermúdez in his *Adiciones* to Llaguno,[10] was built by Miguel de Goyni for Charles the Noble.

<div style="text-align: right;">*Domestic architecture*</div>

There are, indeed, plenty of dates at hand for Sangüesa, but few of them fit. For S. Mary the Royal 1131 is too early and 1330 too late to stand for much. By 1232 the King of Navarre was a Frenchman, Thibaut, Count of Champagne and Brie, but he was little in his kingdom, and the French style of the church is not that of the east. When another French line succeeded, under Charles the Noble, the workmen were Spaniards all. Sangüesa not only commanded the best workmen in

<div style="text-align: right;">*Dates*</div>

Navarre, but formed masters highly approved. In 1410 the masters of the works of Charles III were Simon López and Miguel de Goyni, the former built the castle in Puente la Reyna, the latter that of Sangüesa.[11] The castle of Feliciana at Sos, over against Sangüesa on the slope of Aragon, had been built in 1130 by Mestro Jordan for Ramiro *el Monge*. In 1415 Miguel de *Poyni* (probably the same as that Miguel above) was master and director of the royal works in Sangüesa, building mills and other edifices. In 1419 Andrés de Soria was master of the works there.[12] In 1594 Master Juan Verrueta, of Sangüesa, took up and finished the stalls at Huesca, on the death of Nicolas de Verástegui.[13]

The citadel opens from the *calle Mayor*, by a wide loggia dated 1560; it contains a little street fringed with houses and then a great brown building, wide and low, with towers at each end. The townsfolk are grave and courteous as those of Aragon: a woman alone may haunt the streets for a day without disturbing their dignity. The children are courteous, almost like

Italian children; they eye one like shy but friendly dogs, and make a wide détour, and shrink away as one turns and catches them watching.

Almost Italian, indeed, is the fair courtly air of the little pinkish city, the clean, unfrequented brown streets, the forgotten palace fronts of late Gothic or early Renaissance, the sense of a long life delicately lived and now declining softly, not ignobly. It was some saint's day that called for a procession about the town, and balconies were hung with old brocade and new, with the stuff called turkey red, and grass-green bunting, and calicoes striped in scarlet and yellow like the cigar ribbons, with checked table cloths and white bed-spreads for want of better. The procession was a scanty thing, that came out of the cavernous church with yellow flames dancing in the darkness; first a popping of rockets invisible in the noon, then a rush of old men and young women with yellow flickering candles held aslant, promptly to blow out; then the singing men in albs freshly gauffered and deeply edged with lace, their

harsh antiphon rising up and again lost, in the windings of the streets, like the sound of surf to men inland; then incense blue in the sunlight; finally the Blessed Sacrament under a canopy, set in a bouquet of such vestments that my eyes drew my feet about the entire city and back again till the black church doorway had swallowed up the singing men and the extinguished candles and the sanctimonious old women and the pitiful old men, the starched little girls and the bigger girls in white cotton gloves. They were not so old, those vestments, nor embroidered, nor excessively rich, but they were of a kind of scarlet pink like the sound of flutes and bassoons and hautboys, that one could not have enough of. I sucked it up thirstily: I could have knelt on the cobblestones to keep it longer, and the bored antiphon of the singing men, the hiss of the inane rockets, the scrupulous hangings along the appointed streets were all undertone, the mere accompaniment to the colour of that *obbligato*.

A kind of scarlet pink

IV

PAMPELUNA

*En París esta doña Alda
la esposa de don Roldan;
trescientas damas con ella
para la acompanar:*

*Todas visten un vestido,
todas calzan un calzar,
todas comen á una mesa,
todas comían de un pan....*

*Las ciento hilaban oro,
las ciento tejen cendal,
las ciento tañan instru-
mentos
para doña Alda holgar.*
 —Romance.

THERE were processions in Pampeluna
early every morning, and at any hour of
the day one would hear the call of pipe and
tabor and then the running of countless
little feet, and suddenly about one surged
a skurrying hundred or so of panting little

boys and girls in blue smocks, all running
as they ran in Hamelin Town, till the mass
thickened like boiling gruel and around
a corner came the Giants. Every self-
respecting Spanish town takes out, on the
patronal feast, and Corpus Christi, and
other suitable dates, at least six of these
figures. They are built of papier-maché
and wicker, dressed in calico and velvet,
and carried on invisible men's shoulders.
There is a king and queen, a Moor and
Mooress, and in Santiago the other couple
are pilgrims, in Pampeluna they are knight
and lady. They are, so to speak, the big
brothers of the Marionettes. They exe-
cuted a sort of minuet before the Cathedral,
and led the procession when S. Firmin in
person, or at any rate some bones believed
to be his, went down every morning to
assist at a mass in the church of his name.
Along with the Giants, however, Pampeluna

enjoys a dozen other gigantic mannikins
of fixed type called *Cabezudos;* a sailor, a
cleric, a heathen Chinee, an old person in
a tie wig, and the like, which are merely
heads worn on the shoulders of men in

costume. Hobby Horse is there as well, with a bladder full of pease to bang boys over the head; more than once we came upon a very tired Hobby Horse refreshing his bladder and his hot face in a town fountain. All these were abroad, to certain knowledge, from seven in the morning till twelve at night, how long before and after remains unknown, in honour of S. Firmin, the apostle of Picardy and the patron of his birthplace Pampeluna.

We had left Tiermas hurriedly at nightfall, because of the approaching *feria*, and the Manager had given us a letter to a personal friend of his, one Roque, who was a porter at the station of the electric line. Without his recommendation we could hardly have found where to sleep, but Roque,—after reading the letter aloud, by an odd bit of formal courtesy that enchanted us—took up the bags, on some good excuse showed us to his own niche of two rooms and a half, full of antimacassars and blue vases, and went on across the street to a *Casa de Huespedes*. This belonged to a stout lady who, under

Hobby Horse

pressure of the combined recommendations
of the Manager and Roque, dislodged three
men just making an evening toilet with
plenty of hair tonic and clean towels, and
gave us a room just as wide as the window,
looking on a fairly wide street. We did
not, in truth, sleep much, nobody did;
but we went to bed regularly, which few
did. The meals went on without per-
ceptible interval, for the three dislodged
gentlemen and many more were accommo-
dated in 'Roque's and other adjoining
niches, whence they came in for endless
luncheons and dinners. I think nearly all
the other people at table were men, and
they all looked like *commis-voyageurs*
and their patrons, except one ecclesiastic,
a comely young abbé, grey-haired and
spoiled as a woman. He would stand in
the doorway to be admired, and then ad-
vance *se dandinant*, swinging his hips and
petticoats. His voice and smile and hands
were soft, and he struck one as somehow
improper, even before the night he stood
longer than usual in the doorway and one
discovered that he was dressed in a grey

sack suit. The civilian dress was very becoming: "Perhaps," said a priest to whom we related this one time, " he was a military chaplain; they allow themselves great liberties!" At any rate, there he stood, thus he dined; the thing is incredible but it happened. In the memory of that smiling corrupt face I have forgotten everything about the house of *La Francesa* except the poor fat *francesa* and her sleepless daughters and the darkness of the kitchen where something always was going on.

In the streets something was always going on too: first the procession to S. Firmin, and a solemn mass at the Cathedral with an orchestra of fiddles and other viols; then a concert of military music for which a whole street served as *salon de musique*, penny chairs ranged up the steep ascent and the band at the top. After luncheon the bull-fight lasted from two to nearly six, and after dinner there was the play. But after the bull-fight and before dinner there happened, in the *Paseo*, the prettiest thing we have ever seen in any land or

city,—the Promenade. The very best at
Bath or at S. Cloud cannot have shown
anything like such beauty. For the S. Fir-
min, the nobility and gentry of Navarre
come in, the county families. The level
Paseo is not more than half a mile long,
from the central square to the city gate,
and where the penny chairs were ranged
in a double row on either side the central
walk of trodden earth, the families settled
themselves for talk, pulled up into knots,
spread out into crescents. The elders had
a year of news to give and hear; the girls
walked up and down with their brothers or
cousins, and of course brother and sister
could walk with another brother and
sister. The men were slender-waisted,
distinguished, tall enough, with a charm-
ing carriage and beautiful hands. The

loveliness of the women was like a Watteau
animated, fragrant, and troubling. There
were no hats, and few of the little *voilettes*
of Chantilly that have grown so common,
but golden Spanish blonde and silken
Spanish lace; the sumptuous state of
white mantillas, the various grace of black

mantillas, the courtly kind that lies in a deep ruffle on the shoulders, the delicious chenille kind that is daring; the heavy-worked kind that is romantic. Over one arm lay a folded shawl, of crêpe or soft silk or embroidered in brilliant flowers; in one hand a folded fan. The women were very lovely, very well dressed, very well bred, but their loveliness and their breeding and their dress found its own right expression in their own traditional attributes, fan, shawl, and mantilla.

The mantilla is not easy to wear, and it takes an hour to put on, and a paper of pins; the hair must be dressed high and very firmly; the tall comb will lend further height and stability, then every fold of the lace is separately modified and securely pinned with an infinity of black pins. It exacts, moreover, great beauty of feature, great refinement. Rich contours and soft flesh matter not at all, but the head must have beauty of modelling, and have a noble bony structure, and contours attained by breeding through hundreds of generations. The mantilla, the fan, the shawl: the

Mantilla

Spanish figure is the finest in the world;
the carriage and walk is like Hers whom
Æneas watched through the trees and
knew Her by it, for nothing else could
move so divinely. Shawl, mantilla, and
fan: the Spanish hand is a miracle, a *non-
pareil* of beauty. For an hour and a half
every evening the nobility of Navarre
walked in beauty there, in rustling and
murmuring of silk, and voices, and dark
leafage; warm puffs of perfume through a
night wind blowing out of dark and moun-
tains; a luminous dust filling all the space,
above which hung a pale sky infinitely
remote.

Recalling the S. Firmin, I recall only this
space, glowing, moving, scented, mur-
murous, like a syringa bush on a night of
fireflies. The city I knew already, having
stayed there once in January when the
sign of S. Julian of the North was augury
of hospitality and afforded for the sunless
hours a stove in the hotel dining-room. Of
those long hours in a Spanish winter, after
dark and before dinner, how by the natives
they may be passed least intolerably,

something shall be said later. For a woman alone, they are hard. She has been out seeing things while the daylight lasted and is honestly tired; moreover, most churches close at nightfall and the rest have nothing by any chance worth seeing even were they not wrapped in a midnight of their own, just starred with votive candles. She cannot walk up and down the pavement, in the light of shop windows, as men are doing. She goes back to her room at the hotel. There she cannot go to bed to keep warm, for dinner is still three hours away; she makes her tea, then fills a rubber hot-water-bottle, and wrapping it and herself in a rug lies down under a faint electric bulb to read and shiver and not dare to doze. At S. Julian of the North, to the discomposure of the waiters, I was able to carry the *Chanson de Roland* into the dining-room, and after the good American fashion to put my feet on the stove and digest in comfort the day's disillusions.

To look for Charlemagne I had gone to Pampeluna and I had found the eighteenth

A woman alone

unless stout and grey . . .

The day's disillusions

century, a misadventure always discon-
certing. The *Ayuntamiento* was rather
charming with columns and entablatures,
pediments and inverted consoles, and
wrought iron balconies. The *Plaza de la
Constitución*, like that in front of the cathe-
dral, was Greco-Roman in its intentions,
but vaguely picturesque in its arcaded side-
walks, its individual balconies, its terraces
and doors opening upon them, up among
the slated roofs. The cathedral was flat-
headed: now a Gothic building wants a
gable roof, and flying buttresses, and
pinnacles that function. The other ancient
churches, S. Cernin and S. Nicolas, were
shockingly restored. And . . . and . . .
a woman alone will meet, from time to
time, a little personal annoyance, even
from priests, that however inevitable, yet
leaves her hurt.

If Charlemagne is not at Pampeluna, yet
the Pyrenees are there; it is possible to
walk almost around the town, in the crys-
talline noon, on turfy ramparts and
crumbling walls, and look off to azure
luminous heights and tender vaporous

foldings till it is as if one should walk in the very heart of a star sapphire.

The old cathedral of Pampeluna was fair as a moon even among fair churches. It was a hundred years in building and *Pulchra ut* stood for less than twice that time: founded *luna* by Sancho *el Mayor* who was a wise man and a canny. He had introduced the rule of Cluny into S. Juan de la Peña; he was about to do the same at S. Salvador de Leyre, when the abbot and his friends among the nobility, by way of diversion, urged in assembled *Cortes* the more immediate need of restoring the cathedral. "Certainly, since you recommend it," said the king, "and to that important end we will apply, amongst other revenues, those of S. Salvador." This was in 1023. A great part of the building, however, was done under Peter of Bishop Peter of Roda, who filled the See as Roda late as 1115, and coming himself from near Toulouse, knew whither to send for workmen. He also substituted for the monks who had served the church till then, canons regular of S. Augustine, whose rule of life in common was to leave its mark upon the fab-

ric of the second church. In this action he
had the advice of the abbot Torneros, the
prior of S. Sernin of Toulouse, the arch-
bishop of Auch, and others. His successor,
Bishop William, was a great fighter, who
served *el Batallador*, his king, on many a
field; Bishop Sancho de Larrosa, who con-
secrated it, knew how to get rich gifts;[1]
but certainly we may leave to Bishop Peter
and his craftsmen the glory of what survives
from the portal of 1124 or a cloister adja-
cent, eight lovely capitals built up in a
niche of the present cloister. The detail is
richer and freer than any now in the mu-
seum at Toulouse, the style is identical.

The church and quarter of S. Cernin,
contemporary with this work, form another
link with Toulouse. Just about this time
Alfonso *el Batallador*, in a document given
at Atafalla (Tafalla) in September of 1129,
had sent to repeople the burg of S. Cernin,
destroyed some time before. S. Cernin
or Serninus, S. Saturninus, was Bishop of
Toulouse, and some historians will have it
that the *francos* to whom the king gave
privileges were not merely free men but

Frenchmen, in particular of Cahors, ex-
pelled by Philip, or possibly Albigensian
refugees. Now the Cahorsines, we know,
gave a pope to Rome and money lenders to
Dante and Europe; there is no reason why
they should not have settled in the suburb
of a royal capital, under a French bishop's
protection. Whosoever they were, the
king conceded to the new population of the
plain of S. Saturnine of Irunia, amongst
other rights, the *fuero* of Jaca in respect of
the departments of Justice and the Treas-
ury, and forbade any Navarrese noble or
cleric to settle there; the ground about
might not be built upon; the quarters over-
looking it might not build towers or other-
wise domineer or menace; the citizens
were to elect three candidates of their own
from whom the Bishop must select an al-
calde, and this burg alone might sell wine
or bread to pilgrims.

S. Cernin is the oldest Gothic church in
Navarre, and belongs to the second half
of the thirteenth century. This dictum of
Madrazo, confirmed by Lampérez,[2] leaves
one to wonder into how late an age may

*Qui vulgar-
iter Caorci-
ni dicuntur*

come down all the late-Romanesque and Transitional building.　In the curious plan of the original part of this church, occurs an ingenious modification of a French motive, rather rare, but developed at Estella six leagues away on the same *Camino francés*, the three chapels opening directly from the apse without an ambulatory intervening, as at Souillac and Cahors. At Souillac and Estella the apsidioles are treated as mere niches and the central apse is the main thing: at Cahors the choir is so railed round, in the central apse, as to leave a procession path and access to the chapels: here at S. Cernin the chapels are the main matter and the high altar is placed in the central one.　The west door of this church has been quite spoiled but there are some traces of a porch or an arcade that would have harboured tombs. The north door is sheltered by a porch of five bays stretching along the whole north side that, like those of Ripoll and S. Miguel of Estella, is later than the portal itself but not so much later.　It contains a few tombs or traces of them.　Outside, at the

entrance, S. Saturninus stands upon the
bull of his martyrdom and his pendant is
S. James with a kneeling pilgrim, in long
gown, skin rain-coat, wallet and staff.

Figured
on p. 179

The door itself, though at first glance it
looks like much fourteenth-century work
in Navarre, on examination appears finer
by far, with a very noble distribution and
subordination, among the multiplied mould-
ings of jamb and archivolt, into major and
minor systems. The six capitals on either
side correspond to a strong projection and
their re-entrant angles to pronounced hol-
lows. In the tympanum sits Christ as
Judge, between SS. Mary and John, and a
monk in the right-hand corner interceding:
an angel in the corresponding angle trum-
pets to Judgement. The lintel, or lower
part of the tympanum, is occupied by an
arcade of eight cusped and pointed arches
grouped into pairs by shafts; the spandrels
between them are occupied by tiny angels.
In the arcade the dead are (1) rising from
their tombs, (2) coming to Judgement, and
(3) worshipping their Redeemer; (4) others,
agonized, led off to hell and boiled in a pot.

*Tuba
mirum
spargens
sonum*

The historied capitals begin, on the left, with a larger group under the boss that terminates the dripstone; it represents the Annunciation, and the series continues with the Visitation, Nativity, Presentation, etc., down to the Flight into Egypt, the Epiphany figuring on the projection which sustains the lintel. On the other side, the largest, outermost scene is the Harrowing of Hell, thence (reading inward) the history of Palm Sunday in great detail, with Zaccheus in the tree, the walls of Jerusalem crowded and a man coming out of the gate; the Last Supper, the Agony in the Garden, the Way to Calvary, Deposition, Maries at the Tomb, and *Noli Me Tangere* and, upon the corbel that sustains the lintel, the Resurrection. In the peak of the arch is set a series of isolated figures: Christ crowned, with a book, the Eternal Father holding a crucifix, the Dove hovering above, and the risen Christ. Finally, the hood moulding swirls up into a glorious finial that supports a Calvary, the Crucified between SS. Mary and John.

In all this figure sculpture the elements

and origins are mingled. The iconography of the capitals is French—is French of France—but the symbolism is original and exquisite in its arrangement of correspondences, bringing the Epiphany, the Manifestation of God's Humanity, into relation with the Resurrection, the Manifestation of His Divinity; and, in the same way, the Annunciation to Mary that the close of Eve's long expectation was at hand, into relation with the Apparition of the King of Glory in Limbo, to take up with Him the spirits in prison. The main figures of the tympanum are of the later cathedral tradition. The little figures stuck against the mouldings, with the structural irrelevance that nobody could break a Spaniard of, are Spanish motives, perhaps: they left their mark on churches in Navarre and Navarrese painters as well.

The difference of privilege in the different quarters of the town, for a while adjusted by Sancho *el Mayor* early in the eleventh century, led to a great war in the thirteenth at the end of which the French took and burned it, 1277; but though the cathedral

and significance

The New Cathedral

was sacked the fabric escaped. Again in 1422 Charles the Noble gave to the city the so-called act of Union, which finally reduced the surviving three-quarters under a single civil government. But the great gift of this king was the new cathedral of French Gothic. In 1390, the very year of his coronation, on the first of July, the greater part of the cathedral fell in sudden ruin, wrecking the choir and most of the rest, but without loss of life. The west front escaped, for Moret's continuator writes in the eighteenth century, *de lo antiguo sólo quedó la puerta del frontispicio, que ahora vemos.*[3] The king, it is said, had already begun some works within, both to beautify and to admit light: it is easy to conjecture injury to vital parts of the strong old Romanesque, with its lofty barrel vaults lighted only from the aisles, now out of date and ill-understood; at any rate in 1397 the reconstruction was begun. Much beautiful building had been commenced already, how much it is hard to say, by Bishop Arnald of Barbazan, 1317–1355: a glorious chapter-room, and a cloister of which the

east and north wings were finished and escaped destruction: at their angle, along with the doorway into the south transept, and three precious monuments of the thirteenth century, the Epiphany of Jacques Peyrut and the tomb of the Infants of Luna. The south and west sides of the cloister belong to the fifteenth century, with three other doors hardly less beautiful: that into the Refectory, that close at hand but at right angles to it, which leads into a court or garden, and that called *la Preciosa*.

French sculptor

The cathedral, says M. Bertaux,[4] was begun under a French prince, Philip of Evreux by a French bishop, Arnald of Barbazan, and finished at the end of the century under a French king, Charles the Noble, who was born at Nantes and educàted at Paris. After this there is nothing to find out about the cathedral, it is simply all French; but not French of Paris, be it remarked. The real comparisons must be made with the south, Bayonne, for instance: and the real sources of the style lie often not in the Royal Domain.

French prince

Against the door of the south transept

which, like the cathedral itself, is dedi-
cated to the Assumption, stands a grave
and queenly Madonna, rather Spanish of
face, offering to her divine Son the Book.
In the jamb and archivolts are the Works
of Mercy, the Strong Women of Scripture,
angels making music, and others of the
company of heaven bearing an antiphon
on a scroll, a cadence from the Song of
Songs: "Who is this that cometh up
from the Wilderness leaning upon her Be-
loved? *Assumpta est Maria in Coelum.*"
The symbolism here, and in the figures of
Church and Synagogue at the Refectory
door, is significant in Spain, where such is
rare. The tympanum, greatly admired, is
just a little absurd: of the early fifteenth
century, it represents the Dormition in the
midst of a thick crowd, angels tiptoe and
pushing to look on, apostles wiping their
eyes on the sheet, on their clothes, or a
napkin, and a swarm of little angels buzz-
ing above with a napkin for the little soul
that, dressed as for a birthday, is held up
by a leaning Christ with curled hair and
beard: Franco-Flemish, pronounces M.

Bertaux,[5] and whatever he means by that is probably the truth: provincial, that is to say. It looks almost as if copied from embroidery, rather than developed in a strong iconographic tradition.

The door called *la Preciosa* comes next perhaps in date to this one, flanked by SS. Mary and Gabriel on elaborate panelled bases under canopies. The three bands of the tympanum show scenes from the later life of the Blessed Virgin, culminating in her Entombment, at which assists an admirable group of knights. The five little conversation-pieces in the lowest register suggest, in their arrangement, contemporary French ivories, with a notable difference,—the number of persons engaged. One great beauty of the ivories is the simplification enforced, the reduction of every action to its fewest figures: but here is no syncopation, everything, rather, expanded and "practicable." When the Blessed Virgin addresses the apostles before her death you count the twelve of them; their miraculous arrival at Jerusalem, like that of S. Michael in the row below, occurs

La Preciosa

in the foldings of a cloud with crinkled edges. I take it that the practice of miracle plays must account for this treatment, as it will for that of the Crucifixion in the north-west corner, where the groups are smaller but the action more dramatic.

There, in the upper range, you have, first, the three Maries, leaning upon each other in a lovely and apparently traditional group, fair as the three Graces; then the Madonna sustained by S. John. On the other side of the Cross Longinus testifies with a fine gesture, and two soldiers and a Jew expressively marvel. As in the early painting preserved in the inner sacristy, the Tree of the Cross is a real tree, gnarled and barky, in accordance with a legend that the Cross itself flourished with leaf and bark from noon to compline on the day of the Crucifixion.[6] *Noli Me Tangere* and the meeting of S. Peter with the Magdalen are studied stage tableaux. In the lowest range the jaws of hell are a machine, and the Sepulchre a sarcophagus large enough to hold a man or two. One curious detail not to be passed over is the likeness of this

to the Easter Sepulchre which still sur-
vives in some English churches, for in-
stance, at Lincoln, and the soldiers tucked
up to sleep under the three arcades that
sustain it.

 The door into the Refectory, flanked by
Church and Synagogue that suggest Stras-
burg much sooner than Leon, depicts,
above, the Last Supper and then the Entry
into Jerusalem. This supper table, with
its dishes of fish, its flat loaves, its goblets
and ewers, recalls the enchanting panel
painting of Solsona, precious for the
examples it affords of Hispano-Moresque
pottery. The original sculptural source of
this *Cena* is to be looked for at S. Gilles in
Provence. In the lunette above, both the
crowd and the tree are treated decoratively;
the fortified city of Jerusalem with her
towers, her bulwarks, betrays how fair
was Pampeluna under Charles III, *muy
noble y muy leal*. There is more than a
hint of the Renaissance in this tympanum;
though different, it should be about con-
temporary with the door of the *Assunta*.
Inside the Refectory, the base of the lec-

Cena of Solsona

tor's pulpit is carved with the Hue and
Cry after the Unicorn, with a verve highly
stimulating but quite. secular, and the
capitals are of the same kind. A shallow
niche encloses, under the Pelican in her
piety, two viol players, a centaur with bag-
pipe, a man rending a lion, a lion rending
a man, and all the familiar and secular
imagery which is at its best in the cloister
of Leon.

Lastly, against the delicate mouldings of
la Barbazana, the chapel of Bishop Arnald
where yet he lies, someone fashioned statues
of SS. Peter and Paul, resting them on
figured bases in the same style as the carv-
ings in the Refectory. These great figures
of the apostles are rather fine, and belong
to Spanish art well along; they are later
by a century than the jamb-figures of *la
Preciosa*. They are later by two genera-
tions than the Epiphany on the same wall,
which is signed "Jacques Peyrut fist ceste
istoyre." [7] The figures of the two standing
kings are truly Gothic still in feeling, and
the grand Madonna and kneeling first king
may indeed suggest work that began their

century at Dijon, but in no other sense than would any dawning Renaissance. The asp and basilisk coil under her feet as at Amiens. Close to this signed work, not, alas, dated, is the tomb of the Infants of Luna. · In the niche above, on either side the Crucified stand three little figures as Burgundian as possible. D. Lionel of Navarre was a bastard son of Charles the Bad, a splendid and romantic figure, dead in the flower of youth. He married Doña Elfa de Luna and died in 1413.[8]

·Of slightly earlier date, indeed, is the tomb that Janin Lome of Tournai made for Charles the Good, he being yet alive, in 1416. Its place, formerly in the *Coro*, is now in the ancient kitchen of the chapter. The contract still exists by which he was to have stone *para las obras et ymaginies de las sepulturas del Rey nuestro Seynor et bien assí del Rey su padre, á qui Dios perdone, que ha fecho et entiende fazer el dicto John Lome en la iglesia de S. Maria de Pamplona.*[9] This has twenty-eight little weepers under canopies around the base, and the effigies of King and Queen

An altar-
tomb

recumbent under other canopies, on the black slab atop. The flat head of those canopies is used for an inscription, easy to read by walking around the monument; against the feet are the queen's greyhounds and the king's mastiff: otherwise, as on the tombs at S. Denis, the drapery lies as if the statues were erect. Of the other tomb, intended for Charles II, nothing seems to be known, but I found in one of the eastern chapels an altar built above and around what seemed to be a tomb with a few such weepers under canopies: these may have been designed for that.

It is hard to see just why, when Spanish work for once was in direct contact with the Royal Domain, there should be little to betray the characteristic style of the Isle of France. Champagne, Burgundy, and the Flemish border are what can be identified —the only deduction is that there is no *à priori* in archaeology and that you can barely trust, not documents ever, but simply the look of things.

A little faded painting still stains the wall above the Infants of Luna; just a row

of perishing saints that look French as the little statues do, pure and lovely. French mural painting in the fifteenth century, unless markedly Italianate, was much of a kind. In the sacristy is preserved a small and ruinous panel, very precious, of the Crucifixion, that is usually denied to the sight of travellers but was lent to the exposition at Saragossa in 1904 and there written up by M. Bertaux.[10] When I examined it in 1912 it seemed to me something quite wonderful: done in the same style as the contemporary French miniatures, and very like the *Parement de Narbonne*, with the same dependence on outline and flat washes of tempera barely discernible, but full of character. The scene of the Crucifixion fills the greater part of the panel, the Pelican and the sun and moon being above, the Madonna and two other Maries on one side and a rather grotesque S. John on the other; in the border nine prophets with scrolls on each side and two bishops below. Under all this, a church of three aisles, a Bishop enthroned in the centre giving a book to a

monk: only parts of the body and hands are left. People on the right and left are both secular and religious, one clerk has a rolled document, another a book, an ecclesiastic a roll: six people, between and smaller, are kneeling, one at least has a book. On the steps of the throne a genial fellow in gown and hood, with gloves, has one hand bare. Lamps hang in the aisles; the arches are cusped, with open curves, not horseshoe, and marmosets in the spandrels; the capitals leafy. Above the arms of the cross are figures that seem to be the Church and Synagogue, but sorely ruined. So much I transcribe from notes taken at the time. Now, knowing more about Spanish manuscripts, I have only to add that from the reproduction in the Saragossa monograph may be made out a musician playing the viol on the Bishop's left, and in the crowd under the arch beyond him, an elephant in royal housings. A lady in this crowd wears a coif not unlike that of Anne of Brittany; a layman on the opposite side, a hood of fifteenth-century fashion. The roofs are covered with overlapping tiles such as you

find, variously indicated but intended alike, in Spanish manuscripts all the way from the Ashburnham Pentateuch (which seems to be Visigothic), through the Bible of S. Peter of Roda (called also the *Bible de Noailles*) and the *Cantigas del Rey Sabio*. I should add that the head-dress of the holy women, a veil that falls in scallops past the cheek, is worn in French ivories in the fifteenth century and in a little Annunciation of that date in Vich. There is a fifteenth-century ivory at Paris, I think at the Cluny, which is very close to the main scene of the Crucifixion: there is a reliquary of a Holy Thorn at Pampeluna which is even closer.

In short, the style proves later and perhaps less French on study. The upper part goes back to a common Carolingian tradition rather than a direct French source: the lower part is absolutely in the Spanish miniature tradition and later than the paintings to the books of *el Rey Sabio*. I should suppose that the Greek gift of the *Lignum Crucis* was the occasion of the panel.[11] The mottoes,

The Ashburnham Pentateuch

The Carolingian tradition

which M. Bertaux has published, all bear on the single theme of the Tree of the Cross:

On the title of the Cross:
"Similis factus sum pellicano solitudinis." Amen. Ps. ci, 72.
The Church:
"Ecclesia.—Fasciculus myrrh dilectus meus mihi; inter ubera mea commorabitur." Cant. i, 12.
Angel:
"Angelus.—Beati qui lavant stolas suas in sanguine agni." Apoc. xxii, 14.
On the right side:
"Jeremias.—Ego quasi agnus mansuetus qui portatur ad victimam." xi, 19.
"Osseas.—Vivificabit nos post duos dies, in die tertia suscitabit nos et vivemus in conspectu ejus." vi, 3.
"Joel.—Germinaverunt spetiosa deserti quia lignum attulit fructum suum." ii, 22.
"Joannes.—In hoc cognovimus caritatem Dei quoniam pro nobis animam suam posuit." Ep. iii, 16.
"Ambrosius.—Finis fidei mee iste est: finis fidei mee Filius Dei crucifixus est."

On the left side:
["Ezekiel.—Et erunt] fructus ejus in
cibum et folia ejus in medicinam."
xlvii, 12.

"Daniel.—Post hebdomades LXXII
occi [detur Cristus]." ix. 26.

"Sofonias.—Expecta me, dicit Do-
minus, in die resurrectionis mee in futu-
rum." iii, 8.

"Petrus.—Peccata nostra ipse per-
tulit in corpore suo super lignum
Crucis." Ep. ii, 24.

Of the cathedral itself I see no reason to
speak at length. Street has characterized
it with warmth and appreciation. I found
the arrangement of the eastern part, based
on the equilateral triangle and the hexagon,
dry, fantastical rather than intuitive, and
rather dull. The detail of mouldings, tracery
and capitals is pleasanter than one has a
right to expect, which is often the case in pro-
vincial work. The *Coro* that fills up the nave
with solid masonry, the west front that Ven-
tura Rodríguez applied in the eighteenth
century, are not relevant to the general en-
joyment that Gothic alone can afford.

*fit mundo
semita lucis*

Looking at the plan, one may conjecture of that lost Old Cathedral of Peter of Roda, for which Peter of Paris in 1186 got the relics of S. Firmin from the north, that it belonged to the grand group of S. Sernin of Toulouse, with high dark barrel-vaulted nave, aisled transept, and ambulatory with chapels. It had a westerly cloister, like Burgos, and probably towers flanking the last bay of the nave, like Bordeaux and Bayonne. Against the transept face was built the new cloister, while the common life still obtained, that had a square fountain house for ablutions in the corner next the Refectory. This is turned into a chapel now, and enclosed with ironwork that came, according to tradition, from the field of *Las Navas*. Four Latin verses are written above the doorway:

Cingere quae cernis crucifixum ferrea
 vincla
barbaricae gentis funere rupta manent:
Sanctius exuvias discerptas vindice ferro
huc, illuc sparsit stemata fustra pius.
Anno 1212.

The old chapter-house still stands, where it belongs, eastward of the cloister, opening upon it by a door between two windows, and vaulted in a great star: the square plan is brought to octagonal by arches thrown across the corners and vaulted themselves, as at Burgos and in the eastern chapels of Las Huelgas.

Chapter-house

Pampeluna remains in recollection with all the eighteenth-century virtues, clean, prosperous, just a little old-world, very decent. The beggars wear a brass badge as Dean Swift once recommended, and are both healthier-looking and better-dressed than their neighbours.

Outside the town, on the upper side, beyond all the walls, dry ditches and embankments, the road forks. One way runs back into Old Castile; the other east and north. As we stood and looked toward France, a diligence jingled by with two women atop, on the road to France. It was irresistible, or all but. But the wind blew keen from Spain, and the pilgrim road went west, and we turned our faces where the starry stream still goes.

The road to France

V

SAINT SEPULCHRE

*Ah, see the fair chivalry come, the
companions of Christ!
White Horsemen who ride on white
horses, the Knights of God!
They, for their Lord and their Lover
who sacrificed
All, save the sweetness of treading
where He first trod!*

The house
of a
hundred
doors

THE curious may care to know that,
finding it impossible to pronounce in-
telligibly those Spanish diphthongs which
are a ripple of vowels, I had secured in
Pampeluna a postcard of Eunate, and
mildly proffered it at the ticket window of
the diligence office and in conference at
Puente la Reyna. It sufficed. The church
of Eunate lies, not many miles thence,
quite isolated in the broad and fertile
valley of the Izarbe, to which I drove over

The Queen's Bridge

in a sort of buggy. It is a pleasant, solitary little place: not even the women cutting hay and turning brown moist earth, will cross three fields to say a prayer. The priest comes seldom. Like a boulder in a mountain pasture, it lies there detached but not incongruous.

I know a little about circular churches, less about octagonal, but some, I am credibly told, exist in Asia Minor; I know also one at Laon, one at Le Puy, and one at Segovia in Spain, all three given popularly to the Knights of the Temple: likewise an *ermita* at Torres, on the Logroño road. There is also the church of S. Marcos in Salamanca. It is conceivable that they fetched their plan from the East for those churches and this. The forms, however, of column and arch, of moulding and capital, are those of the region round about.

The church is an irregular octagon with three-quarter columns and capitals at the corners and corbels under the roof. The pentagonal apse has the same column and corbels, and a window with jamb shafts, a bold roll-moulding, and a plain

Circular churches

This, octagonal

dripstone. On five of the eight sides a
strong pointed arch in the masonry of the
wall reaches a trifle higher than the apse.
It is roofed by slabs of stone overlapping
from cornice to centre, laid with plenty of
mortar. Wild grasses wave there. The
entrance is now at the west and a strong
north door is blocked up on the inside by
a wardrobe; a winding stair goes up to roof
and bells in a projection that on the out-
side rather spoils the proportions but was
once the base of a belfry. In the body of
the church, the shafts in the corners of the
octagon go up to a plain string-course level
with the sills of windows, which are open
in the second and third sides and in the
others are blind niches: from the capitals of
these shafts rise others, smaller, to sustain
a curved rib, on top of which, again, rests
each of the eight square ribs that support

and domed the dome. About at the haunch of this
occur openings (now covered by the roof-
tiles), in shape alternately lozenge and
octagon.

. The apse is enriched by simple repeti-
tions: the entrance arch consists of two

orders resting on capitals built into the wall, and the vault rests on four ribs which come down on shafts to the window sills. Around inside, an upper arcade has four round arches and one pointed, a lower arcade, all pointed: the shafts which sustained this are hidden by the steps which go around the inside just above the floor. The capitals are made chiefly of leaf forms, but a few show interlaced grotesques and a few show early Gothic. All this is strong building, albeit clumsy.

The thing really characteristic about the church door, outside, is the local style: dripstone carved with a row of debased human grotesques, as at S. Miguel of Estella and *El Crucifijo* of Puente la Reyna; jamb capitals constituted by a rich interlace, as at the same two churches; archivolts carrying a leaf, the grape, and for the rest, rounds and hollows.

An amazing octagonal cloister encompasses the church outside, but can never have had a roof, or some traces of that would remain on the walls. The cloister has been, to be sure, ruined, built up

strong

and regional

plainly by restorers, and roofed along
the masonry with tiles, but now as always
it remains a mere enclosure, a cincture
and not a shelter or screen. It is hard to
recall a parallel for this. In the ruined
cloister of S. Juan de Duero, at Soria,
though the alleys are roofless now they
had once a timber roof, and the cloister
ran around inside an enclosing wall of the
Commandery. Only three of the sides at
Eunate retain their capitals and their
noble coupled shafts: one of these shows
Oriental motives, and one perhaps the
figures of Templars, the rest interlace, or
leaf forms, all of a sort that cannot be
earlier than the twelfth century.

About this cloister Sr. Lampérez[1] offers
an interesting suggestion, starting from
the common admission that the circular
churches of the Middle Age have a double
origin, deriving possibly from Roman
temples like that of Minerva *Medica* and
the so-called temple of Vesta on Tiber
bank, or else, equally well, from the Holy
Sepulchre at Jerusalem, rebuilt by Syrians
for the Christians at the end of the seventh

century. This was from the tenth cen-
tury the goal of pilgrims and crusaders,
and the Military Orders, born under its
shadow, built after its fashion. As has
been said already, in the twelfth century
(1134) King Alfonso Sánchez in his will
invited them to the inheritance of his
kingdom of Aragon and Navarre. Their
power belongs to the time of Sancho the
Wise, 1150–1194, counting from the founda-
tion of Ribaforada in 1157. Supposing,
then, that they built a commandery here in
the last third of the twelfth century, they
had a chance to evoke, in the Spanish up-
lands, the Sepulchre to which they were
dedicated. Now S. Jerome speaks of an
uncovered, concentric atrium which existed
around the Holy Tomb, so constructed
"not to intercept the space by which the
Lord rose into Heaven," and this was
preserved in restorations of the seventh,
ninth, and eleventh centuries, though it is
covered now. If it was already covered
by the end of the twelfth century, still
the Templars might be familiar with the
passage in S. Jerome. This plausible

Holy Sepulchres

The Virgin's also

conjecture would make the arcade now standing, the *inner* side of a gallery that surrounded the church—which would stand, then, in the centre of a wide cloister garth.[2] That there was a whole monastery, of many buildings, all round about the present church where now the plough goes, is well known: labourers still turn up the stones and expose the remains of walls and foundations.

Virgin of Eunate

In 1312 the Templars left Navarre, but their Virgin is still there: unfortunately I did not know of her existence at the time of the visit, and the woman fetched with the keys did not trouble to mention her; as for the priest, he was miles away. Sr. Lampérez compares her with those of Ujué, Villahuerta, and Irache (now in Dicastillo) and considers them all to be of the first third of the thirteenth century. Some other observations of his are of value: for instance, that there is nothing Cistercian about the place, but it may be compared with the eastern end of Leyre and the cloister of S. Pedro la Rua (I should urge that the art is not so finished by far)

and other constructions of the region.
The capitals inside, he says, are all leaf
forms (I am not quite sure of this, but
most of them are) and to the Corinthian
scheme they unite a Syro-Byzantine man-
ner. He feels that, in the grotesques of
the north door, with a fantastic fauna
alternate a series of personages that seem
meant for priests in hieratic vestments.
He traces two hands in the work: the
church strong, robust, energetic in orna-
mentation, the cloister slimmer and very
fine and free in decoration. But the two
may well be contemporary.

The right name of this strange temple
is the Basilica of Auriz. Its picturesque
bye-name, Eunate, comes from two Basque
roots, and means "the house of a hundred
doors."

Syro-
Byzantine
manner

Puente la Reyna.

> *Quan lo rius de la fontana*
> *S'esclarzis, si cum far sol,*
> *E par la flors aiglentina,*
> *El rossinholetz el ram*
> *Volf e refranh ez aplana*
> *Son dous chantar et afina,*
> *Dreitz es qu'ieu lo mieu*
> *refranha:*
> *Amors de terra lon hidana*
> *Per vos totz lo cors mi dol;*
> *E non puesc trobar me-*
> *zina.*[1]

Unlike Estella, first mentioned in 1076,
and Sangüesa, called into existence as a
lower town in 1131, Puente la Reyna is a
very ancient place. It was, for sure, before
the Moors; it was, perhaps, before the
Romans, for it lies on a main road at the
crossing of a river; but in importance it
ranks simply with those other twelfth
century towns which were stages along the
track of the pilgrimage. The bridge was
the work of Doña Mayor when Sancho III
was building the great Way across Navarre,
or possibly of her daughter-in-law, Doña
Estefanía, the queen of García Sánchez, *él
de Nájera.* The town figures in the reigns

of Sancho the Noble and Sancho Ramírez, in the eleventh century, and in 1122 Alfonso *el Batallador* dowered it well, with privilege of wood cutting and tillage, and water free, "for the desire I have," he wrote, "that here shall come to dwell all peoples, and that they shall make a great and excellent town." When, he wrote that phrase about all peoples, he meant more than Navarrese, or even Spaniards: Lombards and Provençals, Normans and English, Flemings and French, Burgundians, Germans and Dutch, Hungarians, Irish, Tuscans and Romans and half Saracen Sicilians, all who passed incessantly on the same journey westward, under the bright stars. The real life of these towns was from the twelfth century to the fifteenth only, and the greatest centuries of the pilgrimage though not the most crowded were the centuries of the Reconquest, the eleventh, twelfth, and thirteenth, when Spain was just, as we say, opened up for the rest of Europe, as a fresh field for enterprise. There was a hearing at the capitals and the castles, for poets

like Guillermo Aneliers who wrote the *Civil War of Pampeluna.*[2] There was a market for the peddler, with thin silk from Sicily and thick silk from Lyons, or furs from Muscovy and beyond; and at the very core of one of the saddle-bags, safe from a fall on the mountain side or a slip in the ford, something, enamel or jewel, small in size, light in weight, and more precious than the ingot gold. That peddler was your great purveyor of taste. You see him as painted up in S. Isidore of Leon, in the month of May, leading his donkey, in eleven-hundred-something: and again in a background of the Grimani Breviary, at 1500. In May, when the snows were out of the mountain passes and the spring floods had gone down, he set out from Marseilles or Venice or Barcelona, or Toulouse, maybe, or Bruges, where he would have wintered in comfort. He loaded the two beasts which are all one man can manage, with a few things of the very best, with Flemish cloth and linen from the fairs of Troyes. To great ladies he brought a veil of cypress lawn, to great

abbots a bone, or enough embroidered stuff to make orphreys for a vestment. [3]

To the adventurous youth of Christendom, Spain offered a never-ending Crusade without the sea passage. In 1085 French knights were enlisted for the siege of Toledo; in 1096 for Huesca, in 1118 for Saragossa, in 1116 for the defense and re-peopling of Tarragona. There were so many Franks at the conquest of Toledo that they gave their name to a quarter; at that of Valencia nine years later, that they left it in streets along the coast-wise-lying towns. There I saw it. Bretons, Aquitanians and Gascons figured in the Aragonese conquest: the Crusader's vow was commuted to the Normans at Tarragona; Seville was divided into the streets for Genoese, Franks, etc. The White Company of Du Guesclin, the Black Prince's troops, came and went across the north, and left their wounded sometimes, and carried off sometimes their girls.

A pilgrimage was only a little less exciting than a crusade, and needed less experience: it could be made during convalescence

A never-ending crusade

or retrenchment. Monks were always travelling, messengers constantly coming and going between Rome and the great abbeys, great clerics moving on diplomatic business between kings. The circle of European politics suddenly included four more kings at least, as possible husbands for daughters and fathers for queens: the Spanish kings married, so to speak, very widely. Daughters established in strange lands sent home strange folk with gifts and letters; alien queens in the land brought their households and their ways when they came. Spanish students made their way to Padua and Bologna, to Oxford, and above all to Paris, where the College of Navarre was founded in 1304. On the tramp they took in as much of the world as could be embraced; other nations by the thirteenth century came to Seville and Irache, and in Barcelona the B. Ramón Lull lectured to four thousand students. Clerks came down either to get learning from the Arabs in the south and east, or to pick up the scraps in the northern towns as these were retaken. Monks came

across the Pyrenees in hungry droves, and
settled down in the plains of Castile and
Aragon like grackles in a cornfield. The
best of them intended to sit by a king's
shoulder: the least of them could count on
a grange or a mill. Where churches and
castles were building, and convents and
whole cities, labour must automatically
move, workmen must press, sure of good
wages and steady work. Where great
crowds are assembled, vast numbers con-
gested or in motion, there you will find the
vermin that like close lying, warm sitting,
thieves, robbers, pickpockets; also the pro-
fessional cheat, or confidence man; and the
relic-monger. So, too, the huge and shift-
ing company will take kindly to diversion,
and give up to the professional entertainer
an honest livelihood, one fairly earned.
Puente la Reyna would be full of fiddlers,
story tellers and jongleurs, and many of the
same occupation as S. Mary of Egypt.

Police duty would not be light in such a
place. The town was in the hands of the
Templars from 1146 until they were ruined,
and they were succeeded by the Knights

Monks

*Profession-
al enter-
tainers*

of S. John. These, both, were soldiers and were monks, they ensured discipline and military justice, which has the great virtue of certainty.

Their church, *El Crucifijo*,[4] was not finished till after 1487, under John II. The chancellor of Navarre, D. Juan de Beaumont, in 1448 founded, with Papal approbation, a Hospital of *Frailes Commendadores* of his order, in the place where the Templars had kept one for the pilgrims going to Santiago de Galicia, it being then ruined by wars and calamities of time past. To celebrate the solemn foundation a provincial chapter was held in Olite, to preside at which the Grand Master sent a special representative, and to magnify which Eugenius IV gave many graces and indulgences. These included the faculty for a contraternity of three hundred members, whose alms should sustain the hospice. The king himself and his son the prince of Viana were members. Sir John Beaumont, who was Grand Prior of the order as well as institutor of this Confraternity of the Crucified, desired to be buried in their

church, but at the time of his death in 1487 it was not finished, and only in 1577 were the bones moved thither. Today the church is ruined, between the restorations of wealth and the destructions of war: the tombs survived down to 1836. It would seem from the description preserved and the recollections of old men in the 70's and 80's, that it was in some way influenced by that of Charles the Noble. Standing in the *Capilla Mayor*, on the Gospel side, it was fashioned of choice alabaster, with a kneeling effigy likewise of alabaster and an epitaph in rather bad Spanish verse, but the urn or sarcophagus was adorned round about with figures recalling the great lord's burial: priests, the celebrant, deacon and sub-deacon, the sacristan and acolytes with candles. This may, of course, be the description of one of those long ceremonials that in the fifteenth century filled the niche in which a tomb was set. Throughout the northeast of Spain, at the tomb of Mossén Francés de Villa Espesa, in Tudela, at that of Bishop Lope de Luna in Saragossa, on fragments of others in the Museum at

A ruined sepulchre

Lérida, you find them. But, considering
the position, it may well be that an altar
tomb like those at Dijon and Pampeluna
was ordered and commenced and that in
the sixteenth century the family, at the
time of translation, completed it with a
more fashionable sort of effigy.

The pointed south door of *El Crucifijo*
survives, though wasted by weather.
Three shafts in the jamb are patterned
over with knops and other diapers: the
capitals were apparently in the style of
some at S. Miguel of Estella and at Eunate,
a sort of interlace with creatures caught in
the creepers. The abaci have a leaf pattern
or *entrelacs*. Of the archivolts: the in-
most order is of these very fine *entrelacs*
that recall, in their spirit and felicity, the
work at Bari by the eastern sea, and Trani
that great entrepôt of the Crusaders. In
the next order is a pattern that I have not
seen elsewhere and that resembles nothing
but the crimped curls of butter that come
in with your coffee and *croissants* in France,
but whereas those are incredibly thin, these
are rather solid, almost like the half of a

fluted spindle. Follows, in repetition, an elaborate complete ornament made out of the honeysuckle: then a row of grotesques, some leaf, some animal forms, pine cones, an angel, a head, beasts and birds, harpies, and birds pecking; lastly, a large leaf for the dripstone. Sr. Lampérez suggests[5] that the carvings are imitated from Byzantine ivories. The archivolts are, excepting the row of grotesques, quite unlike anything else that I know in the region, and those grotesques are unlike in detail, though in method of application similar, to those at Leyre and Aulnay. The artisan copied such forms as fell under his hand and applied them as he was used; the sculpture of the jambs, though cunning and over-refined, is in a style disused elsewhere after the Romanesque age, or at any rate after the transitional style, and it is well to have the dated example.

At the church of Santiago, in the heart of the new town, the western door is very plain, with a round arch, early Gothic capitals, and the chrism in the tympanum. The south door, however, is magnificent

Oriental carvings

Santiago

and full of delight, though cruelly worn by weather, especially on its western half. The jambs are of a style to be found at Estella, where five shafts are separated and flanked by others much slenderer, topped each with a human head. The richly carved abacus and storied capitals are carried in a continuous band from the face of the door all the way across the buttresses that flank the entire portal. On the face of the east buttress this band is filled by three lions, on the west by four syrens or harpies; the style is like that of the latest decorative work at Sangüesa but much finer. They represent probably, for all their beauty, the two great Wrongs: sins of Wrath, the lions; sins of Desire, the harpies. Above this on the western buttress is a headless relief of a man fighting a lion that symbolizes the strife of soul and body; that on the east is too worn to decipher.

There is no tympanum; the round arch of the doorway is deeply cusped and the face of it carved with a series of seven medallions or scrolls of the days of creation. In the archivolts, the innermost row

contains chiefly birds, and the next grotesques: the outer ones, Scriptural scenes: a pair of prophets, the Visitation, the Announcement to the Shepherds, and Flight into Egypt, the Epiphany, Herod and the Kings, the Massacre. Cruelly wasted, but still fair, it is all late and rich pictorial sculpture. I should not dare to suppose that it was earlier than the second half of the thirteenth century. In justice it should be said that Sr. Madrazo[6] wanted to give it to the time of Sancho the Wise or Sancho the Strong, a hundred years before this, at the same time referring the forms of the portal to the contemporary style of Poitou and Saintonge. In any case it is older than the church, which was built completely over in the fifteenth century, probably under Charles the Noble, who reared himself pleasure palaces here, with bosques and parks. In 1410 Simon López was master of the works at the castle.[7] Of the workmen or the work on the church, we know nothing. Very high and wide, of a single span, the vaulting rests not on columns but on the semicircular inner

face of buttresses of which the projection is inward, into the body of the church. This is the practice at Albi and other places in the south of France, and over the border, at Irun and S. Sebastian. The space between the buttresses is regularly vaulted over in a narrow bay, to form lateral chapels: the transept is deeper than these; the portal opens out of the last bay on the south: a rococo retable blocks the apse and a still more rococo organ the western gallery.

There is a third church, S. Pedro, plain on the outside, with a western door rather like that of Santiago and an interior of the latest of the fifteenth century. In the twelfth century the townsmen of Murula-barren, attracted by the advantages which D. Alfonso *el Batallador* and D. García *el Restaurador* had offered, migrated hither *en masse* and settled in the quarter of S. Pedro; they may have built this church.

For some reason, Cisneros spared the fortifications of Puente, and the hugeous wall,[8] built against and into, brown and high, looms behind the sycamores of a

shabby *Paseo* which gets nothing from the river, not even a view of the beautiful Queen's Bridge. Inside, the streets are narrow, and the children ignorant and wretched—the worst crowd, perhaps, that a woman alone had ever to deal with. The woman in question was driven to earth at last in the Town Hall, ringing the bell there very much in the temper of the poor old horse who nibbled the straw rope in the famous story and sounded the appeal for justice. The town clerks and councillors were all at home and asleep in the long noon, but a frank old woman, who lived in the tower, was persuaded for a while to lend a chair, a kitten and some attention. She felt it not only natural but laudable that children on seeing a woman alone should assume she was dissipated (*borracha* was the word), and hustle and hoot her, and after a bit, growing sleepy herself, and having run through all her family history and that of her husband's relatives, she wanted to lock up, and sent the strange woman packing. By this hour, however, the children were in school, under the

"Company with honesty"...

charge of the quaintly named *Padres Escolapios*, so that it was possible to escape to a bench under the dusty sycamores, and to wait there for the returning diligence. Government schools are said to teach something about a common humanity, and manners toward the outlander; where only parish and Jesuit schools are found, they wot not of such things.

When the diligence came, it had not a vacant seat: the driver and conductor, undisturbed, recommended not as an alternative but as the only action, sleeping at Puente and taking that which would pass early the next morning. One had no night things, one could not believe that any inn might be tolerable, one simply didn't see how, at the end of a long day, to walk the ten miles or more to Estella, but certainly one was not going back like an abandoned cat to the hooting and hustling children of those streets. As a last resort, the woman alone became a lonely woman, very pitiful —afraid to sleep in a strange place by herself, afraid to leave a timorous Jehane by herself overnight in Estella. Incontinent,

four strapping Navarrese lads packed themselves into the space provided by statute for three, and in contentment that amounted almost to hilarity, the diligence swept on to Estella. For this unexpected repudiation of law, decency, and invariable Spanish practice, may places be found hereafter for the driver, the conductor, and the four Navarrese, among the blessed.

El Sepulcro.

Happy day and mighty hour,
When our shepherd, in his power,
Mailed and horsed, with lance and sword,
To his ancestors restored,
Like a re-appearing Star,
Like a glory from afar
First shall head the flock of war!

At about the same distance from Estella in the opposite direction lies another example of the same rare type of church as Eunate, finer and more splendid, albeit unknown. *El Sepulcro* of Torres, octagonal, has dome and lantern, projecting apse, and separate staircase turret intact. The

Logroño road curls around a hill-set city, and then in a wide curve sweeps down steeply to the shallow river valley: and thence you look across to Torres on the ascending hill, and catch the sun on lantern tower and arcaded sides. Travellers, on the other hand, approaching from Viana, may see from the post-road the tower reared above thick trees, and guess what must sustain it. Yet the church, unknown to Madrazo, remains such, undivined by Sr. Lampérez; a French ecclesiologist, it is said, driving through the country eight or ten years ago, before private motors had grown general, saw, and stopped to see more and to photograph, and was much molested by the crowding curious children. They are indeed tiresome as gnats, but not bad-hearted, except one boy, cross-eyed and cross-spirited; and their elders rebuked and dispersed them a dozen times, but always they gathered again, filling the open doorway of the empty church, and blotting out the patch of sunlight on the floor. While the stranger who so intrigued them was taking measurements and photographs,

El Sepulcro

the Mayor arrived and exchanged a few
civil phrases, likewise a tall spare person
all in cool linen clothes, the richest there-
abouts. He supplied the recollection of the
earlier passer-by, who can only, in conjec-
ture, figure as M. Bertaux. Down at the
inn on the post-road, friendly folk kept deli-
cately out of the way, and the traveller
lunched alone, and alone awaited, over a
novel, the evening coach to return, without
so much to bear as a curious glance from
the hall: with only a murmur of voices
quiet as summer flies, reading and dis-
cussing the newspaper that she had brought
down that morning by chance. Oh, the
courtesy of these small Spanish places, so
conscious yet so sure! Just because it is
not spontaneous and necessary and per-
sonal, as in Tuscany, it tastes the sweeter.
Here the landlord still feels himself the
host, and the traveller the guest. The
pretty daughter of the house, who served
the table, was found in calico at the early
arrival, and dressed herself in serge for
dinner, and dressed her black hair, and
craved pardon because the cares of house

and kitchen prevented her sitting down to entertain. The same careful grace marked the gentle hunchbacked postman who had fetched the key and opened the church; after his round with letters, he came back prepared to remain as escort or depart as interruption, with no will except to know the other's wish. The day would have been sweet enough with human pleasantness, apart from the sportsman's zest in hunting churches and finding such game.

A little in history

The town of Torres figures a little in history, like any other: near the road there was in old times a monastery, and the church attached to it, of very good and firm architecture, which D. Ximeno Galíndez gave to Irache in 1100.[1] The parish church, which is dedicated to S. Peter, has only a small establishment.

When in 1134 Alfonso *el Batallador* left his kingdom by will to the three Orders of the Hospital, the Temple and the Holy Sepulchre,[2] the Canon Giraldo, who was sent over to take possession in the name of the third, was unluckily sir clerk and not sir knight, and the Order consequently in Spain

was ecclesiastical and not chivalrous. In 1141 the Patriarch and Chapter in Jerusalem ceded their claims on the kingdom, and received in return from Ramón Berenguer territory and vassals to found a church in Calatayud, next to the Mozarabic quarter. Alfonso VII of Castile took a liking to the Order while he held Calatayud, and introduced it into his dominions, giving it property in Toro and Zamora; in Salamanca, the church known now as S. Cristóbal; in Segovia, that dedicated to Vera Cruz[3] and wrongfully assigned to the Templars which was dedicated in 1208. In Logroño the same canon Gerard, who founded the church of S. Mary at Calatayud, founded a church and chapter: the King had given his palace there to the Order, and this will be *S. María del Palacio*. In Aragon, there were houses also at Borja and Huesca, and in Catalonia the Colegiata of S. Ana; there were houses in Valencia and Mallorca. Of the two nuns' houses, that in Saragossa still exists, and these *Comendadoras* are the only living members of the Order in the world. I can find no mention of a

daughter house at Torres, but this is not evidence that there was none: a document ot 1303 is signed by Fr. Joanne Petri de Torres, among other witnesses, and the same Fray Juan Pérez of Torres was Prior in the years 1385 to 1391. In 1489 the military orders of the Holy Sepulchre and of S. Lazarus of Bethlehem and Nazareth were suppressed and their goods made over to that of S. John, by Pope Innocent VIII in the Bull, *Cum solerti meditatione.* The Bull was not everywhere well received; in Aragon it was ignored. I find the Prior of Calatayud exercising jurisdiction spiritual and temporal in the early sixteenth century, over the five towns that still belonged to the Order [in Aragon?]: Nuevales, Tobed, Torralba de los Frailes, Codos, and S. Cruz de Tobed. Torres, however, is in Navarre, and La Fuente says explicitly that the Order had two provinces and by the same token celebrated chapters. [4]

The Prior of Calatayud took precedence, and called himself sometimes Grand Prior. His church was begun 1144, [5] consecrated

¡Arriba, canes, arriba!

first in 1156, finished and again conse-
crated 1249.[6]

In consequence of the dates, fixed by the
Baptistery at Parma, at the beginning of
the thirteenth century, and the Crusade
under Theobald of Navarre, in Anatolia
and the Taurus, in the second quarter, the
church of S. Sepulchre at Torres must be
assigned to a time well along in the thir-
teenth century.

King Ty-
balt in the
Taurus

The wall arcade outside is pointed;
noble columns run the full height at every
angle; noble windows fill the centre of each
bay in the stage above and admit light
through pierced stone tracery into the
interior; two windows under the wall ribs
flank the apse. The door is a low round
arch, a third of a circle, with the Patri-
archal cross † carved on the tympanum,
with the hood-moulding carved in dog-
tooth, and a leaf on the abacus at the
jamb.[7] Shafts and capitals are lost. The
corbels under the roof are fluted in four
scallops, horizontally, the nearest thing to
this being the supports of the cornice at

Celanova, where the Mozarabic work goes back to the ninth or tenth century. The cornice is a shallow hollow in which lie balls,—a Romanesque motive in Spain, already seen about Jaca and on the way to S. Juan de la Peña. The lantern, floored and blocked up, like that of S. Cruz de la

Serós, has a small, round-headed window in each face and a column with blunt capital at each corner, a heavy cornice, and a door that opens on the western side, to which lead steps from the staircase tower. This lantern and the access to it resemble probably those originally at S.

Martín of Frómista. The roof, like that of Eunate, consists of heavy slabs of stone, now well sunk in mortar. It carried once a stone cross over all, but that being destroyed not long since by a thunderstorm, a clock was set in, of which the face occupies the south wall, and the weights hang down, outside, in the north-west angle between church and tower.

Inside, a low stone bench runs all around, and the shafts of the lower range have disappeared, but their capitals, billet

moulded, project from a string course of the same pattern, and on these descend the upper columns. Outside and inside, the church has a tripartite division marked by horizontal lines: without, one crosses at the springing of the wall arch, and the other at the sills of the windows: within, one at the point where the arch of the apse springs, and the other where the dome-ribs and the vault begin. The capitals of the upper range are varied: an oriental rosette of whorls, a centaur, a formal pattern based on the honeysuckle, pine cones, a leaf pattern based on the acanthus, network, leaf and pine cone, leaves in two rows forming a rich and broken pattern. It is vaulted with ribs that pass across and leave an open star at the centre: these come down on the shafts just named, at the corners, and on corbels fluted like those without, in the middle of each side. This sort of vault Street saw in a chapel of the cloister at Salamanca, and the present writer saw in one at Las Huelgas. It is Mudéjar: the workmen may have come from the Mozarabic quarter of Calatayud,

Capitals

and vaults

or from elsewhere: in 1211, a certain Miguel de Burgana gave to the Prior and the Canons a Saracen slave that he had in Gotor.[8] In the vault appear eight tiny windows of pierced stone, crowned with Mudéjar cusping like some at Toledo, and by tabernacles, "heavenly Jerusalems" like those of the school of Chartres. The same sort of tabernacle reappears on a capital at Sangüesa, which belonged to S. John of the Hospital, at Villasirga, which was a Templar's church, at Carrión close by, and at Moarbes copied from Carrión, but these are not the only instances, even along the way. In the case of Sangüesa,

Torres, and Villasirga, it may refer to the earthly Jerusalem, of which the lords in some sense all were knights. At the entrance to the sanctuary, where under a pointed arch a section of pointed barrel-vault precedes the semi-dome, stand two columns with well moulded bases and storied capitals: on the north, the Deposition in a form that seems copied from Master Benedetto's at Parma,[9] on the south, the empty Sepulchre left after the Resurrection, as at Arles.

The design on the abacus I do not under-
stand, unless it was imitated from metal
work. In the upper part of the two bays
nearest the apse, windows open, their jamb
shafts duly storied in the Romanesque vein.

Here, then, is oddly assorted matter,
gathered up by the side of the Way: capi-
tals derived from Greek, from Roman, Sources
from Romanesque, and from Oriental
sources, handiwork recalling Mudéjar,
French, and Italian artizans. The re-
miniscence of Parma might seem far-
fetched, on the writer's part, or fortuitous
on the sculptor's, were it not for another
still more striking at Estella, in the Last
Supper of S. Sepulcro there. Thus it falls
into place, and clinches the link already
forged, in old records, of pilgrims passing
along the great routes. It is possible that
whoever brought the design of the Deposi-
tion, brought also the way of building,
having seen Master Benedetto's Baptistery,
commenced in 1196, well under way; and,
though simplifying, imitated the structure.
One more note: I recall at this moment only
two places in which a window is pierced at

the point where a plane is tangential to a curved wall: these are, the apses in the *Terra di Bari*, at Bitonto and Bari, for instance, and these windows in the dome of the Sepulcro. Now all that *Terra di Bari* was full of pilgrims and crusaders, arriving and departing; Trani was an important seaport. Straight through it ran the road to Brindisi. Lombard builders and French were there: Roland too; the knights, Oliver, Archbishop Turpin, and all the *Chanson de Roland* on the cathedral pavement. Though there are examples in the highlands of Asia Minor, recorded by Miss Lowthian Bell, of the apse-windows, I am not aware that this particular architectural device in domes is oriental: if it was invented in Italy, returning travellers might bring it with them; if in the Anatolian plateau, then the Crusaders of Navarre. Their trobador king Theobald, who had embarked with them at Marseilles in 1239, led them straight into the Taurus to fight

the Soldan of Iconium.[10] The road into France ran by Parma, Borgo S. Donnino, and Modena, and the road from France

to Santiago passed near S. Cruz and S. Juan de la Peña, through lands certainly of the latter. So this exotic church need not be fetched like the Holy House of Loreto, through the air: there is a good road all the way.

A good
road

VI

TOWN CHURCHES

Arga, Ega y Aragón,
hazen á Ebro varón.

IN the midst of vineyard and olive-garth, with noble approaches and skilful gradients, the road runs fast, past Puente la Reyna and Cirauqui, down to Estella on the Ega. After you have crossed the Queen's Bridge, there is a great patch of green and bosky mountain-side to get around by long white loops of road, but for the most of the way, little towns lie close: Mañeru, where ancient houses stand about a mountain stream, and which belonged as early as the thirteenth century to S. John of Jerusalem, and as late as the sixteenth paid heavy taxes to *el Crucifijo*, just back there on the road: Cirauqui, that

climbs surprisingly up the rock and rears
a church portal reddish brown like porphyry,
pointed and cusped and *répoussé* with
innumerable mouldings,[1] two church towers
further away ennobling the steep streets.
By Lorca the grey of olives hangs like
smoke over the brown soil; Lacar huddles
among low vineyards; in other towns
unnamed a flat mail-bag is dropped or a
letter snatched, without stopping, from a
waiting woman. After Villatuerta, twice
burned in the Middle Age, the road de-
clines into the softer valley of the Ega,
where fruit-trees dispute the enclosure
with grape and olive, and the retreating
hillsides are terraced into gardens. The
Ega, green like a Swiss torrent and flecked
with white, draws the road swiftly up its
course and past a straggling suburb of
mills and tanneries, over which towers the
Apostolado of S. Sepulchre: at last the road
broadens and pauses at Estella.

The phrase used regularly for these
towns is the just one, they are situated *on*
the old road, that is to say alongside it. A
French highway, as you follow it, runs

<div style="text-align: right">Little
towns</div>

into a village and out again, and the High Street of English towns is often a segment merely of the line stretched from sea to sea. But here the little towns draw their walls about them, and lock out the passing troops, the tramping pilgrims: even where, as at Estella, a suburb throve on the farther bank of the river, still there was a clear track left for the road and those upon it, against which gates could be barred.

When Sancho Ramírez was building the Pilgrims' Road he determined that it should pass thereby and a town be established. The monks of S. Juan de la Peña held a place less than a league off, Zarapur by name, and they wanted the road to go their way and bring traffic and custom of sorts. The story reads like the early history of railways, in the intrigues and pressure brought to bear. The king won, after a fashion, the road passes through Estella, but he had to yield to the monks what tithes and churches were just coming into being, and a tenth of the royal rights. As late as 1174 the abbey was adjusting

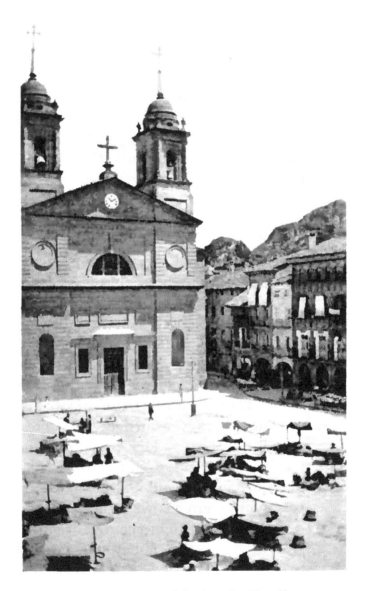

The Thursday Market in Estella

matters with the Bishop of Pampeluna, and keeping in its own hands the control of S. Miguel and S. Sepulcro, while S. Pedro la Rua remained as always a direct dependency. Sancho the Wise, when he founded the church of S. John and peopled its parish, gave it to another monastery — Irache. After that things went easier: townsfolk bought rights for themselves,— that Thursday market under Jehane's window they purchased from Theobald I.[2]

A sweet place it is, and a comfortable, the burgher using always to sleep soft and feed high. Aymery Picaud stayed there, and liked the cooking: he praised the bread, the fish, the wine. We stayed there long, in the *Casa de Gorgonio* that outlanders would call the Hotel Comercio, where the son of the house is a heaven-born cook, and about whose *œufs à la Béchamel* Jehane still feels as felt Aymery about the fish. The house was clean, kind, and quiet. We had choice, on arriving, of two dining-rooms: whether to eat at a little table quite alone in the room except when motor-people stopped for luncheon or dinner and hurried

Thursday market

on, or for a lesser price, at the long table, which Spaniards idiomatically call *mesa redonda*, partake of the identical meal served hotter. There we elected to practise Spanish and good manners. On the rare occasions above mentioned it accommodated the chauffeur at the other end, but he looked as a rule more interesting than his employers, and had always more to tell that was wanted about roads and distances, inns and connexions.

The upper town, called Lygara, was peopled by Sancho Ramírez at the end of the eleventh century with *francos*—which may mean free men and may mean Frenchmen, *i. e.*, subjects from the north side of the Pyrenees. *El Parral*, the vine-garth around S. Miguel, was constituted by Sancho the Wise in 1187, who gave the same rights as other freemen enjoyed on condition of a sort of ground-rent. In the same year he had founded the church of S. John on the Sands, in the river-side place called *el Arenal*, in which the Jews congregated. This he gave to the monastery of Irache. The town was reduced under a

single government only in 1266, by the
Frenchman Theobald I. The Jews, who
had enjoyed by the laws of Navarre liberty
of person and property, were under the
same king driven out of their quarter;
they gathered in the steep streets around
the castle, and walled their Ghetto, which
however was sacked with slaughter in 1322
under the direction of a Franciscan friar
Pedro Olligorzán. In 1329 the townsfolk
again sacked the Ghetto, though walled
and gated: the land where it stood still
lies waste. Later on, when in 1492 the Jews
were expelled from Castile and Aragon, the
queen and king of Navarre, Catherine and
Jean de Labrit, wrote to the governing
body of Estella to give the exiled Jews free
passage and aid, and "give settlement in
Estella to as many as possible, for they are
a docile people, easily subject to reason."
In the end, unfortunately, the king of
Navarre had to yield to the general up-
roar and the fixed policy of the Catholic
Kings, and the Jews had to move on.

The truth of course is that in the first
place they were too prosperous, and in the

second place the feuds between Francos
and Navarros had been patched up that
year of 1329, and the town had need of
blood. It is said that ten thousand died
at this time in Estella alone. The town,
naturally, throve. When after the battle
of Salado the value of gold fell by one-sixth
in consequence of the quantity of precious
metal in the booty taken, the old chroni-
cles state that the effect of this was felt
in the markets of Burgos, Bruges, and
Estella, these being the greatest trading
centres. As early as 1254 the *tabla de
cambio* of Estella was universal, or nearly.
The rich merchants filled up, in the thir-
teenth and fourteenth century, the streets
that the Jews had built above the river-
side, and they built them a church de-
dicated to *S. Salvador del Arenal.* Early
in 1264, Theobald I had given to the
Dominicans the church of All Saints on
the hillside above, which had been a
synagogue till García Ramírez *el Restau-
rador* gave it to the Bishop of Pampeluna.

Commerce flourished. Alfonso of Cas-
tile, *él de las Navas*, on February 1, 1205,

gave to the merchants of Estella the right to traffic in all his realms and lordships, without any person's impeding them, and Jaime I *el Conquistador*, in midsummer of 1254, gave them the right of trade and contract in all his realms under royal protection.

The merchants had the best of it at Estella, but at times they had suffered, like those elsewhere, under the feet of their betters. In 1206 Sancho the Strong gave the city to the Lord of Vizcaya, D. Diego López de Haro: he entrenched himself in the castle and thence made raids into Castile. During the wars of Charles the Bad, the men of Castile lifted the cattle, and burned the palaces and houses, but in 1390 a privilege of Charles the Noble gàve the town equal rights with Pampeluna. The *fueros* of Estella are often quoted as a sort of norm of liberty. In spite of the Castilian raids and the flood of 1475, when the river Ega rose and destroyed half the city and that the best, the palace of the Dukes of Granada still remains one ot the few grand examples of

D. Diego López de Haro

domestic Romanesque. The carved capi-
tals of the great columns have the vigour
and fire of the cloister at Soria. Other
palaces also, fallen from their high estate,
line the winding street that leads to the
church of the Sepulchre. The castle was
destroyed by the jealousy of Cisneros.

The luxury of the fifteenth century is
reflected in sumptuary legislation of Charles
the Noble. A pragmatic says:—"Inas-
much as the King is certified that the
principal cause of the poverty of the city
consists in the excessive dressing and
ostentation of the ladies and other women,
he ordains, taking example from ancient
princes and from the kings of. Castile and
Aragon, that the said ladies of Estella
shall not be so bold as to wear upon them
either gold or silver, in chains or garlands,
or in any other thing excepting girdles and
buttons of white silver, ungilt, and, if they
desire, on the sleeves only. Further, that
they may not wear pearls nor precious
stones, orphreys nor toques, nor buttons
where there is a gold thread, nor furs of
gris, except, in the long sleeves, trimming

of otter the width of half a skin, and the purfles of the front of a mantle a finger broad of ermine, no more, nor wear scarlet cloth nor clothes of gold or silk. . . . Licence, however, is given to wear clothes already made till they are worn out but not to make new. Item, this ordinance applies also to the Jews." [3]

Not only were there French-born subjects filling the quarters of Estella, there were French shrines. Sancho the Strong in 1201 built and endowed a sanctuary for Our Lady of Rocamadour, just about at the time when the church of S. Pedro la Rua was building too. He had had a bad time in Africa, and once safe home, he gave to the Monastery of S. Mary of Rocamadour, on the road of the pilgrims as you go out of Estella, twenty-three moneys of gold in perpetuity, charged on royal rights in the Old Slaughter-house, and eighteen more charged on the mills of Villatuerta. Of this, thirty-nine was for lights for the Virgin's altar, for his own soul's good and his parents'; of the other two, for incense one, the other for a preacher on certain

A sumptuary pragmatic

feasts. The ancient *fueros* of Navarre recognized Rocamadour as a privileged place of pilgrimage, like Rome, Jerusalem, S. James, and Overseas, and protected debtors during a fortnight's absence:

"Ata qué tiempo non deve ser peyndrado omne que va en romería. Nui ynfanzon que va en romería non deve ser peyndrado ata qué torne. Si va á S. Jaime deve ser segure un mes; á Rocamador XV dias; á Roma III meses; á Oltramar un aynno; á Iherusalem un aynno et un dia."[4]

Across the river and up the hill, the shrine of Notre Dame du Puy is referred by pious tradition to a miraculous apparition of stars in 1085. It is more likely that the devotion came from the greater Virgin of the same name in Velay, whose shrine was flourishing at that date and lay on a pilgrim route, and whose Bishop in the tenth century had gone to S. James. The miraculous image may be of the thirteenth century. There are only two documents, in the archives of the city, that bear upon the church: in one, dated 1386, Charles the Noble acknowledges the gift of some mills from Mossén

Pedro Godillo, Prior of S. Mary of the Peak (*S. María del Puig*); in the other, dated 1174, the Bishop of Pampeluna gives the church of Puy to the seventy members of the brotherhood of Santiago on condition of their paying three maravedis to the Bishop and his successors. The officers of this confraternity included in 1322, D. Benedict of Limoges; and their goods, and those of the Confraternity of Nuestra Señora de Salas, were in the hands of Frenchmen as trustees: Jean Paté, Dean of Chartres, Hugon de Visac, and Alphonse Robray, for "it was not intended that the said goods nor any part of them, should be put in the power of our lord the King."⁵

For the great churches we hold no documents, and must read as we may, from the stones, of their buildings and rebuildings. About 1200 is the date accepted for the cloister of S. Pedro la Rua, and the church itself, with well-pointed arches, can hardly be earlier. It lies so nearly at the top of a steep hill, that the west end runs blindly up into a tower, and down into buttresses and substructures, and the main doorway

S. Mary of the Peak

S. Peter Roadside

occupies the second bay on the north, another opposite, of pure·early Gothic, admitting to the hill-crowning cloister. The pointed arches of the north door are decorated with patterns, billet, dog-tooth, and various chevrons, spirals and diapers, without a tympanum; the arch curiously cusped like that of Cirauqui. On the shafts in the jambs the capitals are partly decorated with leaf forms, and partly with very oriental motives: two bearded griffins *affronté* on one jamb, and on the other a mermaid holding her two tails, a centaur shooting at her, and a superb pair of woman-sphinxes, crowned, with strong curved wings and dragon tails.

The church, of three aisles, without a transept, consists of three bays only, with a western gallery and the *Coro* under it. In the last bay of the north aisle, which is pinched off at the corner above the steep hillside, stands an early retable with a gold ground. The nave has a star-vault of the sixteenth century, the aisles a strong quadripartite vault with moulded ribs and large carved bosses, that show S. Stephen stoned,

S. Andrew as Bishop blessing, the Agnus Dei, etc. The piers, once cylindrical with four attached columns, are most of them spoilt. The sanctuary is raised eight steps, a rare feature in Spain outside of Catalonia and rather Italian-seeming. It is hard to see a reason here, where no tomb or shrine occupies a crypt, unless in mere imitation. The apses have a bay of barrel-vault, and then a semi-dome: those on the sides open upon the central by arches like tomb recesses; the central, arcaded within and without, has in addition three deep niches which on the outside barely show as intercalated buttresses below the fine Gothic corbels that sustain the cornice, but within constitute true apsidioles. In brief, the plan of this apse is French; it corresponds to that of Souillac, which lies only two hours' walk from Rocamador.

The church still keeps, besides its relic of S. Andrew fetched from Patras, a Madonna of Mercy; a fine stone statue of the late thirteenth century, of a Bishop probably S. Andrew; and a fifteenth century wooden figure of S. Peter, quite delightful.

Apse

Of the cloister, timber-roofed, only two sides are standing: by accounts of the ruin it seems they have been repaired within a generation. The northern walk, along the church, has storied capitals and the western, leaf forms or oriental creatures. Here are the sphinxes and manticores and estriches and antelopes that Spain in the twelfth century received from Asian lands.

The great capitals on the coupled shafts are historied all around, commencing all on the garden side. Beginning here at the eastern end, they read on as follows:

Figured on p. 349

The first, finest of all, is very Byzantine: on the narrow sides the Harrowing of Hell and Christ as Gardener, on the broader, the Entombment and Maries at the Tomb; the Sepulchre itself, a dome with curtains and a hanging lamp, the carved sarcophagus, set high on four legs, and in the last scene, half open, the winding-sheet hanging over as at Arles, the angels sweeping down with censers, are all of more loveliness, softer yet more poignant, than Europe then produced ungrafted.

2. The three kings on horseback before Herod; he talks to soldiers and they bring him babies' heads; the Massacre.

3. The Annunciation; Visitation and Presentation; Announcement to Shepherds; and Epiphany.

4. Soldiers fight a lion and a griffin, and savages fight on the broad faces, men and lions on the narrower.

5. History of S. Vincent.

6. History of S. Andrew, including his interview with devils.

7. History of S. Andrew's dealings with the proconsul, one Egeas, including his preaching, judgement, and martyrdom when he said "If I doubted the gibbet of the cross I would not preach the glory thereof."[6]

8. Saintly story, I think the close of S. Andrew's legend.

9. Corner: nine shafts in all, with leaf motives, of a kind that occur at Soria and in the oldest cloister at Las Huelgas.

On the western side the devices, as I said, are very oriental, including birds,

In the city of the Man-Eaters

long-necked and twisted, what the elder English called mantigers, birds pecking, head to head or back to back, sphinxes kissing, small lions regardant above leaves of honeysuckle. These are very like some at Silos; they are quite unlike the Romanesque motives that came through France and may be seen at Fontevrault, S. Eutropius of Saintes, S. Juan de la Peña and S. Pedro of Soria. It cannot be said too strongly that they are not in the least French, even in the sense in which the word is used of the portal of S. Miguel.

Though round-arched, this great door of S. Miguel belongs at earliest to the beginning of the thirteenth century, the porch enclosing it to the fourteenth or fifteenth. The earliest part, probably, is the row of eight apostles and prophets, who cannot have been intended for the place in which they now stand, on either side the arch. They appear to be copied from the Prophets at Cremona. It seems indeed as though they must have been designed for just such a grand row as that at Cremona, which was

Entirely oriental

S. Michael on a Mount

1117

perhaps imitated later at S. Sepulcro of Estella. Next comes the doorway proper, with the capitals of the jamb shafts, the tympanum, and the sculptured archivolts. Here also appear traces of a *pentimiento*, for the figures do not quite attain the just centre, in the successive rows, and for the four and twenty elders there is not space enough to accommodate three couples who are tucked into the spandrel spaces outside. Latest, and of finer and more sensitive work, are the great sculptures that flank the jambs, of angels killing the dragon and weighing the souls, and talking with the Maries at the tomb. None of this work recalls in the least that of Toulouse. The iconography of the scene last mentioned is that of Provence. Now precisely from Arles and S. Gilles came the great rectangular sculptured slabs, adapted by workmen of the school of Toulouse to use in the Cloister at Silos. This work was known at Estella, where the cloister of S. Pedro was under way, and the slabs were adapted by some inventive master to the façade on either side the door, possibly with knowl-

Angelical activities

edge of what Master Nicholas had done,
in the same way, at S. Zeno of Verona.

In the tympanum you have Christ amid
the tetramorph, between SS. Mary and
John Evangelist; a solemn majestic Christ
seated within a beautiful four-lobed man-
dorla, His book marked with the chrism.
In the archivolts, row by row, are ranged
all the company of heaven:

1. Six censing angels;
2. Eighteen of the twenty-four elders,
crowned and making music, the other
six, as said, being placed elsewhere;
3. Ten prophets with scrolls;
4 and 5. Groups illustrating saintly
legends — S. Martin and the Beggar, S.
Vincent, S. Peter, Tobit, Esther, etc.

The capitals run, from east to west, on
one side: (1) Annunciation; (2) Visitation
and Nativity, the Blessed Virgin lying in
bed; (3) Cradle with ox and ass, Shep-
herds; (4) Epiphany; (5) Presentation.

On the other side: (1) Flight into
Egypt; (2) Herod and the Kings; (3)
Massacre of the Innocents; (4) and (5)
the scheme breaks down in an interlace,
a man killing pretty little dragons.

Finally, the great reliefs show, on the left, S. Michael overthrowing the dragon to S. Gabriel's admiration, Abraham holding souls in his bosom, and S. Michael and the devil weighing out more; on the right, two angels at the half-open sepulchre, tiny soldiers asleep below, and three Maries with lovely spice boxes.[7]

Weighing Souls

The themes and treatment belong to the cathedral builders of the Royal Domain, and the technique, the actual forms, are Spanish. In the treatment of the hair and eyes I am reminded of the earlier, barbarous style of S. Juan de la Peña, and some faces in the archivolts, one, for instance, in the story of Tobias, have the curious Greco-Buddhist air of those at S. Tomás ot Soria, which seems to be a graft of that same stock. The only way to account for these incoherencies is to suppose successive workmen in charge: a Spaniard superseded by a Frenchman, and the scheme, which came from the north, carried out by workmen imported from other parts, from Aragon chiefly. On the

Successive workmen

one hand, S. Juan de la Peña owned this church, and on the other, Alfonso Sánchez *el Batallador* was raiding Soria at about this time.

Unfortunately it is impossible to delay the hypothetical rebuilding of the door to the time when the church was altered, for this was in the fifteenth century. The nave, of four bays, is of late Gothic, the vaulting and the capitals that belong to it are quite Renaissance in character. The aisles are quadripartite-vaulted with large bosses, the nave piers compound, with shafts in all the angles. The north transept is early, a bay and a half deep: the south transept of two bays with a great middle-pointed window. The apse belongs to the earlier building, preceded by a deep bay of pointed barrel-vault before the semi-dome; the side apses have simply a pointed semi-dome, and on the north side a window over that, and a shallower apse in the half bay. The south doorway, opening on a tiny walled garden, is early Gothic in character, the capitals a sort of belated transitional, like an outgrowth from Irache.

These two churches, S. Pedro and S.
Miguel, lying both on hilltops, are both
pinched in the last bay of the aisle; S.
Pedro on the north and S. Miguel on the
south. Both want a triforium and a Merchants'
Churches
clerestory, and the two are very like in
style, a style suited to wealthy merchants,
open, comfortable, pleasant, and pretty,
in which one may move about freely to see
and be seen. It is an inland solution of the
same problem that Jayme Fabre and the
other Catalans were to settle after their
own fashion, and that the churches of
Betanzos, near Corunna, met just as well.
Almost as much as early Renaissance
building, is it the expression of a moment of
ease and expansion, the sort of scene in
which to lay the opening of the *Decameron.*
 The tale of the churches is not yet half
told, and two at least cannot be ignored,
that occupy almost a whole suburb, S.
Sepulchre and S. Dominic.

To two monks of S. Dominic, Fray
Miguel and Fray Fortunio, in 1264, Theo-
bald II gave the church of All Saints, that
which had earlier been a synagogue. At

the king's request five years before, Alex-
ander IV had given a Bull, the Bishop of
Pampeluna conceded indulgences, and the
friars preached well and to the purpose.
The convent grew upon the hillside, rich
and gracious; Philip the Fair and Queen
Joan gave baths and a tower; Louis le
Hutin in 1307 ordered the Jews to build up
a wall between the convent garden and the
Ghetto; a great knight and a king's grand-
son, D. Nuño González de Lara, in the
fourteenth century bequeathed his sword
and his right arm. The ruined church
stares from the hillside, wrapped in ivy.
Above the refectory the pointed arches that
once sustained a vast barrel-vault still
stand, sharp against the blue, but of the
church or the cloister little is to be seen
except the plan of a mighty nave, as well
suited to the Friars Preachers as the T-
shaped plan of Italian churches, and a
chapel and chapter-room eastward, that,
given also by Count Nuño González,
wear the delicate and refined grace that the
fourteenth century kept in remote places.[8]
Like the other churches of Estella, that

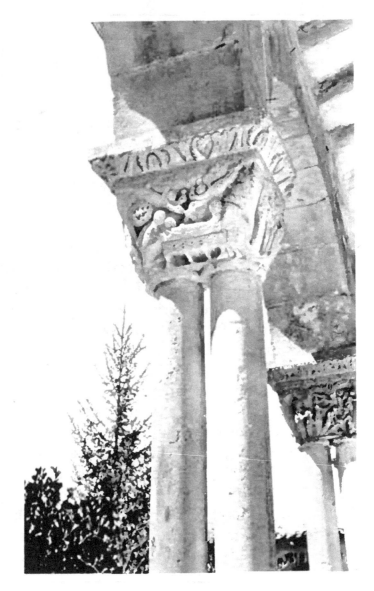

Capital at Estella

of S. Sepulchre is entered from the north side; and Sr. Madrazo[9] is probably right in his suggestion that the church which now stands is merely the north aisle of a great one projected and half-ruined, perhaps never finished.

Some church of the Sepulchre there was in the twelfth century, for in 1174 S. Juan de la Peña, renouncing others, still keeps peaceful possession of S. Michael's, S. Nicholas, and S. Sepulchre.[10] When it came to be rebuilt, "the merchants made the door or portal," says the Licenciate Lezaun describing it in the eighteenth century with more enthusiasm than sense as "having images of saints in half relief and others full-figured, admirable in sculpture and, stuck to the wall of the church, some tombs or ossuaries with stones which denote great antiquity."[11]

The innumerable thin mouldings of the sharply pointed archivolt, the late thick leafage of the very small jamb-capitals, and the arching of the tomb recesses on either side, the cusped arches of the curious arcade under the roof, the statues flanking

the door, and the very exquisite sculptures
of the tympanum, belong to the late four-
teenth century—a little preceding that
loveliest of the cloister doors at Pampeluna
which offers a passage into the canons' gar-
den. In the peak at S. Sepulchre is fig-
ured the Crucifixion with Longinus blinded,
and another pagan, besides SS. Mary
and John: under that, in a row, the
Sepulchre with soldiers sleeping below, and
an angel sitting above, the three Maries,
Christ bringing up the patriarchs from the
yawning jaws of hell, and the *Noli Me
Tangere*. On the lintel is set a beautifully
Cena ordered Last Supper, far more solemn than
those at Pampeluna or Toledo. It closely
resembles that on the related portal at
Ujué, but it would seem that these two
astonishing architraves are not copied
one from the other but both, with dis-
coverable likenesses and variations, from
the Modena-Parma-Pistoja group.[12]

Estella and It is pretty plain, from the mouldings cf
Ujué these two doors, the forms of the bases to
the wide jambs, and the treatment of the
capitals, that the portals as they stand are

the work of one man. These elements show precisely that likeness without identity, which is impossible to a copyist. The sculptures of the door at Ujué must be later than the lintel here, but the group of the Epiphany is more Gothic in its vivacity of action and relative simplicity of drapery than the tympanum sculptures at Estella. At Ujué, in somewhat the same way, the apostles at the table are very deliberately individualized. On the architrave at Estella they are kept back in a straight line, and the conscious quaintness of Judas's position, at the front of the table, is given up. We càn, more or less, date the door of Ujué: Madrazo says[13] he has reason to believe that it was built, like the nave, under Charles the Bad, who died in 1387.

The Apostolado that flanks this portal directly under the roof, is certainly earlier than the doorway and not made for the present place; earlier than the statues of Olite; and in situation more surprising. Its position is like that of the sculptures at Carrión, Benevivere and Moarbes, that lie along the Way. In the figures of the

One artist

Apostolado

Apostles may still be traced the same style as on the portal of S. Miguel, in the conventions of eyes, of head, and of hair; both short and curled, and long and waving. The style, however, is dying out. If a great church was planned on this site, the figures may have been intended for the western façade as at Carrión, and when the plan was abandoned in the fourteenth century, and the main portal established in the flank of the north aisle, the architect put it under the roof, in a square-headed arcade, gave up the Apocalyptic Christ at the centre and, copying the portal, with variations, from S. Cernin, adorning the angle of the archivolts with six little angels, he set the transfigured Saviour alone, on the finial that crowns the arches, which has a little roof all to itself, lifted above the rest. He carved the tympanum suitably to the dedication in a style not identical but possibly contemporary with the corresponding one at Pampeluna, and then underneath that tympanum, and below the level of the jamb-capitals, he set a lintel left on his hands from the

in two genera- tions

abandoned western doorway, carved half a century before with the Last Supper in imitation of that at Pistoja.

If the patient reader enquires why Pistoja, the answer is, first of all, because it looks like that one, and secondly, that the connection was facile, for Pistoja claimed a relic of S. James and was in constant relation with the shrine of Compostella, men coming and going incessantly along the road: the reader will then recall Bishop Gelmírez's *Maestrescuela* called Ramiro: and his letter to his friend S. Aton, abbot of S. Giacomo in Pistoja, for some articles to be sent by the pilgrims.

Why Pistoja?

The streets of Estella, excepting that one which runs past the *Ayuntamiento* toward S. Sepulchre in which palace chambers now lodge donkeys and goats, are comfortable and friendly; the squares simple, their *soportales* rather like the Rows in Chester. The city in greatness was commercial rather than courtly, and this is the end thereof. But it keeps yet a green walk by the green water, planted with ancient trees, broad and grassy,

Soportales

starred in spring with flowers, cooled in midsummer by the swift and foam-flecked waters. So dense the leafage, so tall and fresh the grass, one might be walking beside the Cher or the stripling Thames.

Town churches, like those of Estella and Sangüesa, seem to have been built with what means were on the spot, by a king's initiative. Neither the bishop of the diocese nor the monastery which was lord did much except collect tithes. Estella had a *chantier* from the end of the eleventh century well along into the fifteenth. If Alvar García of Estella did not plan the cathedral and fortification of Avila, in 1091, as Ponz believed,[14] yet the plausibility of the attribution remains more important than the truth of it. In 1348 Pedro Andreo, who was master-mason of the Kingdom of Navarre, took charge by royal order of the substructures necessary to support the rock on which stood the chief castle of Estella, the *Castillo Mayor*. In 1387 Juan García de Laguardia, had been master-mason in his turn, who died in two years, and his place was taken by Mar-

tín Pérez Desteilla, which is to say *de Es-*
tella. Charles IV, in 1399, sends this Martín
Pérez de Estella to work at Olite. An
order on the king's treasurer in 1438 calls
for the payment of 149 *libras* and 4
sueldos carlines to Angel Dastean, *mazo-*
nero y vecino de Estella, for work that
he had directed and executed in the
palaces of Olite for the royal marriage.[15]
The work done in Sangüesa by other
workmen of Estella has been told al-
ready: the masons of Estella were famous
and were great.

<div align="right">_{Martín}
_{Pérez}</div>

Irache.

> *"Operuit montes umbra ejus:*
> *et arbusta ejus cedrus Dei."*

Irache lies on the mountain-side a couple
of miles away, under the Mount of Jurra,
protected from the sickly south wind that
Shakespeare disliked, like other men of the
Renaissance, and open to airs from north
and east, that are cool and health-giving;
once set thick about with oaks and live-
oaks. That the Benedictine foundation

was very ancient, Yepes[1] shows reason for
supposing: possibly Visigothic, it persisted
under Moorish rule. It is said that when
Sancho II of Navarre went to besiege the
castle of S. Stephen on Monjardin, he
stopped in Irache and made a vow to Our
Lady there, who gave him victory accord-
ingly.[2] He and his son, D. García Sánchez,
it seems, are buried here. To his son,
the Infant D. Ramiro he gave among other
properties the church and honour [estate]
of S. Stephen at Monjardin; this D.
Ramiro, who had made the pilgrimage to
Rome and Jerusalem, had a fate like Ban-
quo's in the play[3]: he spent his last years at
the court of Castile befriending the orphans
of his hapless brother the last King of
Nájera, *él de Peñalen*; and he was the
grandfather of D. García of Navarre called
el Restaurador.[4] At any rate D. García,
él de Nájera, in 1045 exchanged for Mon-
jardin a convent called S. María de Hiart.

This same hill of Monjardin, it will be
remembered, baffled for long the editors
of *chansons de geste*, until M. Bédier had
the idea of looking it out, geographically,

in the place where it belonged, somewhere near Estella, and in clearing up one point more of mere scholarship welded one more link of his argument that the *chansons de geste* grew up along the Pilgrim Ways.

Five years later D. García founded a hospice for pilgrims and dowered it well. At the very beginning of the restoration of the Church in Spain the monastery of Irache was very rich, and it came by the time of the Renaissance to claim nearly all the land in Estella, and to have many monasteries dependent upon it: at the beginning of the twelfth century, there were at least twenty-six, for the Abbot S. Veremund besides working miracles, so that the blind could see, devils were expelled, and the like, collected monasteries, and nine more were added in the remainder of that century or in the next. The monks early accepted the Rule of Cluny but never the authority, nor, indeed, that of any prelate until 1522; since then, until 1833, it contained a university that ranked with Salamanca, Valladolid, and Alcalá, and the *studio* of Sahagún was transferred

Hospice

S. Veremund

thither, in 1560. Yepes's chronicle was
commenced here, and printed, two volumes
of it, in 1609; the third, dated at Valladolid,
was, the author says,⁵ printed at Irache,
one of the best presses in Spain being seated
in that university. Today a poor handful
of Seminarists walk in the fragrant planta-
tions of box and cypress within the four
cloisters, drink of their springing fountains
fed from mountain brooks: shrink away or
clatter down the glorious cloister where
in 1547 a Renaissance builder dreamed
Gothic. The church, which Yepes calls
more aged and strong than good-looking,
strikes the traveller as a strayed sister of
Zamora, Toro, and Salamanca, and as a
fine instance of the transitional style:
built early in the twelfth century at the
east end, and continued, a little later, west-
ward of the crossing. The three parallel
apses open under their deep semi-domes by
a pointed arch, and the middle one inter-
calates a bay of pointed barrel-vault and
adds a double arcade around the interior.
The transepts consist of one bay each of
quadripartite vault, and the nave of three

more bays of the same. The dome rests on
squinches in the shape of shells; there is a
window in each face of the square drum
and in each corner a shaft, resting on a
capital, that carries the figure of an
Evangelist, and the symbolic beast above.
Sr. Lampérez, who has studied and loves
it well, and has published drawings of the
dome, the apse, and the nave, says that
the curious dome (though rebuilt in the
upper part) is not so near to the Salaman-
tine group as it looks, and questions
whether it may be owed to some Syrian
architect—"come like so many others by
the *cuenca* of the Ebro to seek the *Camino
francés.*" [6]

 In the second bay on the north opens
a doorway richly moulded on the outside,
with pointed arch and the chrism in the
archivolt. Two coupled shafts, and four
plain, in each jamb, have, nearly all, storied
capitals, some from the life of S. Martin;
the sharing of his cloak and the visit of
Christ wearing it are easy to recognize,
but opposite a knight is fighting a Sagittary
and one savage is fighting another, two

Lampérez

A wandering Syrian

dragons, men with swords and shields (one round and one triangular) a harpy in a hood and an animal in such another, confuse inferences. These last two belong to the fifteenth century, whether at SS. Creus or at Pampeluna. S. Martin of Tours appears frequently in Spain and all along the length of this road; the original church of Iria Flavia was, possibly, dedicated to him[7] before the invention of S. James's relics, though more probably the patron intended there was S. Martin Dumiensis. A scrap of rich arcading was tried outside the window in the wall above, but proved, I suppose, too costly in time and skilled labour. On the whole, this door should be contemporary with that of Puente la Reyna.

The western porch is later and rather odd: five little graduated round-headed windows under a pointed barrel-vault occupy the upper part of the face; below, a pointed arch of five orders, strong and square, rests on the four shafts in either jamb and is crowned by a plainly moulded dripstone. In front of this the deep

porch is sustained by three transverse
arches, pointed, resting on capitals, and
these on corbels figuring busts or heads and
arms:—a bearded man, a beautiful woman
in a coif, a negro, another woman, etc.:
outside, the trumpeters of the Doom.
The door itself has lovely ironwork.

The rebuilding of the dome was all but
finished in 1597 when it fell, the builder
being saved by a miracle of S. Veremund:
according to the Bollandists, he was about
to lay the last stone when he heard a voice
that said the abbot summoned him and was
scarcely in safety before the whole fell in.
This miracle resembles pleasantly some
which will be met later on, at Castrojeriz.
Yepes testifies that the tower was finished
in 1609 and the rebuilding done within the
forty years, preceding, dormitories, stair-
ways, cloisters, courts and fountains. The
effect of the church, however, with its
strong plain arches and coupled columns,
its austere early capitals and early vaults,
and absence of triforium, is to recall the
early Cistercian building. strictly contem-
porary, south and west of Rome. The

The
Master
Builder

rich Benedictines here, lying close to the
Way, attracted the new forms in archi-
tecture and embodied them all, from the
Syrian dome and its great Evangelical
sculptures, down to the lovely curving
star-patterns of the cloister vault. When
Alexandeı II was engaged in trying to
wrest their own ritual from the Spanish
church and substitute the Roman use,
this abbey sent two precious MSS. to
Rome, a missal and a sacramentary: the
latter had been copied at the monastery of
Albelda.

The monks when, as I said, they were
reformed in 1522 by Fray Diego de Saha-
gún, the Abbot of S. Benedict of Valladolid,
still kept some of their ancient customs.

For instance, when a monk died each priest
among his brethren gave him seven masses,
and those not in orders recited ten Psalters;
on the day of his death they fed thirty
poor men, and for thirty days of mourn-
ing thereafter they entertained a poor man
in his place in the refectory, to whom
they gave the dead monk's portion. In
Yepes's day the ration was still a dole, but

the poor man was not fetched into the refectory, the monks finding that sort of guest embarrassing. The old way was very striking, in its transsubstantiation of pagan into Christian use, its consecration of the food and drink once offered to speed a lingering soul on its latest longest journey, by the word of the Son of Man, the "done unto Me."

A Christian transsubstantiation

VII

THE LOGROÑO ROAD

*S'en istres de la ville sans nule
 destourbance
E tant esploiterent on la Jesu
 sperance
Qu'au Groing furent venus.*
　　　—La Prise de Pampeluye.

LEAVING Estella, the road turns, ever and anon, running for a space between high, bare hills, crowned by ruins of hermitage or castle, all one now, past where Irache suns its low massy dome on a bland slope: through the welcome greenery of woods, in the scent of box or juniper; past a widening golden valley where brown towns couch like hares in their forms; smooth and swift it runs to the pretty place, with its water-side church, of Los

Arcos. Hereabouts, in the twelfth century, a man met a merchant, barefoot, carrying chains to Santiago, and heard how he had been sold thirteen times into slavery and S. James had delivered him. Indeed, the Apostle was not well pleased with the contract,[1] but God Almighty, whose patience is eternity, held him to it. Somewhere between Estella and Logroño the tale as it was told shortened a dusty mile or twain.

The superb cloister of Los Arcos imitates Pampeluna and anticipates Nájera; the belfry, of openwork, flamboyant, is more deserving of Charles V's famous *mot* about the coffer, than either tower to which he fitted it, that of Burgos or that of Florence; the church itself is a luxurious piece of rococo enamelling, a scented casket, lined all with what looks like Spanish leather, of colour laid over silverleaf, and fitted all with gilded Churriguesque altars, exquisite and effeminate. It is possible that the fifteenth century church still exists under this gilt and jewellery, fard and ceruse, but it would be a

<div style="text-align: right">A Miracle
of
S. James
(No. xxii)</div>

sad pity to go restoring, for Spain has a plenty of the fifteenth century elsewhere, but nothing so good in its own kind as this, like a portrait-study by Nattier.

The town claims to have been known of Ptolemy;[2] it was favoured in the second half of the twelfth century, Sancho the Wise exempting townsfolk in 1175 from obligations of bakery and butchery even to the king;[3] but what it holds of that age, if anything, I know not; from the fifteenth to the eighteenth century it was a part of Castile. It enjoys a *feria* in August: to watch families reuniting for the feast, Jehane leaned over, from the motor-omnibus, one day as we passed through, just in time to see a sleek little black priest with a pink nose, called Enrique, seized by a bigger girl and kissed soundly on both cheeks.

The wind blows strong-scented and earth-warmed. The way runs on past sparse grain fields, in wide turns and long descents, past Sansol steep-scarped; past Torres climbing a river bank and rearing above tufted trees the tower and cross of

the Holy Sepulchre; past Viana, founded
in 1219 and cherishing still some crumbling
walls, a strong church tower, and the
memory of a brief and tragic principate. [4]
The red soil of the Pyrenean outliers
below Pampeluna, tinged as though with
Christian blood undried, has yielded to
yellow earth and yellow rock, and the very
dust is impalpable gold. About the walls of
Viana the road turns once more, and then
lies straight as a stretched string across
ten miles, from that last hill-spur to
the Ebro. There at Logroño S. Juan de
Ortega built a bridge, or perhaps only
rebuilt, for the *fuero* of 1095 makes men-
tion of one. Thereon stood a chapel dedi-
cate to S. John, but in the flood of 1775
the Ebro took it. [5]

Bridge and Bridge-Warden

The Spires of Logroño.

Abolladas los concavos arneses
Y las huecas celadas sin resplandor,
Sin file las espadas.
　　　　　　　—Lope de Vega.

At Logroño we crossed an iron track, saw and might have touched railway metal, but we never travelled by rail till the other side of Burgos. Always the road invited, and the motor or diligence set out and arrived, grey with dust, crowded, and from the broad seat on the top we felt it licking up the miles. Considering that the railway runs there, it is curious how few ecclesiologists have visited the town, or even know its whereabouts, or have so much as heard of its churches. Not so was it once. Today the city is indeed commercial, but still historical. The heart of the Rioja, all the red wine flows through. Situate at the crossing of a great river, Logroño was always self-important: the earliest knights knew it, and John of Navarre and Walter of Aragon, and poets of Padua and Verona; the pilgrims made havoc of the name but relished

the hospitality; even Purchas's[1] rhymester
remembered, out of the confusion,—"Then
to the Gruon in Spayne." Jacob Sobieski,
who went on the pilgrimage in the spring of
1611, describes the city[2] "on the abundant
river Ebro, built after the Spanish fashion,
for in Spain there are no such notable
buildings always as in other places, and
above all they want height." This means
probably that the northern eye missed the
steep roofs, but it is oddly charged against
this of all places, for the steeples of Logroño
were right famous: Enrique Cock[3] counts *la
Redonda, el Palacio, S. Pedro, S. Blas* and
S. Bartolomé, "that all have lofty belfries
that make a fair view from afar"; and
Lope de Vega wrote, in much-admired
lines, of

<div style="margin-left:2em">

Esa ciudad que superior preside
 a estas amenidades,
y con sus torres las estrellas mide,
 gloria de España, honor de las
 ciudades.
</div>

"They use linen windows instead of

glass," the noble Pole goes on, "for cool and for shade, which does not contribute so much to the gayety of a place as glass in the windows."

The town lies fragrant in memory with the scent of ripe grapes and sprinkled pavements, cooled with little runnels that crept into a pool by every tree in the Plaza. full of the sound of soldiers' movements, from the bugle's reveille that they call in Spanish *la diana*, to the band-concert that went on in the square past midnight. All day the blue uniforms hung in view like dragon-flies under a bridge, and the shuffle and purr of marching squads held the ear, or the quick rattle of a cavalry trot. Those were perilous times in Spain, of which the writer may not speak, no more than one visiting in a house when trouble befalls. We dropped eyelids, stopped ears, and triple-sealed the doors of speech.

To be called later "ciudad muy noble y muy leal," as early as 926 the name appears in documents: the men are called, in 1076, "gente dura y terrible." At two great

moments, well remembered, was their
temper approved. In 1336, the Castilian
army, routed, fell back upon the town, hard
pressed by the Navarrese under Gaston
de Foix himself, hot-foot and drunk with
victory. Then Ruy Díaz Gaona held the
bridge against them all. Captain and
citizen of Logroño, with but three soldiers
he saved the city. He died, but not too
soon, and Ebro took his body, and washed
it down to the deep eddy that yet keeps,
secure, his bones, his memory, and his
name. [4]

In the sixteenth century they stood a
siege, with artillery, from May 25 to the
Feast of S. Barnabas, and the little garrison
beat off the French who had conquered
Pampeluna and overrun Navarre in that
year of 1521, and still they celebrate the
feat on Barnaby Bright.

The fifteenth century rebuilt Santiago
and the two S. Maries: that called *la Redonda* and that called *del Palacio*. The
latter carries, plump in the middle of
everything, a most lovely spire, smooth-
sided, crocketed and stone-cased, the price

"gente dura y terrible"

Ruy Díaz Gaona

of which was that the central piers of the church had all to be monstrously built up and the interior spoiled. "Do you suppose," said an acolyte, spotted with candle-grease, shaking his bunch of keys, "that they would have spoiled the vista for anything less?"

Certes, this is the fairest spire in all Spain. Madrazo[5] compares it with that of Sangüesa which it surpasses in size, and that of Olite which it resembles in the perceptible entasis of its ribs; but the only just comparison is either with Litchfield and Salisbury, or, better yet, with Chartres and Senlis, set as it is with gables all around, like that lone lost spire of the sleepy city in the sweetest of the Isle of France.

No Spaniard drew the plans for it. Sancho the Wise and Sancho the Strong commissioned the church; Alfonso VII made it over to the Order of the Holy Sepulchre and it became the seat of a Provincial Chapter.[6] Though in the fourteenth and fifteenth century the church was rebuilt, the strong transitional style

of the late twelfth century still appears in the *trascoro* and flanking aisles; a single western bay in each. Eastward of the Renaissance rebuilding, a vast Gothic transept rears three bays of star-vaulting; then the apse appears sixteenth-century again; the retable is dated 1581. Shallow side-chapels cling under the walls of the transept, and the cloister, star-vaulted, is of the sixteenth century.

In 1435 by a bull of Eugenius IV, the *Collegiata* of Albelda was transferred to *S. María la Redonda.* The church, in spite of accretions—a domed and painted oval salon at the west, a bleak eastern transept like the hall of a ducal house, with three domes and an eastern doorway, the aisle-apses being pierced to admit to this—does show, in the part intermediate, the late fifteenth-century Gothic of all this region at its richest, loftiest, and most splendid. Without proper transepts, it consists of four bays, aisles, and nave, four shallow chapels opening along the south aisle. Great piers carry a few thin shafts. The vaulting is very high

La Redonda

and very fantastical; the rejas, retables,
and tombs are abundant and good, and
vastly enrich the interior, which is, fur-
thermore, entirely painted, vault and
aisles, with dim greens and blues, dull and
tawny golds.

S. Bartolomé, however is of another sort,
dedicate to the Far-traveller whose legend
is so enviable to travellers. "Little, but
good," says Sr. Lampérez. [7] Built in the
thirteenth century, rebuilt in the four-
teenth and fifteenth, it has three apses of
pointed barrel-vault, transepts and crossing
raised with a star-vault, one bay of nave
and aisles and a western transept lifted
high on the south side into the tower, and
filled elsewhere by a low gallery enriched
upon the bosses with rather good Renais-
sance heads. The only original capitals
are those of the piers to the main apse,
which has abacus and string-course of
billet moulding. On the south side little
round-headed windows are set in the clere-
story place.

The whole is of a noble stone, grey
within, brown where weathered. The

façade, built in the fourteenth century,
combined the two chief ornaments of
Estella: the crowded tympanum, multiplied
mouldings, and reedy shafts of the door
proper, with a wide band of sculpture
stretching back from the jambs across the
entire front, carved with the history of
S. Bartholomew. But under this runs a
blind arcade, diapered, in the French fash-
ion, recalling, a little, Bourges, and, a little,
Noyon, and, in a way most of all, the pure
and early Gothic porch near Saumur, on the **at Candes**
pilgrim's road. The tympanum and lintel,
the former still showing its original arch
under the later debased curve, have been
lowered from their proper place, probably
when the gallery was built inside, and **The Five**
leave room for a triangular window. If **Portals of**
this portal belongs with those of Estella **Navarre**
and Pampeluna, Ujué and Artajona, it is
the latest and the coarsest in workmanship.
The capitals of the lower arcade are in
the same style as those of SS. Creus; the
spandrels above them are crowded with
little figures rather more delicate: above
the canopies of the statues swarm other

personages, like Zaccheus and his friends
in the palm tree. The large reliefs begin
their story at the right-hand door-jamb,
and continue around the south corner,
then recommence in the corresponding
corner on the north, and end again at the
jamb of the portal. The work is coarse
and racy; a flaying of the titular saint out-
rivals Spagnoletto's; the Apostle, flayed, is
too like that too-famous image in Milan.
On the south side the scenes are quieter
in conception and a trifle earlier and graver
in work. In the tympanum, the Saviour,
erect, holds up His wounded hands, S.
Mary and S. John kneeling in desperate
intercession; below, the twelve apostles
stand free, under rudimentary canopies.
The story condensed is this:—

The
Golden
Legend

S. Bartholomew the apostle went into
India, which is in the end of the world.
And therein he entered into a temple
where an idol was and he as a Pilgrim
abode therein. And the temple was
full of sick people, and could have
no answer of that idol, therefore they

went into another city whereas another idol was worshipped named Berith, and Berith said: Your god is bound with chains of fire that he neither dare draw breath ne speak after that Bartholomew entered into the temple. He hath his hairs black and crisp, his skin white, eyes great, his nostrils even and straight, his beard long and hoar a little, and of a straight and seemly stature, and it is twenty-six years that his clothes never waxed old ne foul. The angels go with him which never suffer him to be weary ne to be an hungered, he is always of like semblant, glad and joyous. He seeth all things tofore, he knoweth all things, he speaketh all manner languages and understandeth them, and he knoweth well what I say to you. And when Polemius king of that region heard of this thing, which had a daughter lunatic, he sent to the apostle praying that he would come to him and heal his daughter. And when the apostle was come to him and saw that she was bound with chains and bit all them that went to her, he commanded to unbind her and then anon she was unbound and delivered. And

Nor moth nor rust

nor hunger nor thirst

So Greco
painted

anon then they set cords on the image
for to pull down and overthrow the idol
but they might not. The apostle then
commanded the devil that he should
issue and go out, and he brake the idol
all to pieces. And forthwith all the sick
people were cured and healed. And it
was told the king Astrage his God Bal-
dach was overthrown and all to-broken,
and when the king heard that he brake
and all to-rent his purple in which he was
clad, and commanded that the apostle
should be beaten with staves, and that he
should be flayed quick and so it was
done. Then the Christians took away
the body and buried it honourably. 8

Logroño, practical, seated at a centre of
traffic and exposed to all passing armies,
all chances of victory and defeat, was
content to adopt and adapt motives en-
countered close at hand. At Estella you
feel how the townsfolk took what they
could get of money and privilege, and built
after their own fashion, hiring their own
workmen. The king might fetch, for
Pampeluna, an architect from Paris, the

abbot might fetch a builder from Gascony, as for Iranzu in 1776 did Abbot Nicholas the brother of Bishop Peter of Paris,[9] but in Estella and Logroño the Spanish style appears alive and growing, taking what it can, where it can.

<div style="float:right">Cathedral and convent builders</div>

Along the Battlefield.

> *The breath of dew and twilight's grace*
> *Be on the lonely battle-place.*

Across the wide plain between Logroño and Nájera, where the Black Prince's army moved softly in the grey dawn, even to the bridge where Roland fought for three days with Ferragus, the track runs as on a bowling green, and Logroño in the morning sun lies comfortable, purchasable, and Nájera in the dusty noon, filthy and fly-specked, crumbles red into the arid river-bed. But if you had turned long since your dusty feet toward home, and at the day's end were moving back from the west just beginning to burn stilly about

As one that
travels

the huge sun's pyre, then you should see
with the counted miles blue hills arising
fold on fold, enchanted in their quietude,
magical in their vaporous amethyst. The
dusty chicory burns whitely in little
patches; the wind is warm with the memory
of the day and fresh with the hope of the
dark. You do not see Logroño in such
approach, for it lies low upon the river:
you see but mountains softly folded, wide-
encircling, far as the eye can trace them
or the memory tell, enclosing and allur-
ing the Road back into the misty Pass
where dripping hemlocks and streaming
crags still echo the *olifaunt*. Southward,
among sharper peaks, lies the abbey of
S. Millán, and that of Albelda cavern-
toward the
darkening
east
hewn; northward the twilight swallows up
the ranges.

Hereabouts was the battle: and O, how
green the corn!

Here the most strange and splendid figures
of that gorgeous, lusty, heady fourteenth
century of Froissart's are brought together
as in a *chanson de geste:* Edward the Black
Prince, Bertrand du Guesclin; the tragic

and bitter Peter, the subtle and deadly Bastard; the Captal de Buch, Olivier Clisson. They had the most outlandish and romantic titles: the Bègue of Villiers, l'Allemant de S. Venant, the Souldich de l'Estrade.

"Then they dislodged and took the way to Navaret, and passed through a country called the country of the Gard, and when they were passed then they came to a towne called Vianne. There the Prince and the duke of Lancastre refresshed them, and the erle of Armynacke, and the other lordes, a two days. Then they went and passed the river that departeth Castell and Navar at the bridge of Groygne among the gardeyns under the olives, and there they founde a better country than they were in before; howbeit they had great defaute of vitayle. And when that king Henry knew that the Prince and his people were passed the rjver at Groygne, then he departed fro saynt Mychaulte where he had long lain, and went and lodged before Navarette on the same river. When the Prince heard that king Henry was approched,

[Marginal notes:] Greathearted gentlemen . . .

Bridge of Logroño

he was right joyous, and sayd openly:
By saynt George this bastarde semeth
to be a valyaunt knight, sythe he desireth
so sore to find us; I trust we shall fynde
eche other shortely."

The Spaniards characteristically never
went to bed at all: they supped well, and
talked awhile, and at midnight were ready
for business:

> The Prince and his company went
> over a lytell hyll, and in the descendyng
> therof they parceyved clerely their
> enemyes comyng towarde them; and
> whan they were all discended down this
> mountaine, than every man drue to their
> batayls and kept them styll, and so
> rested them, and every man dressed
> and aparelled hymselfe redy to fight.

There in the April weather, in the early
light Sir John Chandos came up. He
brought his banner rolled up together to
the Prince, and said:

> Sir, behold here is my banner; I re-
> quire you display it abroad and give
> me leave this day to raise it; for sir, I

thank God and you, I have land and heritage sufficient to maintain it withall. Than the Prince and king Dampeter took the banner between their hands and spread it abroad, the which was of silver a sharp pyle gules, and delivered it to him and sayd, Sir Johan, beholde here your banner: God sende you joye and honoure thereof. Then sir Johan Chandos bare his banner to his own company, and said, Sirs, behold here my banner and yours, keep it as your own; and they took it and were right joyfull thereof, and said, that by the pleasure of God and saynt George, they wolde keep and defend it to the best of their powers. And so the banner abode in the hands of a good Englysshe squyer, called Wylliam Alery, who bare it that day, and aquitted himself right nobly. Than anon after thengylsshmen and Gascoins alighted of their horses, and every man drew under their own banner and standerd, in array of batayle redy to fight: it was great joye to see and consider the banners and pennons and the noble armery that was ther.

es una escuela de honor . . .

In the wind that runs before the sun, the pennons shivered: the white flag of S. George shook out its red cross above twelve hundred flickering *pensels* ot the free companies. They were bad men, no doubt, but they were good soldiers, seasoned. In the pale level sunrays lance-heads twinkled, steel caps glittered: the bugles that had cried in the night, sang now for the fight. The English bowmen were well matched with Spanish slingers, whom they liked no better than had the Romans before then.

"That day sir Johan Chandos was a good knight, and did under his banner many a noble feat of armes; he adventured himself so farre that he was closed in amonge his enemyes, and so sore overpressed that he was felled downe to the erthe; and on him there fell a great and a bygge man of Castell, called Martyne Ferrant, who was greatly renomed of hardynesse among the Spaniards, and he did his entent to have slayne sir Johan Chandos, who lay under hym in great danger. Then sir Johan Chandos remembred of a knyfe that he had in his

bosom, and drew it out, and strake this Martyne so in the back and in the sydes, that he wounded him to dethe as he lay on him. Than sir Johan Chandos tourned hym over, and rose quickely on his feet, and his men were there about him, who had with moche payne broken the prease, to come to him whereas they saw him felled."

In this battle the Chancellor Ayala, the historian and poet, was taken prisoner, as he relates himself. He barely mentions his own in a long list of names,[1] for he is more preoccupied with Mossén Beltrán de Claquin, and el Vesque de Villaines, and D. Garci Álvarez de Toledo *Maestre que fuera de Santiago*, and *el Clavero de Alcántara*, who was called Melén Suárez, and other good knights who were taken, too, by those in white surcoats with scarlet crosses, whose cry was *Guiana, Sant Jorge!*

being indeed in rebellion

Du Guesclin

"There were of Spaniards and of Castyle, mo than a hundred thousand men in harnesse, so that by reson of their great number, it was long or they

could be overcome. King Dampeter was greatly chafed, and moche desired to meet with the bastard his brother, and said, Where is that whoreson, that calleth himselfe king of Castella. And the same king Henry fought right valiantly where as he was, and held his people togyder right marvellously, and said: Aye good people, ye have crowned me king, therfore help and aide me, to keep the heritage that you have give me; so that by these words, and such other as he spake that day, he caused many to be right hardy and val-yaunt, whereby they abode on the felde, so that because of their honor they wolde nat flye fro the place."

His cry that day, says Pere López de Ayala, was *Castile! Santiago!* and he rode a great grey Castilian horse, in a shirt of mail, until, when the day was lost and the horse was spent, a squire of his, Ruy Fernández de Gaona, came up on a little jennet and exchanged, saying: "Lord, take this horse, for yours can't move." The king took it and got away from Nájera, taking the Soria road for Aragon.

"The batayle that was best fought and lengest held togyder, was the company of sir Bertram of Clesquy, for there were many noble men of arms who fought and held toguyder to their powers, and ther was done many a noble feat of arms. And on the Englysshe parte, specially there was sir Johan Chandos, who that day did like a noble knight, and governed and counsayled that day the duke of Lancastre, in like manner as he did before the Prince, at the batell of Poycters, wherein he was greatly re-nomed and praised, the which was good reason; for a valyant man, and a good knyght, acquitynge hymselfe nobly among lords and princes, ought greatly to be recommended." *Mozos codiciosos de honra...*

If the ordeal of battle means anything, this day the issue declared for that Don Peter, who wanted to be called *the Just.* "The Prince [Edward] had indeed with him the flower of chivalry, and there were under him the most renowned combatants in the whole world." What sumptuous phrases they had, these men that made King Dampeter

history as they wrote it, and what magnificent certitudes! Here with these words, unlike enough to the actuality of the sullen and ferocious Englishman named less from his black armour than his black heart, and of his host of alien and mercenary invaders, our good knight and loyal servitor evokes the very figures of the great-souled, the Happy Warriors, the—

"White Horsemen who ride on white
 horses, the Knights of God,
Forever, with Christ their Captain,
 forever He!"

"Than the Englysshmen and Gascons lept a horsebake, and began to chase the Spanyardes, who fledde away sore disconfyted to the great ryver: and at the entry of the bridge of Navaret, there was a hideous sheddinge of blood, and many a man slain and drowned, for divers lept into the water, the which was deep and hideous, they thought they had as lieve to be drowned as slain. And in this chase among other, ther were two valiant knights of Spayne, bearing on them the abyte [habit] of religion: the

one called the great priour of ˋsaynt
James, and the other the great maister
of Calatrave. They and their company,
to save themselfe, entred into Navaret, *1 Ay, qué buen Caballero!*
and they were so nere chased at their
back, by Englysshmen and Gascoyns,
that they wan the bridge, so that
there was a great slaughter. And then
englysshmen entred into the city after
their enemies, who were entred into a
strong house of stone; howbeit, inconti-
nent it was won by force, and the knights
taken, and many of their men slayn,
and all the city overron and pylled, the
whiche was greatly to the Englysshmen's
profit. Also they wanne king Henries
lodgynge, wherein they found gret
richesse of vessell, and jowelles of golde
and sylver, for the king was come thyder
with great noblenesse, so that when they
were disconfyted, they had no leisure
for to return thyder again, to save that
they had left there. So this was a hide-
ous and a terrible disconfyture, and speci-
ally on the river side, there was many a
man slain; and it was said, as I heard
after reported of some of them that were
there present, that one might have seen

the water that ran by Navaret to be of
the colour of red, with the blood of men
and horse that were there slayn. This ba-
tayle was bytwene Naver, and Naveret,
in Spayne, the yere of the incarnacyon
of our Lorde Jesu Christ, a thousande
thre hundred threscore and sixe, the
thirde day of Aprill, the whiche was on
a Saturday." [2]

As at Cologne upon the winding Rhine,
and among the stony deserts of the *Bouches
du Rhône*, as on the sacred plains of Châlons
and of Poitiers, so here the quiet air is
swept with confused alarms of struggle
and flight, is thickened and cloudy with
the figures of clashing armies that like the
tides withdraw and return again. Half a
millennium before Henry of Trastamare,
Charles the Emperor had gathered the
most renowned combatants in the whole
world, and camped in sight of Nájera,
whence the hosts of Spain and Aragon came
prepared and glad. "Moult fu beaus
Feragus": the time was early summer, the
time of birds' singing, the time of love-
making,—

This geant issued out of the town and demanded [combat] singular, person against a person. Charles, which never had refused that to person, sent to him Ogyer the Danoys. But when the geant saw him alone on the field, without making of any semblant of war he came alone to him and took him with one hand and put him under his arm, without doing him any harm, and bare him unto his lodgings and did do put him in prison, and made no more ado to bear him than doth a wolf to bear a little lamb. . . . After that Ogyer was borne thus away, Charles sent Raymond d'Aubepyne. When Feragus saw him he bare him away as lightly as the other.[3]

Last came Roland. Roland went to pray in the dawn, S. James and S. Michael came always when he called them, he talked theology to Feragus in the pauses between thrust and parry, and found him a stone for his head when he slept exhausted, and in the end pricked the poor gentle giant in the one spot vulnerable, and so the Bridge of Nájera was

SS. James and Michael

won, and the city baptized.[4] The battle
occupies three days and three thousand lines
and more. There is not a word of history
in the whole, yet it was by some other
virtue than the author's vain imagination
that precisely there, where he had never
been, these figures of ancient song, *muy
noble y muy leal*, "peopled the hollow dark
like burning stars."

S. Mary the Royal.

> *Mother of misericord,*
> *For thy dead is grief in thee?*
> *Can it be, thou dost repent,*
> *That they went, thy chivalry,*
> *Those sad ways magnifi-*
> *cent?*—Lionel Johnson.

Nájera in the Sunday noon consisted of a
rotting cliff and a bone-dry bed of stones;
between them, dirt and flies and good
Christians. Bells tinkled for the last
Mass, dogs quarrelled, children cried out;
the arid heat droned and hummed. While
the narrator went to look for S. Mary
the Royal, Jehane was welcomed with
a shaded room, cool water, and hospitality

without grudging from a little tavern keeper. His reward came immediately and thirty-fold, in the drinks he sold to those who drifted in to stare. Meanwhile a small boy, and a smaller *Cura*, were giving to the narrator more counsel than comfort: the church, it appeared, belonged to a convent of *frailes*, who through the noon hours were bound to dine and sleep, and for neither knocking nor ringing, for neither the Pope nor the King, would they open the door before mid-afternoon. Just the glimmer of a chance, however, searching and bitter inquiry brought out that a certain *apostolical* ecclesiastical dignitary of the town might stir them up. Anyway, we went about to see: and at a corner the good lad raised a cry and set off running: the convent door it seemed, was not yet closed, a beggar woman who waited along with me was confident it would not close until she had her daily mess. We knocked and rang at *and ecclesiastical* intervals, she and I and a few loungers, and when at last the brass wheel spun in the door I could see at a glance the green of cloister-garth as background to the

Italian breeding

brown of frieze cassock. At the crack
I made my plea, of a long day's journey
only half measured yet, of recommenda-
tions from the Apostolic Nuncio, of a book
in course of writing; and anon two tall
Franciscans, incredibly clean and kind,
were talking with me in the cloister and
unlocking for me the church. It was not
just for pride in their church that they fore-
went the meal and the Recreation that
echoed in discussion and laughter from
the upper galleries of the princely cloister:
it was that they did, as a matter of daily
practice, take the stranger in. Though
the need, in this case, was not for soup
but for photographs, not to feed but to
see, it mattered no whit, and that they
wonderfully discerned.

Kings of Nájera

The city of Nájera was probably an
Arab foundation; it played a part in the
Reconquest and at one time was a sepa-
rate kingdom from Navarre. Seven kings
reigned there and these are they:[1]

1. Sancho Abarca (Sancho II of
Pampeluna), 905-c.—926. He won

back from the Arabs most of the Rioja
(which the *Chronicle of Albelda* calls
Cantabria) even from Nájera to Tudela.
He married Doña Toda.

2. His son (D. García) he called to
share the throne, giving him conquered
land on the right bank of the Ebro with
the title of King of Nájera. Abderraman
brought up a huge army and though D.
García fell back and Ordoño II of Leon
came to his help, yet the two kings were
defeated in the battle of Valdejunquera.
Abderraman pushed into France by Jaca
and Somport and D. García followed
after him and recovered as far as Cala-
horra. He founded Albelda and with
his queen Doña Teresa gave much to S.
Millan. He died in 970.

3. His son Sancho kept the kingdom
for eighteen years against Almanzor, by a
sort of guerrilla practice, now withdraw-
ing, anon harrying the Moor. He died
in 995 and is buried in S. María on the
north side, with his queen Doña Urraca.

4. D. García *el Tembloso* was no
coward: he fought at Calatañazor in 998,
and died the next year. Dozy explains
this famous victory as a pure fabrication [2]

*Valdejun-
quera*

*Calata-
ñazor*

to salve the Spanish pride: it has raised
for us at any rate the mysterious wailing
figure on the shores of Guadalquiver
who cried aloud in a grievous voice, in
Arab and Spanish, thrice:

> En Calatañazor
> perdió Almanzor
> el tambor!

5. Sancho *el Mayor*, whose queen
Doña Munia or Elvira is also called
Doña Mayor. She built the bridge at
Puente la Reyna. In 1001 she signed a
document conjointly with him and with
D. Ramiro, who is called Regulus.

He was a bastard son of the king's, but
his mother was a great lady, either Doña
Caya of Aybar, or a Castilian heiress. The
Chronicle[3] and the Romances both tell
one story about this prince. The queen
had a horse fleet and sure given her by
the king, and her eldest son begged it of
her, and in the end, by the advice of her
castellan, she refused to give away the
king's gift. Then her eldest son conspired

with his two brothers to accuse her to the
king, involving the castellan, and there
was nothing for Doña Elvira but the
ordeal of fire. At the day and hour, how-
ever, a good knight came, and the young
men, bethinking themselves, sent a monk
of Nájera, to stipulate for pardon if they
should confess, and in the end they did.
The champion was D. Ramiro. Then the
queen put out D. García her eldest son,
the mischief-maker, from the inheritance
of Castile, and the kingdom of Aragon
which was her own she gave to D. Ramiro
her stepson. That was a great woman,
say I.

Sancho *el Mayor* conquered from the
Arabs Sobrarbe and Ribagorza, and
from Leon all the land between Cea and
Pisuerga, and divided his lands among
his four sons, and died in 1035.
6. García IV *él de Nájera*, con-
quered D. Ramiro and took Aragon,
reconquered Calahorra, dowered *S. Ma-
ría de Nájera*, and after reigning
twenty-four years, four months and
some days, died fighting his brother

Ferdinand of Castile, in the battle of
Atapuerca, in the year 1054.

7. Sancho the Noble *él de Peñalen*,
was killed in the wood by his brethren,
1076. With this for an excuse, Alfonso
VI of Castile took the Rioja and Sancho
Ramirez of Aragon took Navarre.

This is the end of the kings in Nájera.
The wife of D. Sancho the Noble is called
in her epitaph, like Chaucer's lady, "the
White" for her sweet soul's sake, and
Placencia for her gentle ways, but for all
her pleasantness her paths were not of
peace. When the king was murdered, she
disappeared from history.

There was another good queen Blanche
buried at Nájera, the daughter of García
Ramírez *el Restaurador*, wife of Sancho *el
Deseado* of Castile, mother of Alfonso VIII
él de las Navas. She bore a son, and died;
but her husband lit a silver lamp above
her tomb, that burned for centuries.

The church was dedicated on Saturday
the 12th December, 1052, and endowed
with most amazing gifts. The complete
inventory of that dowry has been pub-

And goodé,
fairé, white
she hete...

lished by Dr. D. Constantino Garrán and may be bought on the spot, so may be spared here: instead, we may consider a list of the books that a king borrowed thence at one time. In the thirteenth century, Alfonso X borrowed, against a receipt and in good form, from the prior and monks of S. Mary of Nájera, besides other books, the *Bucolics* and *Georgics* of Virgil, *Epistles* of Ovid, *Thebaid* of Statius, poems of Prudentius, two books of Donatus, the great grammar of Priscian, the *Consolations* of Boethius and his commentary on the ten predicaments, *Scipio's Dream* of Cicero, the *Libro Juizgo* (the Visigothic code), a catalogue of Gothic kings, a treatise on jurisprudence ("un libro de justicia"), the *History of the Kings*, the *History of Isidore the Younger*, and the *Book of Illustrious Men* by S. Jerome or S. Isidore or both.[4]

Books borrowed

According to tradition, the foundation of Nájera was on this wise: D. García was hunting and pursued the prey into a cave where he found an image of the Virgin. He adored and built a church. The cave

is there to prove it, westward of the church but opening into it, and the tombs of the kings lie within or before it, and the image reigns at the high altar of the church. It is completely habited and not easy to see, but from photographs appears archaic work of the thirteenth century. In the cave is enshrined another image, the Virgin of the Alcázar, that Sr. Lampérez⁵ attributes to the close of the twelfth.

Of the early church and sepulchre of kings, founded in the beginning of the eleventh century and consecrated 1056, nothing remains: the church was rebuilt by Prior Pedro Martínez de S. Coloma, 1422–1456; the cloister in the next century; the royal burial place, by Fray Rodrigo de Gadea, 1556–1559. D. García Sánchez had brought monks from Cluny and settled them there; in 1486, on Monday the 8th May, the monks elected their first abbot independent of Cluny, D. Pablo Martínez de Uruñuela. ⁶

In the church, the transepts and nave of six bays are unusually high, with vault sexpartite or star-ribbed; there is a true

Virgen de la Cueva

del Alcázar

Independ-ence

clerestory and a curious series of openings, like a triforium, on the south, which gives access to the vaults. The apses are square; the buttresses, without, cylindrical and big as towers, like those of Albi and of Assisi. There are low galleries over the transepts and the west end, all these in *clausura* of course; and a glorious south chapel of two bays with stalls and tomb recesses; but nothing breaks the soaring beauty and noble grace of this thrice royal church. The stalls, late Gothic, were made in 1495 by Master Andrew and Master Nicholas: the organ doors, in Antwerp now, were painted perhaps by Memling.

Albi and
Assisi

The *Claustro de los Caballeros* is built, lofty and long, in five bays by seven of plateresque that simulates Gothic; begun under Abbot Juan de Llanos (1517–21) it was ended under Abbot Diego de Valmasida, (1521–28); on either side the walls, on every pier, a canopied niche had once held a saint, and tomb recesses open down three sides of it. Here lies that López de Haro called, by exception, the Good, and a quaint use survived about his tomb from

his death in 1214 down into the last cen-
tury. When a *Corregidor* or a new Council
was elected in the city, the Council went
in procession from the *Casa Consistorial*
to the tomb, on which was laid a pall, and a
carpet was laid on the pavement, and two
candles were lit. Then, they standing in a
semicircle, the presiding member handed
the sealed ballot to the scrivener, and he
broke it open and read the election aloud.

Eastward, in the chapel of Holy Cross,
lies like a foundress Doña Mencía López
de Haro. Her mother was a sister of
Ferdinand the Saint, her first husband
was a knight of his, for whose honour and
glory she defended, with a handful of
gentlewomen and maidservants her castle
of Martos, when the Moorish king Alhamar
besieged her there. In her widowhood, a
king of Portugal married her, infatuate
with her beauty, her charm and her person-
ality, and she ruled the realm as though
it were her own inheritance. In the end

Portugal was lost, D. Sancho died for-
lornly at Toledo, while she came back to
Nájera where she had grown up, and

founded this chapel, December 7, 1272,
with four chaplains, "that masses might
be sung for her soul every day, even until
the end of the world." Did she feel that
they were needed so?

Door of the Holy Sepulchre

VIII

TWO ROAD-MENDERS

*The world is his house.
He serves all men alike;
ay, and for him the beasts
have equal honour with the
men. No man is depen-
dent on his earnings, all
men on his work.*
　—Michael Fairless.

TRAVELLERS in Italy may recall, some
of them, a valley hidden away in the heart
of the Central Apennine, behind Gubbio,
between Scheggia and Fossombrone.　It is
entered through a land bare as the Sistine
Creation of Adam, it is left by the Furlo
Pass where the Romans ran their road
through the living rock of the mountain
flank.　The capital city is Cagli.　As,
before an invading race, the indigenes

withdraw to mountain fastnesses, and the last tribe of those who once held the land smoulders away among the highest peaks, so, before the railway and the factory town, Italy found asylum there—the romantic Italy of our grandfathers' past, of Claude and Wilson, of Richardson and Byron, and under the stone-pine and the vine-wreathed elm, dreams eternally. In much the same way the *campo* about S. Domingo keeps still unspoiled the romantic Spain of the Elizabethan and the Augustan age. Here tawny Spain, lost to the world's debate, rejoicing in the abundance of corn and vine, salutes the coy dawn with the tinkling bells of mule-trains, and wakes the early moonlight with pipe and guitar. Translucent grapes, flushed peaches, freckled pears, with white and powdery bread, strong and limpid wine that glitters like jewels in the reddened glass,—these transmute into something venerable and sacramental the ancient sun-burnt mirth. On every hand the land is green, and the *campo* of La Calzada is famed as far as once the *huerta* of Sahagún. The cool well-

Unspoiled

water is abundant, wholesome, and delicious. The town plants poplars and sycamores in multiplied rows along the roadside, till *camino* becomes *paseo*, turning the dusty track into a place of solace and refreshment. Women are handsome here, babies clean, men devout. Only of late a narrow line of railway has pushed down from Haro, and the spell of the sleepy centuries is not yet rent. It is strange in a world of trippers and tourists to find a happy land so abounding in its own kindly life, and a church so richly undespoiled, still intact of dealers and restorers.

Two saints hereabouts in the twelfth century took care of God's poor and God's pilgrims, Dominic of the Causeway and John of the Bramble-Bush. Says Govantes[1] —and the account seemed good enough for Madrazo[2] to transcribe with only verbal alterations:—In the eleventh and twelfth centuries there were a number of saints whose piety was directed to helping pilgrimages to holy places, and who mended old roads, built new ones, erected bridges, and founded hospitals and hospices. This

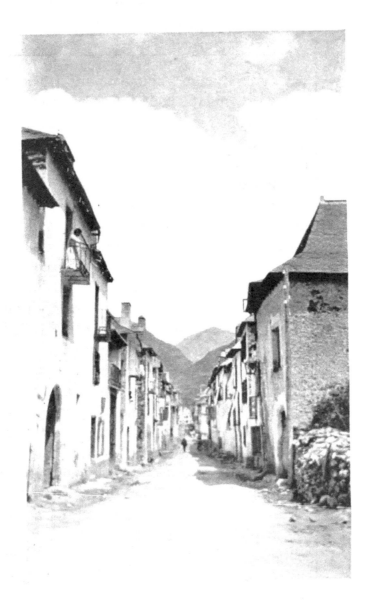

A Mountain Town

fell in with the wishes of Alfonso VI. Possibly S. Domingo had retired to an anchorite's life in an old palace or castle which stood where now the city stands, a league to the south of the bridge by which the Roman road crossed, that ran from Italy to Astorga; and seeing the distress of the pilgrims he set about relieving it. The river Oja, though usually a slender stream, gets up in thaw or in rainy weather and is dangerous enough. He probably built so far from the Roman bridge and turned his road out correspondingly, either to take the stream where it was narrower, being nearer to the mountain, or to get a better foundation for the piers. Beside the bridge he built a hospice or free lodging and served there humbly: thus the new settlement began. In the *Flos Sanctorum* it is said that S. Domingo was an Italian, who for love of God sold his patrimony and distributed it to the poor, and then, to be more entirely in the state of a pilgrim and a stranger, passed over into Spain and sought admission in the Benedictine convent of Valbanera. He was denied for alleged

illiteracy; the same happened at S. Millan. This was about 1050: that year the locusts ate up everything, and S. Gregory of Ostia came preaching a mission: S. Domingo joined him and stayed with him until his death. Then he settled down in a place of thick forests and shameless highwaymen, built his cell and a chapel to Our Lady, and afterwards burnt off the woods and built a causeway. Here S. Domingo de Silos visited him, and the two held holy converse together, and he approved his labours and travails.[3] Alfonso VI when, after the death of D. Sancho *él de Peñalen*, he took possession of the kingdom of Nájera, gave to S. Domingo all the land he needed for his works, and he built a little church, consecrated 1105. There he lived, attending to travellers and in especial nursing those who needed him, till he was very old. He died in 1109.

A hundred years later, his figure enters, familiar, easy to identify, in the *Vision* of the Ploughman Thurkill: though the English chroniclers could not recognize his name, the Pilgrims knew it perfectly. He

is the Warden of the Basilica which is the
gathering-place of souls and the goal of the
long Causeway, and S. James himself com-
mits the visitor to his charge. The Apostle,
by the way, figures there in a mitre as
Metropolitan and Primate of the Spains;
and for the same reason he is arrayed with
mitre and crozier when, with S. Millan, in
the Apparition of Simancas, they turned the
day. Gonzalo de Berceo is explicit about Twins
the nature of the great twain:

> White Horsemen who ride on white
> horses, O fair to see,
> They ride where the rivers of Paradise
> flash and flow.

Now the abbey of S. Millán de la Cogolla
lies not many miles away, to southward of S. Millán
the Road, and, as related, legend connects
S. Domingo with it: the account which
determined Thurkill's vision in this part,
will have been picked up here in La Calzada.

The place was called in those days, Bur-
go de Santo Domingo. The new road, the
safe crossing over the bridge, the convenient

Bishop
Covel

lodging, the good site, the level, fresh, fertile and healthful land, drew settlers. The Bishop of Burgos laid a hand on them, the Bishop of Calahorra warned him off: the case was put to arbitration by the king's order and Calahorra was sustained; this being in 1137. Alfonso VII the Emperor, who had seen to this, with his wife Doña Berenguela, dowered the city in 1147 with a share of woods, mountains, pasture and grass-land, and water rights. In 1152 the Bishop, D. Rodrigo Cascante, raising the church to collegiate rank, decided to enlarge and rebuild. In 1168, with royal help the work was begun; in 1180 the offices were sung in the new church;[4] in 1232 Gregory IX transferred thither the see, at the request of the chapter and Bishop D. Juan Pérez, the situation of Calahorra being both unwholesome and perilous. The lordship of the town belonged to the chapter till in 1350 S. Ferdinand took it over to the Crown, giving an equivalent.

Kings
reside

The king D. Peter rebuilt the walls; his successor D. Henry died within them, on Sunday the twenty-second of May, 1379.

In 1440 the shrine of the saint was ordered by Bishop D. Diego López de Zúñiga. In 1517 the cloister was begun, finished in 1550. The splendid detached belfry was built in 1762–67 by Master Martin, at the expense of Bishop Porras.

Says Ceán Bermúdez:[5] the king D. Alonso VIII and the Bishop of Calahorra and Nájera, D. Rodrigo Cascante, laid the first stone: the work lasted seventeen years, and was not finished when in 1180 the see of Nájera was transferred thither, though the divine offices were celebrated. It consists of three naves, and is of a robust and heavy architecture, without grace or elegance, as were all the edifices of that age. It was finished in 1235 when it was raised to a cathedral. This is hard to reconcile with the sentence before, about the transference of the see: all accounts are indeed fairly confusing. The name of the see, according to Govantes, runs still "of Calahorra and La Calzada," though Madrazo says it was joined to Burgos in 1574. The abbey church was certainly dedicated to S. Saviour, as the retable indicates,

Robust and heavy

though some confusion is caused by a kind of joint-ownership with S. Mary, explicable by a tradition that Madrazo[6] also records of the original site's being that of the little sanctuary of the *Virgen de la Plaza*, against the great belfry. As there must have been some such tower before Master Martin's time, it is worth noting that at S. Léonard de Limoges, on the same Causeway, the tower is isolated similarly.

This church was begun, then, in 1168, and within twelve years was fit for use. Thereafter building went on, and then rebuilding. The original plan is plain, and is French; and especially is the structure French, pier and rib. The nave is three bays long, the westmost of only half the size, as though it stood once between two western towers: and the eastern end had a chevet of five, an ambulatory and three radiating chapels with a plain bay in between these. The Lady-chapel survives, and the next bay north of it: the rest has been rebuilt. The north transept is a plain strong rectangle vaulted octopartite, like the nave. The south transept has been rebuilt with a

Towers like S. Léonard

French plan

chapel eastward and a portal of the full transept width, to fit the shrine of the Saint: also, the bay just west of this, clear across the church, aisles and nave, is as high as the crossing and as richly vaulted. Though, where only one transept aisle occurs, it is usually on the eastern face, I believe this arrangement to represent an original divergence from the norm for the sake of the crowds of pilgrims, giving, with such a lofty western aisle beyond the transept, a vast and noble environment for the shrine.

Master Pedro or Juan Rasines rebuilt, in the beginning of the sixteenth century, the *capilla mayor*. Andrés de Nájera began the stalls in 1517; in the end of the same century they were moved down, and damaged, and a lawsuit followed: in 1825 they were damaged again by fire, and repaired with faithful care by a local carver. The *retablo mayor* belongs to the first half of the sixteenth century, it is beautiful Renaissance work in the style of Berruguete. About this woodwork discussion rages.

The stalls of S. María la Real, at Nájera,

Western transept-aisle

Stalls

Con suma prolixidad

were carved by Maestre Andrés and Maestre Nicolas, in 1495, says Ceán Bermúdez[7]; "con suma prolixidad por el gusto gotico"; Madoz[8] says they were executed in 1493 by two brothers called Amutio, of Jewish persuasion, citizens of Cárdenas, a town a league off; who, Dr. Gárrán[9] adds, were disciplined by the Inquisition. This detail he had from his father, the late D. Restituto Garrán of Acedillo, who supplied the information to Madoz, and who learned everything from old monks, his intimates, that knew by heart the traditions of the monastery. He wants this Master Andrew to be the same with Andrés de Nájera or Andrés de S. Juan, of whom Ceán Bermúdez says, in a manuscript note intended for a second edition,[10] "it appears from trustworthy documents that he designed and carved the stalls of S. Benito of Valladolid in 1528; and likewise carved the quire of S. Domingo de la Calzada." The quire of Nájera the present writer has not seen for it is in *clausura*, but views of it are published by Dr. Garrán, by D. Pelayo Quintero,[11] and by Sr. Martí y Monso,[12]

Master Andrew at Nájera

and from these it is easy to understand the beautiful late flamboyant traceries and delicate fifteenth-century forms. A phrase of Street's occurs to mind, where he calls a tomb "in no sense unworthy of a good Gothic sculptor." That was Master Andrés, a good Gothic sculptor, and by the same token incapable utterly of the luxuriant loveliness of the stalls in S. Domingo.

For these Sr. Martí y Monso has published abundant documents.[13] They were begun in 1517, Andrés de Nájera being master of the works. He lived at that time in S. Domingo. For some reason not stated, the chapter in proper person made the contracts with the several workmen: these were, Guillén de Holanda (who was not necessarily William the Dutchman), Juan de Castro, Francisco de S. Gil of Burgos, Ortega of Cordova, one Lucas of Burgos, and one called the Burgundian for whom a notary signed. This last could not have been Felipe Vigarny, but it is worth remembering that Maestre Andrés was possibly working in

Master Andrew of Nájera

Burgos and in relation with Vigarny four
years earlier, for, says Dr. Martínez y Sans,
in 1513 the work of Master Philip was
valued by the master-mason Andrés de
S. Juan.[14] Moreover in Valladolid in 1533
he served on the same commission with
Vigarny and one Julio Romano, about the
valuation of the retable of S. Benito, that
Berruguete had just finished.[15] To have
taken two or more workmen from Burgos
into the Rioja, makes it more likely that
Maestre Andrés was really formerly at Bur-
gos, and this contract gives us another
Frenchman, of name unknown, who lived
once in Burgos in the time of Maestre Felipe
Vigarny, sculptor (before 1498–after 1532),
and Juan de Langres,[16] *entallador* (known
1522–1532). From S. Domingo, Maestre
Andrés went to Valladolid, where he was
working pretty steadily, between 1522 and
1528, on the stalls of S. Benito: he was living
however in Covarrubias in 1521, and as
late as 1531 he reappears in the Calceaten-
sian account-books as master of the works
on the trascoro.[17] Apart from questions
of style, it is unlikely that Master Andrew

should be judging Renaissance work in 1513 if he had finished mature Gothic work twenty years before, and it is almost impossible that one of the judaizing brothers of the fifteenth century in the Rioja should move so freely and be fetched from so far in the second quarter of the sixteenth, as an expert qualified and highly esteemed. He would be, if nothing else, at any rate too old. Here then within forty years, between 1493 and 1533, we have two Masters called Andrew and quite possibly three, working from the Ebro to the Pisuerga, in Navarre, and in both parts of Castile.

Before the *retablo mayor* comes up again the whole question of likeness and unlikeness in names and personalities, of documentary evidence and the evidence of style. The retable is a noble and precious work of the Spanish Renaissance, a shade less mannered and agonized than Berruguete's at S. Benito. Straight at the sides, level at the top and bottom, it bent into three planes to accord with the curving apse; also, it wants a proper predella. In

Retable

the central place is the *Salvator Mundi,*
above that the *Assunta,* above that an
oculus or almond-shaped glory for the
Host. On either side are four great panels
of the life of Christ where, as nudes, the
Baptism supplies a pendant to the Resur-
rection; between and beyond these panels,
figures, singly or in pairs, are set between
columns and under cornices, and flanking
all, another row of statues, freer and more
sinuous, rises from a sort of console formed
by leaning figures. As in the Milanese, the
columns are treated like balustrades and
candelabra; the friezes, frankly heathen,
depict not only young fauns and old
centaurs, but tritons and sea nymphs,
Eros and Amphitrite, and the nude is not
confined either to sacred persons or to
putti.

For this also, Sr. Marti y Monso pub-
lishes some documents.[18] It seems that
the sculptor was named Formente, that, a
citizen of Saragossa, he was living in 1539
and was dead in 1543; that of his two
daughters one called Esperanza, married
Bartolomé García and the other, Isabel,

left no other heir: the daughter and niece
of these, Úrsula García, was married to
Jerónimo Daza, and in 1569 she gave power
to Juan García and Juan de S. Cruz to try
to recover for her money which the Dean
and Chapter of S. Domingo were still
owing on the retable, as they had admitted
in 1543. Now, of course, there is a sculp-
tor ready at hand, Damian Forment, who
lived one time in Saragossa, and made two
retables there, and one in Huesca, besides
one for Poblet in 1517, and some earlier
work at Gandía. But he was supposed
to be dead by the time the second quarter
of the century commenced. Ceán Ber-
múdez[19] cites a document of the chapter
of the *Pilar* dated 1511; then he mentions
the retable of Huesca contracted for in
1521 and finished in 1533, also Gothic;
and finally refers to two notes in the MS. of
Martínez: first, that in this retable For-
ment changed his style, being influenced
by Berruguete; and second, that when
Charles V wrote to the chapter, begging
for the services of the sculptor when they
had done with him, it was too late, for he

and
Forment

had died shortly after completing the work, and the canons had buried him in the cloister. There the sacristan still shows an epitaph, which is not Forment's, as Carderera pointed out, but of his composition, being put up by him to the memory of a pupil Pedro Monjois. Carderera also says that the name of the sculptor does not occur in the book of Obits and Anniversaries, which he has scanned, and which one would expect to record a memorial of him. Still, the evidence is negative both ways: if Forment did not necessarily die in 1533, yet he did not necessarily live to quit Huesca. To these two works we must add the retable of S. Pablo in Saragossa, given conjecturally by Ceán Bermúdez and since confirmed by documents. These three have everything in common: the curious shape, raised over the central compartment, the tall canopied predella, the rich interlacing pattern of the frame, like stallwork; the deep canopies over groups and about figures, and in this Gothic setting, the plastic style of the Florentine Renaissance. This, unluckily,

is not all we have of his authentic work:
Sr. Tramoyeres[20] has unearthed the con-
tract for the *retablo mayor* of Poblet.
Dated April 2, 1527, it was drawn between
Abbot Pedro Quexas and Damian Forment
del regne de Valencia, living in Saragossa.
In 1531, a thousand ducats were still due
him on it. This is pure Plateresque work,
made up of columns and niches from which
most of the statues have gone, but one
standing figure keeps the grave beauty of
early art. Lastly, he was to make a re-
table for the cathedral of Barbastro. The
base, still unfinished, fell to his daughter
at his death, and was only completed in
1560 by a pupil of his, Juan de Liceire.
From the plates of retable and base that
Sr. M. de Pano publishes,[21] I should say
that the groups in the base were his and
the design of the enframing parts, but not
the detail of these: the style shows still
the transition to pure Plateresque, to the
style of silver-smiths and not of wood-
carvers. Everywhere his beauty is a little
hard, and the richness is mere overlay.
He was of Valencia, not of Aragon, but his

Poblet

Barbastro

archaic quality of resistance serves him like a northern strain, and his is a pure but not a stubborn art. In every work of Forment's that we know for his, the groups are enclosed in boxes or niches; the figures have a setting and background as in painted retables; the framework is made of mouldings and vegetation; the foundation of the retable is in one great plane, and not bent obliquely. With three Gothic and two plateresque works, we have plenty on which to base a judgment, and as in the case of Maestre Andrés, so here in the Forment case, the judgement confirms the first opinion. The retable of S. Domingo is not by the same man as the retable of Huesca.[22] There was at least one other Forment, in the sixteenth century, who was also a sculptor by profession: Lucas Forment, in 1552, was witness for Innocencio Berruguete about the recumbent effigy of Pedro González de León. He was then twenty-four and had known Berruguete for four years, and his testimony was rather flippant, viz.: "If he himself had that piece of work to do

he would not do it unless they gave him more." [23]

The ritual choir, but not the architectural, is denoted by the Spanish use of the word *coro*, and it is necessary to have in English some such distinction of terms when the stalls are looked for in the nave. I venture to propose the revival, merely, of the elder English form *quire*, as it appears for instance in the rubric that provides for an anthem "in quires and places where they sing." The quire, then, of S. Domingo is covered on the south side with paintings of the life and legend of the saint, in their original sixteenth-century frames. Opposite these is a chapel consecrated to a local devotion, with a statue of the titular, the Blessed Jerome Thermosilla, a mitred Abbot in a black cloak over white habit and scapular. In a chapel once dedicated to the Baptist and S. Martin but now oddly enough to S. Teresa, a tall retable that antedates some of the rebuilding and the present invocation, yet dim-glimmering with tempera and leaf-gold, reigns above an altar-tomb of a knight and two wall tombs with recumbent

The quire

effigies, these of the fifteenth century, another with a kneeling pair of the seventeenth. The central figure is D. Pedro Juárez de Figueroa, Lord of the town of Cuscurrita, of the family of the Dukes of Frias and Counts of Haro, who died in 1418. In one of the niches lies next to his spouse Doña Juana Fernández, with a book in his hands and two more at his bed's head, D. Pedro González de Santo Domingo y Samaniego, sometime *Corregidor* of Vizcaya and the *Encartaciones*, founder of one of the *Mayorazgos* included in the house of the Marquesses of Ceriñuela that possess the place. That word Mayorazgo means here, manifestly, a title and the estate which goes with it, devolved upon the eldest son. It also means property and inheritance, and is used at times as a proper personal title of the eldest son before, but also after (I think) he has come into the property: the *Mayorazgo de Labraz* is just such a title as the *Master of Ballantrae*. An old flag hangs here: it is the banner of the Alférez Perpetual of the city, an honour which Philip II bestowed on his guards-

<div style="margin-left:2em">The tombs</div>

man D. Francisco de Ocio in 1566. The *trascoro* is adorned with huge oil paintings of the Passion; Maestre Andrés's carvings have disappeared. In the chapel of the Magdalen, on the north side, lies D. Pedro Carranza, Apostolic Protonotary and *Maestrescuela* of Burgos Cathedral, in a lovely rich tomb carved in the head of the niche with the Annunciation. He built the chapel and ordered the tomb in 1539. The chapel of S. Andrew belongs to the *Mayorazgo* of Tejada: there rests D. Fernando Alonso de Valencia, sometime canon of the cathedral, who died in 1522, and another canon, his kinsman, D. Juan de Valencia: the statues, vested exquisitely and nobly conceived, are from the hand of some unknown Burgalese sculptor.

Burgalese sculpture

The shrine of S. Dominic stands in the south transept painted and gilded and carved with a wealth of ornament and a complete history of his miracles. The wrought-iron grille is painted and gilded likewise; and the whole is just such another as that of his disciple S. Juan. The statue of the titular was made and placed in

. . . que canto la gallina asada

1789, the sculptor being Julian S. Martin of Burgos (1762–1801.) Above the west wall of this transept, behind a grating, a fine pair of white fowls cluck and scratch in memory of the most famous of the miracles.[24] It was painted by Palmezzano, perhaps from Melozzo's designs, in the fifteenth century at Forli, where the chapel is dedicated to S. James, the church to SS. Blaise and Jerome.[25] It was painted also in the Aracoeli, in Rome, by one Juvenal de Orvieto, in 1441. Jacob Sobieski mentions[26] that the French Pilgrims, and more especially the Poles, feed the white chickens thinking that if these eat, they will get safely to Santiago. The editor suggests, a little vaguely, that the chickens may have prompted the story. This story, as I conceive, although it occurs within the full light of history, offers a very delicate instance of a mythopoeic process; being probably invented *après coup* to explain some Roman relief discovered in the twelfth century here, somewhere along the line of the Roman street. Mrs. Arthur Strong publishes one found in the Rhine-

land[27] which shows all the *dramatis personae* of this legend: persons seated, by intention the family and the judge, and standing, by interpretation the father, and the roasted fowl on the table. The tablet bears suggestions of the cult of Mithras; such another might easily turn up under the plough in Spain to-morrow.

Mithras

Sieur des Orties.

> *This was the little fold of*
> *separate sky*
> *Whose pasturing clouds*
> *in the soul's atmosphere*
> *Drew living light from*
> *one continual year.*
> —The House of Life.

The day was yet young when at Zalduendo we quitted the modern highway and for some three miles crossed a high rolling moor, odorous with box and rosemary, flushed with heather, glad with larks, cooled with hill-borne airs, to reach the shrine of S. Juan. So we came down, past a carved stone cross, into a green valley among rustling trees, with broad smooth turf before the door and stone benches in

Entrar de prisa . . .

the shade for the elders of the hamlet.
The *Cura* had said his Mass long before,
and gone elsewhere to say another, but
at the return we encountered him inside
his house-door unsaddling the rough ass
like a younger and less troubled S. Joseph.
S. John his patron I imagine as a figure not
unlike this, small and friendly, but keener,
with the engineer's face, square chin and
overhanging brow, spare cheek and puck-
ered eyelid, for he spent his life at laying
out roads and then making them, at plan-
ning high bridges, wide-arched in mid-
stream, narrower in the shallows, and then
cutting the stone and placing it. He spent
his best days working in the sun and direct-
ing other workmen, but he ended them
here, in a grassy dell, on a stone bench
under whispering trees. He would get up
when a pilgrim came around the turn,
meet him, and ask the news as they reached
a quiet room, swept and scrubbed, deep-
windowed and strong of door, cool in mid-
summer, warmed in snow-time; and from
the hearth where the white ash always
winked and lisped, fetch warm water and

if needful wash a man's feet; he would
dish up a stew, tasting of meat, and savory,
out of the little blackened pot that sim-
mered there, and fill a horn cup from the
bloated wine-skin in the shed, and lastly
show a bed, warm, well-shaken up, and
clean. He slept usually on the floor
himself. He who had given orders so
long would hand out a little joke with the
piece of bread for breakfast; he would
answer questions and remember news and
report the state of the roads and the run
of the weather to outgoing travellers,
from the account of those returning. He
whose advice kings had requested would
serve the meanest, and tend the foulest, *y el servir es*
and wait upon the lustiest,—a tiny trot- *señorío . . .*
ting old man, white headed and white
handed with age, with tanned and shrivelled
face. In 1080 he was born;[1] he died in
1163.

Certainly he began this church; with
three apses, the central one arcaded and
adorned with carved capitals and small
windows under a second set of arcades.
Inside, the semidome of this apse is carried

Late
Gothic
stalls

on four curious heavy ribs that taper upwards, and are nicked along the edges with the same desire to decorate as S. Cuthbert's abbey shows on the high hill at Durham. Each apse is preceded by a pointed barrel-vault, but the high crossing and transept of two bays are of sound transitional vaulting, quadripartite. The nave consists of but a single bay, rebuilt, with six ribs for the aisles and eight for the centre, and is filled up with a choir gallery. The lovely late Gothic stalls, up there, though neglected, recall not unworthily those that Nájera keeps closed away, and those that Celanova boasts were fetched from Sahagún. Behind the north apse a passage leads to the cloister, and by a turning stair, to the upper cloister and tower. The eastern capitals of the transepts, and these of the chapels opening therefrom, are original: on the north side, in a style recalling the tabernacles at *S. Juan de Duero* in Soria, the Annunciation and Nativity; on the south side, more delicate, under tabernacles, the Annunciation and Visitation, the Epiphany and

Massacre. The piers of the crossing have finely moulded bases and pretty *griffes;* on the western transept face, capitals and balustrade are flamboyant and more commonplace. They belong possibly to the time when Bishop Pablo de S. María restored the church, the rents, the income, and the offices, sending Jeronymite monks from Fres del Val, in 1434.[2] Sr. Lampérez distinguishes in the early work two hands: the saint's own, on the lesser apses, and the lower parts of the central one and the transepts, and another on the high walls and vaults; the stones, he says, testify.[3] Flórez confirms this,[4] saying that this building, begun in 1138, got as far as the crossing, being all of stone. He was the most famous architect of his time in Castile, says Ceán Bermúdez,[5] and this notion of his genius is confirmed in turn by Sr. Lampérez, who says: "S. Juan de Ortega appears to us as a master of grand and robust conception, and of the purest Romanesque style, which is somewhat archaic in details, and belongs to no determined school of architecture." Here, that

Early Romanesque building

is to say, the creative imagination has perfectly fused the matter and brought forth personal and perfect work.

The shrine of the saint, which is simply a rich canopied tomb not unlike the royal tombs in SS. Creus, stands in the chapel of S. Nicholas, now the parish church. This was the original chapel that S. Juan built in thanksgiving to S. Nicholas of Bari, on his return from the Holy Land, and there he must have said his daily Mass for many years, for he was not only monk but priest, ordained by Bishop Pedro Nazar of Nájera. In the course of time men had come to live with him; amongst these, two nephews of his named John and Martin, and he had organized them under the Rule of S. Augustine and had his household confirmed by the Pope in Rome in 1138,[6] and had his valley confirmed by the King D. Sancho in 1142, so that in his testament of 1152, he calls himself quaintly *Senior de Hortega*, the Lord of Nettles.

The chapel was rebuilt by Isabella, who had come in pilgrimage, seeking a child, in 1477: now the saint was himself an only

child, for twenty years desired, and he
"was an especial mediator in this need,"
says the chronicler. He gave to Isabel
her three tragic children; the prince D.
John, cut off in his first flowering, who
lies inurned at Avila; Joanna the Mad,
and the most unhappy of English
queens, called Catharine of Aragon. It
is recorded that when the monks in the
year 1450 in the time of Bishop Alonso
of Carthagena, Fray Gómez de Carrión[7]
being then prior, wished to translate the
body of the Saint into the church, and to
that intent, in the presence of many nobles
and prelates, opened the tomb, there came
out from it a multitude of white bees, with a
sweet odour; they hummed about, they
even stung the obstinate, and the tomb was
closed again.

Here we are again in the richest vein
of folklore: all over the world bees are
souls, and it becomes apparent how under
the form of bees he kept the hosts of
unborn souls, ready for women who should
come to beg for babies. There is a Tyrolese
figure of Frau Holda who lived in a moun-

tain and kept the souls in a big chest, not half so pat as this. S. Rita of Cascia has also a swarm of these white bees, but as she was beatified only in the seventeenth century and canonized in the twentieth it is not easy to discover from her legend as then drawn up and confirmed what she does with them.

A pretty story Flórez also preserves, of an ivory crucifix which the king D. Alfonso gave to him, in which he took much delight and carried it about and conversed with it, and one day when he had no one to assist at Mass, the Crucifix responded and helped him to the end of Mass. Certain of his miracles as Helper and Harbourer are carved around the base of the cenotaph (the body itself lies in a stone coffin underneath) much as those of S. Sebald may be read about his shrine in Nuremberg: on the east side S. Nicholas appearing to him in a ship at sea: on the south, the restoration of a man that fell asleep by the roadside and a loaded cart passed over him; and the return of the robbers who had stolen the saint's cows

and wandered all night in a fog, and in the morning found themselves with their booty at the convent door. The north side begins with the history of how his ass, when he was once in Nájera, broke its headstall, and the saint when cobbling it wounded his own eye with the needle, but when the Bishop came to condole with him, God restored the sight and he arose joyfully to greet his noble guest. The other history is not in Ribadeneyra or Flórez: two dead men lie under trees, the saint prays and anon a monk receives the two men under a florid Gothic door. An altar set against the west end hides the remaining subject. It was set up in 1474; the *verja* is dated 1561. The style is charming, fresh, luxuriant, and delicate. With James and his brother and cousin, we could wish to make three tabernacles, for it is good for us to be here. *Spes lumen splendor*[8] is the only inscription on the shrine: perhaps it means that John of the Nettles was set, like a lighted candle, in a golden candle-stick.

These moors are a part of the mountains

Spes lumen splendor

. . . y salir
corriendo

of Oca, and from the higher levels we
looked across green tilth and unripe har-
vest, where church-towers drew tree-tops
about them, under a low-hung sky, to a
lofty blue chain of hills, along which
sunstreaks chased the shadow-streaks of
rain. From Zalduendo to Burgos the
road is modern and rather dull, easily
flowing over the unfrequented hills till the
high shoulder of Miraflores was lifted into
sight at a turning, and in the basin of the
Arlanzón the city lay, every spire and
tower plain, familiar, and very fair.

NOTES: BOOK ONE

CHAPTER I

See, for the matter of this chapter, the following books, used often too freely or too generally for page reference:
Dieulafoy, *Art in Spain and Portugal*—Strzygowsky, *Orient oder Rom*—Id., *Klein-Asien*—Butler, *Architecture and other Arts*—Spiers, *Architecture East and West*—Rivoira *Le Origini della Architettura Lombarda*—Lasteyrie, *L'Architecture Religieuse en France*—Michel, *Histoire de l'Art*—Lampérez, *Historia de la arquitectura cristiana española en la edad media*—Street, *Some Account of Gothic Architecture in Spain*.

[1] Gayet, *L'Art Arabe*, p. 7.
[2] Lampérez, *Revue Hispanique:* 1907; vol. XVI, p. 565.
[3] Phené Spiers, *Architecture East and West*, pp. 153-198.
[4] In *The Thousand and One Churches* with No. 32, plan p. 199, *cf.* S. Juan de Baños; with a base in this church, p. 220, and a capital, p. 216, *cf.* S. Miguel de Linio: with Ala Klisse, p. 451, *cf.* Sahagún. This is the extent of likeness that I have found

among the churches explored by Miss Bell and Sir William Ramsey.

[5] Since these pages were written, that brilliant and picaresque figure in contemporary letters, has passed into the greater glory. In January of 1917, Emile Bertaux died for France: *Dona ei requiem sempiternam.* It seems best, however, to let the pages stand as they were once written in the hope of meeting his eye and enjoying his commentary.

[6] The words are: "Le maître d'œuvres . . . de la cathedral de Tolède était Français, s'appellait *Petrus Petri*, Pierre fils de Pierre, et mourut en 1290." In the plan of the cathedral "cette alternance ne se voit que là et dans un dessin de l'album de Villard d'Honnecourt, donné comme le fruit de sa collaboration avec Pierre de Corbie. Le maître d'œuvres *Petrus Petri* serait-il Pierre de Corbie, mort en ce cas tres agé, ou son fils." C. Enlart, in *Michel*, II, ii, 111.

[7] He wrote *Les Architects des Cathédrals Gothiques.*

[8] The Commendatore Rivoira is not exempt from this charge in his latest book on *L'Archi- tettura Musulmana.*

[9] Out of a clear sky comes an American instance to hand. "If the unmistakable evidence of northern imitation did not exist in the literature itself, the strong current of influence in the arts would justify us in searching for it *or even, examples failing, in assuming that its traces were lost.* The arts spring *in their entirety* from across the Pyrenees, and are a voucher for the French domi-

nation which we have already discovered
[read, *asserted*] in much of the epic, popular
and cultured, in religious, lyric, and drama-
tic verse, in encyclopedic, sententious, and
narrative prose." The false process of the
first sentence being assisted by the false
statement of the second (italicized here for
convenience) the great gulf between influence
and origin is safely passed. *V.* Post, *Mediae-
val Spanish Allegory*, pp. 278–280.

[10] Kleinclauz, *Claus Sluter*, p. 42.
[11] *Album de Villard de Honnecourt*, pub-
lished by the Bibliothèque Nationale and
printed by Berthaud Frères, Paris.

CHAPTER II

Gaston Paris, *Histoire Poétique de Charle-
magne*—Dozy, *Recherches*, II, *Le Faux Turpin*,
pp. 372 seqq.—Bédier, *Les Légendes Epiques*,
III—Fita and Guerra, *Recuerdos de un viaje*—
Baring Gould, *Curious Myths of the Middle
Ages*.

[1] Bédier, *Les Légendes Epiques*, III, 98–9.
[2] Thomas, *L'Entrée d'Espagne*, Societé des
Anciens Textes Français, Paris, 1913.
[3] *Cf.* Roger of Hovenden *Rerum Brit. Script.*
II, 147: "Port of Cise was called Port of
Spain."
[4] This identification is probably wrong.
The Sant Mart of hearsay was more likely S.
Marta de Tera in the diocese of Palencia, a
pilgrimage place with a Romanesque church

and sculpture of the decadent school of Toulouse.

⁵ Mussafia, *La Prise de Pampeluna*, Vienna, 1864.

⁶ So substantially, says M. Bédier, *op. cit.*, III, 134.

⁷ *La Prise de Pampelune*, l. 5686.

⁸ *Id.*, l. 5836.

⁹ *Id.*, l. 6025.

¹⁰ Alton, *Anseis von Karthago*, in Bibliothek des Litterarischen Vereins in Stuttgart. Vol. 194, Tübingen, 1892.

¹¹ *Id.*, l. 3538.

¹² In this matter of S. Charlemagne *cf.* Gaston Paris, *Histoire Poétique de Charlemagne*, pp. 58–66.

¹³ Bouillet, *Liber de Miraculis S. Fidis*, 1897.

CHAPTER III

Fita et Vinson, *Le Codex de S. Jacques*—Fita y Guerra, *Recuerdos de un viaje*—*Acta Sanctorum*—Dozy, *Recherches.*

¹ Delisle, *Notes sur le Recueil:* Passim.

² *Analecta Hymnica*, XVII, 218.

³ Murguía, *Galicia*, p. 419.

⁴ For the dates and incidents of the Miracles *v. Appendix.*

⁵ Fita, *Recuerdos de un viaje*, p. 43.

⁶ I should not have analysed the *Codex* so fully in this and the following chapter, if I had known sooner that it figures in Ward's *Catalogue of Romances!* It is also discussed

by Friedel under the title *Études Compostel-
lanes* in *Otia Merseiana*, but to little purpose,
for lack of comprehension how things stood
in Spain.

7 G. Paris, *Histoire Poétique de Charlemagne*,
p. 58.

8 Caxton, *Golden Legend*, "The Life of
S. James the More."

9 Fita, *Recuerdos*, p. 69.

10 For the Apparition at Simancas consult
Gonzalo de Berceo in the *Life of S. Millán:*

> . . . Vieron dues personas fermosas y
> lucientes,
> mucho eran mas blancas que las nevies
> recientes;
> vinien en dos caballos plus blancos que
> cristal,
> armas quales non vio nunqua omne mortal:
> el un tenia croza, mitra pontifical,
> el otro una cruz, omne non vio tal. . . .
> Et que tenia la mitra e la croza en mano,
> essi fue el apostol de Sant Juan hermano,
> el que la cruz nía e el capiello plano,
> esse fue Sant Millan el varon cogellano.
> *Vida de S. Millán*, stanzas 437, 438, 447.

11 P. Claudel, *Corona Benignitatis: Anni
Dei*, p. 83.

12 Fita, *Recuerdos*, p. 63.

13 *Congrès Scientifique*, Bruxelles, 1894: L.
Duchesne, *Les Anciens Recueils des Légendes
Apocryphes*.

14 Gómez Carrillo, *Flores de penitencia*,
pp. 11–14.

[15] Duchesne, *S. Jacques en Galice*, in *Annales du Midi*, 1900, pp. 145 *seqq.*
[16] Cf. *España sagrada*, XX, 473.

CHAPTER IV

Fita et Vinson, *Le Codex de S. Jacques*—Daux, *Les Chansons des Pèlerins de S. Jacques*—Baron Bonnot d'Houët, *Pèlerinage d'un Paysan Picard*—Fita y Guerra, *Recuerdos de un viaje*—Bédier, *Les Légendes Épiques*—Friedel, *Études Compostellanes.*

[1] Published, the former in Fita, *Recuerdos de un viaje*, p. 45, the latter in Leclerc, *Histoire Littéraire de la France*, XXI, 276. Also in Dreves, *Analecta Hymnica*, XVII, 210, 213.

[2] Fita y Guerra, *Recuerdos de un viaje*, p. 45.

[3] Murguía, *Galicia*, p. 45.

[4] López Ferreiro, *Historia de la S. A. M. Iglesia*, VI, 51, 84.

[5] Pierce Butler, *Legenda Aurea*, p. 12, citing Echard, *Scriptores Ordinis Prædicatorum*, I, 514. This quotation, which I am compelled to take at second hand, was certainly not understood by Dr. Butler. Considering the life and acts of Fray D. Berenguel and his devotion to S. James for protection during the stormy months that followed his election, it is likely that what he projected was a much fuller collection of miracles brought up to date. Indeed, in Caxton's *Golden Legend*

the story of Hermogenes and that of the Translation are given "as Master John Beleth saith," and the miracles thereafter "as Calixtus the pope saith," and "Hugo of S. Victor rehęarseth," and "Hugh the abbot of Cluny witnesseth." In short, they correspond fairly well with the *Book of S. James.* How much of this was in the original text of the Genoese, I am not in a position to say; only I know that the loss of Archbishop Berenguel's intended compilation, can never be enough deplored.

⁶ *De Pseudo-Turpino* (1865) and *Romania* XI (1882).

⁷ Fita y Guerra, *op. cit.*, p. 44.

⁸ In *Otia Merseiana.*

⁹ M. Adrien Lavergne says (*Revue de Gascoigne*, XXVII, XXVIII, p. 76; 1887) that this is the Hospice of Montjoy at Compostella. The Mount I know, and thereon a church dedicated to S. Mark, but no hospice. There was a Mount of. Joy where first the Roman pilgrims came in view of the Eternal City: if there stood a hospice it would satisfy the rhetoric, that is rehearsing the old triad of Rome, Jerusalem and Compostella. "Whosoever wishes to go to the holy city Jerusalem, let him always direct his courses toward the sun's rising, and so, God being his guide, shall he come to this holy Jerusalem. From the western side the Mount of Joy was a conspicuous object; and from this mountain it is one mile to the city." From *How the City of Jerusalem is Situated*, c. 1090, published by Palestine Pilgrims' Text Society.

[10] This has been said to us in another form: *Quien lengua lleva, a Roma llega.*

[11] Reprinted, the Spanish part, in *Appendix.*

[12] Villa-amil y Castro, *Pobladores, ciudades, monumentos y caminos antiguos,* p. 109.

[13] Dozy, *Recherches,* II, 87.

[14] López Ferreiro, *Historia de la S. A. M. Iglesia,* V, 91. *Cf.* also Murguía, *Galicia,* p. 417.

[15] Quadrado, *Asturias y León,* p. 623.

[16] G. Parthey and M. Pinder, *Itinerarium Antonini Augusti,* p. 204.

[17] *Boletín de la Real Academia de Historia,* XXI (1892).

CHAPTER V

The substance of this chapter is drawn chiefly from Pardiac, *S. Jacques le Majeur et le Pèlerinage de Compostelle*—Lavergne, *Les Chemins de S. Jacques en Gascoigne*—Villa-amil y Castro, *La peregrinación a Santiago de Galicia*—Murguía, *Galicia*—López Ferreiro, *Historia de la S. A. M. Iglesia*—Victor Le Clerc, in *Histoire Littéraire de la France,* XXI—*Acta Sanctorum.*

[1] It should be noted for later comparison that in England the Milky Way was called the Walsingham Way, and that Glastonbury was identified with the Isle of Avalon, whence the three Queens came and fetched Arthur of Britain when he was dead. *V.* Gaston Paris,

Conte de la Charette, in Romania, XII, pp. 459–534.

[2] Fita y Guerra, *Recuerdos de un viaje,* p. 54.

[3] Paul the Deacon, *History of the Lombards,* III, xxxii.

[4] *Recherches,* II, 277. In view of the date c. 830 often given for the Invention, the importance of this incident is apparent. Dozy seems not to have questioned it. His MS. dated 649 of the Hegeira, *i. e.,* A.D. 1251, by Ibn-Dihya (died A.D. 1235) draws from Tammam-ibn-'Alcama, died A.D. 896, who had known personally Al-Ghazal and his companions. *Op. cit.,* 267, 268.

[5] Cited by Sr. D. Francisco Fernández y González in *Boletín de la Real Academia de Historia,* 1877, I, 461.

[6] Cahier and Martin, *Nouveaux Mélanges,* IV, 320.

[7] Morales, *Crónica general,* Bk. IX, chap. vi.

[8] *Cf.* La . Fuente, *Historia eclesiástica de España,* III, 537.

[9] Quoted by Govantes in his *Diccionario geográfico-histórico,* Sección II, p. 176.

[10] Okey, *The Story of Avignon,* pp. 21–26.

[11] López Ferreiro, *Historia de la S. A. M. Iglesia,* V, 82.

[12] López Ferreiro, *op. cit.,* IV, 75–76.

[13] Fita and Vinson, *Le Codex.*

[14] *España sagrada,* XXXV, p. 246.

[15] *Id. ibid.,* XXXV, 108.

[16] *Id. ibid.,* 137.

[17] *Galicia,* 419, note.

[18] Roger of Hovenden, in *Chronicle: Rerum Britannicum Scriptores,* II, 117.

[19] Murguía, *Galicia*, 426. Reprinted here in *Appendix*.
Cf. Colas, *La Voie Romaine de Bordeaux à Astorga dans sa Traversée des Pyrenées*, in *Revue des Études Anciennes*, 1912.

[20] Luke of Tuy in *Hispaniae Illustratae*, IV, 104-5.

[21] G. Paris, *Légendes du Moyen-Age*.

[22] Villani, *Chroniche Fiorentine*, Bk. VI, 90.

[23] Murguía, *Galicia*, p. 425.

[24] Froissart, *Chronicles of France, England, and Spain*, Bk. I, chap. cx.

[25] Michel, *Le Pays Vasque*, p. 337.

[26] *Histoire Littéraire de la France*, XXI, 290.

[27] *The Stations of Rome* and *The Pilgrms' Sea Voyage*, E. E. T. S., 1877, vols. 25-26, p. 37.

[28] Arber, *English Garner*.

[29] J. R. Menéndez Pidal, *Poesía popular*, xlvi, p. 273.

[30] J. R. Menéndez Pidal, *op. cit.*, lxiv, lxv.

[31] Bonilla y San Martín, *Flores y Blancaflor*, 1916.

[32] Acta SS., May, vol. vii, 144.

[33] This, at any rate, is how Enrique Cock the guardsman understood it, and he brought away a white chicken feather in evidence. *Jornada de Tarazona*, p. 52.

[34] Dante, *Vita Nuova*, § xli.

NOTES: BOOK TWO

CHAPTER I

[1] La Fuente, *Historia eclesiática*, III, 299.

[2] Fita and Vinson, *Le Codex de S. Jacques*, p. 7.

[3]A. Lavergne, *Les Chemins de S. Jacques en Gascoigne*, p. 15.

[4] Quadrado, *Aragón*, p. 314.

[5] Fita, *Elogio de la Reina de Castilla Doña Leonor*, pp. 9–10.

CHAPTER II

Briz Martínez, *Historia de la fundación y antigüedades de S. Juan de la Peña—Crónica de S. Juan de la Peña*—Sandoval, *Historia de los reyes de Castilla y Aragón*—Pedro Abarca, *Los reyes de Aragón*—La Fuente, *Historia éclesiástica*—Yepes, *Corónica general de la Orden de S. Benito*—Rodrigo Ximénez, *Crónica de España*—Quadrado, *Aragón*—Victor Balaguer, *Instituciones y reyes de Aragón*—Lampérez, *Historia de la arquitectura*, and *Notas de una excursión.*

[1] We who are worth as much as you and can do more than you, we choose you king that you may guard our rights and liberties; and between you and us one who has more authority than you. If not, then,—not!

[2] *Crónica de Aragón*, Edition de 1499, fol. 3 and fol. 17, quoted by Quadrado, p. lix., note.

[3] Briz Martínez, *Historia de S. Juan de la Peña*, lib. I, cap. xxix.

[4] La Fuente, *Historia eclesiástica*, III, 534.

Jaca: the Cathedral:

[1] Lampérez, *Notas de una excursión a S. Juan de Baños . . . S. Juan de la Peña* in

Boletín de la Sociedad Española de Excursiones,
(1899), VII, 177.

[2] Lampérez, *Historia de la arquitectura,* I,
375, 381, 674. For a general discussion of
developed Romanesque, *cf.* Robert de Las-
teyrie, *L'Architecture Réligieuse en France.*

[3] Quadrado, *Aragón,* p. 295.

[4] Sandoval, *Historia de los reyes* in *Crónica
general,* XII, 208.

[5] La Fuente, *Historia eclesiástica,* III,
354.

[6] Charles de Lasteyrie, *L'abbaye de S.
Martial de Limoges.*

S. Juan de la Peña:

[1] Briz Martínez, *op. cit.,* p. 77.

[2] Lampérez, *España moderna,* October,
1899; also Lampérez in *Boletín de la Sociedad
Española de Excursiones,* 1899, VII, 177.

[3] *Op. cit.,* p. 324.

[4] *Op. cit.,* II, xiv.

[5] Briz Martínez, *op. cit.,* I, xxix.

[6] La Fuente, *op. cit.,* III, 303.

[7] The suggestion of this I owe to Professor
Kingsley Porter, who after studying photo-
graphs of these capitals and the portal at
Estella, proposes the converse of it.

[8] In *Crónica general de España,* XII, 208.

Alfonso el Batallador:

[1] Briz Martínez, *op. cit.,* i, xxii, and xii,
ix.

[2] Dozy, *Recherches,* I, 348.

[3] *Op. cit.,* p. 792.

CHAPTER III

Govantes, *Diccionario geográfico-histórico*—
Section II—Llaguno, *Noticias de arquitectos
y arquitectura*—Madrazo, *Navarra y Logroño*,
and *Museo español de antigüedades*—Lampérez,*Historia de la arquitectura*—Iturralde y
Suit, *Las grandes ruinas monásticas de Navarra*—Enlart, in Michel, *Histoire de l'Art*, I,
ii, 558 *seqq.*—Bertaux, in the same, II, i,
214 *seqq.*

Leyre:

[1] *Diccionario geográfico-histórico*, I, i, 438–446.

[2] Lampérez, *Historia de la arquitectura*,
I, 593.

[3] Madrazo, *Navarra y Logroño*, I, 545.

[4] *Leçons professés à l'école du Louvre*, I,
577–579.

[5] Lefèvre-Pontalis, *Congrès archéologique
de France*, 1913, p. 302: an article also in
1903.

[6] Iturralde y Suit quotes *Historia del
monasterio de Leyre*, in *Las grandes ruinas
monásticas de Navarra*, pp. 307, sqq.

[7] *Op. cit.*, I, 560.

[8] *Museo español de antigüedades*, V, 209;
also in *Diccionario geográfico-histórico*, I, i,
441.

[9] S. Luke, i, 41.

[10] To confirm or connect this consult, in
addition, Lasteyrie, *L'Architecture religieuse
en France*, Baum, *Romanesque Architecture
in France*, and the fine series of plates in the

series called *Archives du Commission des Monuments Historiques.*

Sangüesa:

[1] *Diccionario geográfico-histórico* I, 297.
[2] Madrazo, *Navarra y Logroño.* II, 488.
[3] Michel, *Histoire de l'Art,* II, 258, 261.
[4] *Historia de la arquitectura,* I, 602.
[5] Pons occurs in the second *Chanson des Pèlerins:—*

"A Lusignan avons passé,
a Saintes, à Pont, puis à Blaye."

Quoted by Lavergne, Revue de Gascoigne, 1887, p. 175.
[6] Genesis, iii, 15–16.
[7] Minns, *Scythians and Greeks,* passim; M. Anatole de Roumejoux, *L'Ornementation Mérovingien et Carolingien,* in *Congrès Archéologique de France,* 1894, pp. 317, sqq.
[8] Madrazo, *op. cit.,* p. 495.
[9] *Id. ibid.,* p. 493.
[10] *Noticias de los arquitectos y la arquitectura,* I, 87.
[11] *Op. et loc. cit.*
[12] *Op. cit.,* pp. 27, 92, 95.
[13] Pelayo Quintero, *Sillas de coro,* p. 112.

CHAPTER IV

Diccionario geográfico-histórico, (s. v. Pamplona)—Iturralde y Suit, *Miscelánea*—Madrazo, *Navarra y Logroño,* II—Alvarado, *Guía del viajero en Pamplona*—Lampérez, *Historia*

de la arquitectura—Bertaux, in Michel, *Histoire de l'Art*, II, ii—Street, *Gothic Architecture in Spain*.

[1] Madrazo, *Navarra y Logroño*, II, 212–216; Moret, *Annales*, xvii, c. vi, § 1.
[2] *Historia de la arquitectura*, I, 348.
[3] Quoted by Madrazo, *op. cit.*, II, 341.
[4] Michel, *Historia de l'Art*, II, ii.
[5] *Id. id.*
[6] Cf. *Cursor Mundi*, ll, 16859–16868 (E. E. T. S.).
[7] Madrazo, *op. cit.*, II, p. 290, note.
[8] Madrazo, *op. cit.*, II, pp. 317–318, 521–523.
[9] Madrazo, *op. cit.*, II, pp. xlix, l, li, and 351–353. A digest of this in French was published by Bertaux in the *Gazette de Beaux Arts*.
[10] *Exposición retrospectivo de Zaragoza*, p. 41.
[11] Madrazo, *op. cit.*, II, pp. 337–8. I owe a final chance to examine this treasure, more jealously locked up every year, to the landlord of the Grand Hotel. After examining the houses of *La Francesa* and *S. Julián*, I were ungrateful not to pause and praise this one, where were found European ways and cooks, quiet and space that seemed luxurious, rest, and, from the landlord, untiring kindness and interest.

CHAPTER V

Madrazo, *Navarra y Logroño*, II and III—La Fuente, *Historia eclesiástica*, III, IV, and *España sagrada*, L—Llaguno, *Noticias de los*

arquitectos y arquitectura, I—*Diccionario geo-gráfico-histórico de España,* I—Yangüas, *Diccionario de antigüedades de Navarra*—Altamira, *Historia de España y de la civilización española* —Lampérez, *Historia de la arquitectura*—Iturralde y Suit, *Miscelánea* and *Las grandes ruinas monásticas.*

[1] *Cultura Española,* VII, November, 1907.
[2] It would seem, however, that the open arcading stuck in the mind of thirteenth-century pilgrims, for it figures in Thurkill's *Vision.* V. *Appendix.*

Puente la Reyna:
[1] Jaufre Rudel.
[2] *Cf.* Madrazo, Navarra y Logroño, II, p. 200, note; and Iturralde y Suit, *Miscelánea,* 73-77.
[3] *Cf.* Lampérez, *Historia de la arquitectura,* I, 309-339, and Altamira, *Historia de España,* vols. I and II, § 216-555, passim.
[4] Traggia, in *Diccionario geográfico-histórico,* I, i, 263, *s. v. Puente la Reyna;* Madrazo, *op. cit.,* II, 538-540; Iturralde y Suit, *Las grandes ruinas,* 242.
[5] *Op. cit.,* I, 617.
[6] *Op. cit.,* II, 540-547.
[7] Llaguno, *Noticias de los arquitectos y arquitectura,* i, 87.
[8] Madrazo, *op. cit.,* II, 547-548.

El Sepulcro:
[1] Traggia, in *Diccionario geográfico-histórico* I, i, 387, *s. v.* Torres.

[2] Briz Martínez, *Historia de S. Juan de la Peña*, p. 806.

[3] *Cf*. Street, *Gothic Architecture in Spain*, I, 130, 260.

[4] La Fuente, *España sagrada*, L, 139.

[5] *Id. id.*, 143.

[6] *Cf*. La Fuente, *op. cit.*, 133–138.

[7] The cross of the Order is the double cross *fleurie*, a cross of Lorraine, with two bars ending in fleur-de-lys. Torres wears that with a difference. At the present moment it is familiar enough as the badge of the 79th Division, U. S. A.

[8] La Fuente, *op. cit.*, l, 141.

[9] *Cf*. A. Kingsley Porter, *The Development of Lombard Sculpture in the Twelfth Century*, in American Journal of Archaeology, 1915, vol. XIX, p. 148, note.

[10] Iturralde y Suit, *Las cruzadas de Navarra en tierra santa* in *Miscelánea*, pp. 24–30.

CHAPTER VI

Yepes, *Coronica general de la Orden de S. Benito*—Madrazo, *Navarra y Logroño*, III —Govantes, *Diccionario geográfico-histórico de España*, I—Iturralde y Suit, *Las grandes ruinas monásticas*, and *Miscelánea*—Lampérez, *Historia de la arquitectura*—Llaguno, *Noticias de los arquitectos y arquitectura*— Serrano-Fatigati, *Portadas artísticas*—Venturi, *Historia dell'Arte*, III—A. Kingsley Porter, *Lombard Architecture*.

[1] Iturralde y Suit, *Portada de la iglesia de*

S. *Román en Ciranqui*, in *Las grandes ruinas mónásticas*, pp. 246–249. *Cf.* the church door of Montmoreau in France and, in general, Lasteyrie, *L'Architecture Religieuse en France*, figs. 235, 378, 581, 582; likewise S. Michel de l'Aiguille in Le Puy, where the Estella road was well known.

[2] Träggia, in *Diccionario geográfico-histórico*, I, i, p. 264, *s. v. Estella*.

[3] Yangüas, *Diccionario de las antigüedades de Navarra*, s. v. *Estella*.

[4] Traggia, *op. et loc. cit.*

[5] Madrazo, *Navarra y Logroño*, III, 49, 125.

[6] Caxton, *Golden Legend*, The Life of S. Andrew the Apostle.

[7] Fine plates of this portal, among others, may be consulted in Serrano-Fatigati, *Portadas artísticas*.

[8] Madrazo, *op. cit.*, 53–56.

[9] *Id. ib.*, p. 98.

[10] Traggia, *op. cit.*, 268.

[11] Quoted by Madrazo, *op. cit.*, p. 94, from an unpublished MS. entitled, *Memorias históricas de Estella, compuestas y dedicadas á la ciudad por el licenciado D. Baltasar de Lezaun y Andia, abogado de los Reales Concejos y vecino de ella. Año de 1710.—Añadidas con algunas noticias que no tuvo presentes el historiador, por otro hijo de la misma ciudad, en el año 1792.*

[12] *Cf.* Venturi, *Historia dell'Arte*, III, pp. 64, 296, 937.

[13] *Op. cit.*, p. 297.

[14] *Viaje de España*, XII, 309.

[15] Llaguno, *Noticias de los arquitectos y la arquitectura*, I, 71, 105.

Irache:

[1] Yepes, *Coronica general de la Orden de S. Benito*, III, 165.

[2] Madrazo, *op. cit.*, 127.

[3] "Thou shalt get kings, though thou be none": Macbeth, I, iii.

[4] Garrán, *S. María la Real de Nájera*, p. 23.

[5] *Op. cit.*, iii., 365.

[6] *Historia de la arquitectura*, I, 599; *v.* also 447, 595 sqq.

Madrazo says, *op. cit.*, 136, that there were once tribunes above the aisles, now blocked; Sr. Lampérez, however, testifies, p. 596, that there was no more than a beginning. Madrazo's whole discussion of the abbey, pp. 128–155, is admirable, drawing from Yepes and other sources both rare and unprinted, and likewise from the data of D. R. Velázquez Bosco's expedition in 1883, with his students, among whom was Sr. Lampérez.

[7] Yepes, *op. cit.*, i., 240.

CHAPTER VII

Thomas, *L'Entrée d'Espagne*—Madrazo, *Navarra y Logroño*, III—*Diccionario geográfico-histórico* — Froissart, *Chronicles of France, England, and Spain*—Lampérez, *Historia de la arquitectura*—Garrán, *S. María la Real*—Pere López de Ayala, *Crónica del Rey Pedro*.

[1] V. *Appendix*.

[2] Traggia, *Diccionario geográfico-histórico* s. v. *Los Arcos* I, i, p. 456.

[3] Madrazo, *Navarra y Logroño*, III, 158–9, 168.

[4] Established by Charles the Noble in 1423, extinct under John II, in 1461. V. *Diccionario geográfico-histórico de España*, I, ii, 44.

[5] Govantes, *Diccionario geográfico-histórico*, Sección II, p. 107.

The Spires of Logroño:

[1] Purchas his Pilgrims, VII.

[2] Riaño, *Viajes de extranjeros*, p. 241.

[3] *Jornada de Tarazona*, p. 57.

[4] Govantes, *Diccionario geográfico-histórico*, Sección II, Logroño, 106.

[5] *Navarra y Logroño*, III, 560.

[6] La Fuente, *España sagrada*, L, p. 140.

[7] Lampérez, *Historia de la arquitectura*, II, 289.

[8] Caxton, *Golden Legend*, The Life of S. Bartholomew.

[9] Madrazo, *op. cit.*, III, 202.

Along the Battlefield:

[1] Pere López de Ayala, *Crónica de los reyes de Castilla*, vol. I, pp. 557, 559.

[2] Froissart, *Chronicles of France, England, and Spain*, Bk. I., chap. ccxli.

[3] Caxton's *Lyf of the most Noble and Crysten Prince, Charles the Great*, Early English Text Society, extra series, XXXV, ii, 221.

[4] The English romances are too farcical to supply happy quotations, nor is the measure other than the butter-woman's rank to market:

"Charles com to Nasers—with his doussy
 peers—to see that Paynim.
He asked withouten fail—of King Charles
 battayl—to fight against him:
Charles wondered tho—when he saw him go
 —he beheld him each-a limb,
For sithen he was y-bore—he no had y-seen
 before—none that was so grim."

 —*Rouland and Vernagu.*

 E. E. T. S., vol. XXXIX, ii.

S. Mary the Royal:

[1] *The Chronology of the Kings of Nájera,*
as given by Fr. Moret, was published by
Govantes in his *Diccionario Geográfico-His-*
tórico de España, Sección II, where I found it,
pp. 131–133, and supported by documenta-
tion in Appendix 3, pp. 245–248.

[2] Dozy, *Recherches* I, XIV.

[3] J. R. Menéndez Pidal, *Primera crónica*
general, cap. 791; pp. 474–475.

[4] Cahier et Martin, *Nouveaux Mélanges*,
IV, 39.

[5] *Op. cit.*, II., 502. This architect's analysis
and judgement of the building, though just, is
severe, and allows little for the splendour of
magnitude.

[6] Garrán, *op. cit.*, pp. 72–3.

CHAPTER VIII

Lampérez, *Historia de la arquitectura*—
Madrazo, *Navarra y Logroño*, III—Govantes,

Diccionario histórico-geográfico, Sección II—
Martí y Monsó, *Estudios histórico-artísticos.*

[1] *Diccionario geográfico-histórico*, Sección II,
pp. 176–180.

[2] *Navarra y Logroño*, III, 695–6.

[3] Ribadeneyra, *Flos sanctorum*, II, 68.

[4] So Sr. Lampérez, *op. cit.*, II, 210. D.
Ignacio Alonso Martínez, *S. Domingo de la
Calzada*, p. 80, says 1158. The later date is
the likelier.

[5] Llaguno, *Noticias de los arquitectos*, I, p. 30.

[6] Madrazo, *op. cit.*, 698, 701.

[7] Ceán Bermúdez, *Diccionario histórico de
los más ilustres profesores*, I, 30.

[8] Madoz, *Diccionario geográfico* s. v. Nájera,
30.

[9] Garrán, *S. María la real de Nájera*, p. 54.

[10] Published by Martí y Monsó in *Estudios
histórico-artísticos*, p. 83.

[11] In *Sillas de coro*, p. 52.

[12] *Op. cit.*, p. 99, Nájera; 95, S. Domingo;
84–94, S. Benito.

[13] *Op. cit.*, pp. 96 seqq.

[14] Martínez y Sans, *Historia del templo
catedral de Burgos*, p. 285.

[15] Martí y Monsó, *op. cit*, p. 101.

[16] Martínez y Sans, *op. cit.*, p. 204, 205.

[17] Martí y Monsó, *op. cit.*, p. 585.

[18] *Op. cit.*, pp. 574–583.

[19] *Op. cit.*, II, 130–132.

[20] Tramoyeres y Blasco, *El retablo de Poblet*
in *La Vanguardia*, Jan. 12, 1911.

[21] M. de Pano, *Damian Forment en Barbas-
tro*, in *Cultura Española*, 1906.

[22] M. Bertaux has discussed this, in Michel, *Histoire de l'Art*, IV, ii, 946–950, but without seeing the retable.

[23] Martí y Monsó, *op. cit.*, 176.

[24] V. p. 130 and *Appendix*,.

[25] B. Berenson, *The Central Italian Painters of the Renaissance*, p. 215.

[26] Riaño, *Viajes de extranjeros*, pp. 242–275.

[27] *Apotheosis and After Life*, pp. 220, 221, Plate XXVII.

Sieur des Orties:

[1] Llaguno, *Noticias de los arquitectos*, I, 27.

[2] *España sagrada*, XXVII, 193.

[3] Lampérez, *op. cit.*, I, 482–484. Plan, p. 483.

[4] *España sagrada*, XXVII, 180.

[5] Llaguno, *op. cit.*, I, 20, 27–28.

[6] *España sagrada*, XXVII, 177.

[7] *Id., id.*, p. 194. Cf. Ribadeneyra, *Flos Sanctorum*, II, 183.

[8] Eloy García Concellón, *Boletín de la Sociedad Española de Excursiones*, 1895, III, 37.

HISPANIC

HISPANIC SOCIETY

ImTheStory.com